· DAVID FINOLI ·

PITTSBURGH'S
Greatest Teams

THE
History
PRESS

Published by The History Press
Charleston, SC
www.historypress.net

Front cover, top left: Boston College Athletics; *top center*: University of Pittsburgh Athletics; *top right*: Pittsburgh Pirates; *bottom*: University of Pittsburgh Athletics.
Back cover: University of Pittsburgh Athletics; *inset*: Duquesne University Athletics.

First published 2017

Manufactured in the United States

ISBN 9781625859174

Library of Congress Control Number: 2017944972

To my father, Domenic, as well as my Uncle Vince Finoli and my Uncle Ed DiLello, the three people who were most responsible for igniting my passion for sports that comes out in these pages. There is never an event I watch that I don't think of these three exceptional human beings.

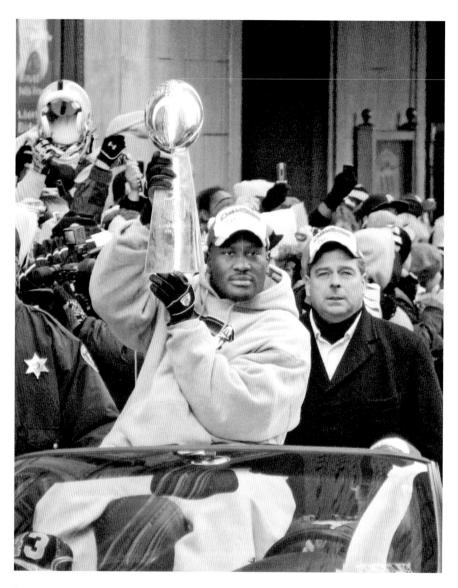

James Harrison hoists the Lombardi Trophy during the parade to celebrate the Steelers' Super Bowl XLIII victory. *Author's collection.*

CONTENTS

ACKNOWLEDGEMENTS

In an enjoyable career of researching and writing about the teams I am most passionate about, those that represent western Pennsylvania in the sports landscape, this book encompasses the ones I hold most dear, the fifty greatest teams this area has ever known.

Projects such as this are never complete without the incredible support of many. In this case, most important, my wonderful family, including my wife, Vivian, as well as my children, Matthew, Tony and Cara.

My extended family has always been a source of support over the years no matter where I've been and what I've accomplished. Those who have all been essential in any success I've enjoyed in my life include the following people: my brother Jamie; his wife, Cindy; my nieces Brianna and Marissa; my sister Mary; her husband, Matthew; my aunts Maryanne and Betty; my cousins Fran, Luci, Flo, Beth, Tom, Gary, Linda, Amy, Amanda, Claudia, Ginny Lynn, Pam, Debbie, Diane, Vince and Richard; the memories of my father, Domenic, and my mother, Eleanor; my cousins Tom Aikens and Eddie DiLello; my Uncle Vince; my grandparents; and my aunts Louise, Norma, Jeannie, Libby, Mary and Evie. A thank-you also has to go to my in-laws Vivian and Salvatore Pansino.

There is my round table of Pittsburgh sports experts, who provide insight both on the teams of today as well as those in the past when needed. They include Chris Fletcher, Bill Ranier, Dan Russell, Rich Boyer, Shawn Christen, Matt O'Brotka, Don Lavell, Gary Degnan and Bob Healy, whose help and enthusiasm in researching the list of western Pennsylvania champions was extremely valuable.

ACKNOWLEDGEMENTS

Finally, a thank-you to those whose generous help in securing the photos for this book was most essential in the completion of this project: Dave Saba, Jim Trdinich, E.J. Borghetti, Jillian Jakuba, Dan Colleran, Pat Salvas, Malcolm Butler, Mark Majewski, Doug Hauschild, Chris Caputo, Ken Best, Eric Capper, Aaron Chimenti and Zekeya Harrison, and those who helped with essential research, such as Craig Britcher at the Western Pennsylvania Sports Museum and the Latrobe Historical Society.

INTRODUCTION

Looking up at the ceiling of the Civic Arena as a young high school student in the 1970s, it was easy to be jealous of the Boston Garden. That arena had many championship banners and retired numbers hanging from its rafters, a celebration of the Celtics' and Bruins' rich history. Our facility was as bare as could be. It was no different at Three Rivers Stadium when the Steelers moved in. Forty years into the team's history, and a one-sided loss to the Eagles in the 1947 Eastern Division Championship game was the closest it had come to raising a banner.

Fast-forward four decades, and sports fans across the country are jealous of what Pittsburgh teams have accomplished. Six Super Bowl titles, nine national football championships (ten if you recognize one of the greatest Pitt teams of all time in 1980), five World Series crowns and five Stanley Cups are part of our now rich sports legacy. Fans who were around in the desolate years of the early 1970s and before are still in awe of the unbelievable Steel City titles they've witnessed over the course of their lives.

Being one of those amazed western Pennsylvanians from that era, I set out to try to research and honor all area champions at the college level and above that have raised those sacred banners. I began the research in 1995, intending to take a week or two in my quest; little did I know that a week or two would turn into twenty-one years before I was comfortable that the list was complete—or as comfortable as I can be, as one more always seems to come to light.

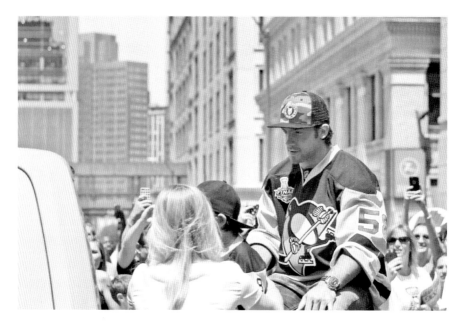

Defenseman Kris Letang is enjoying the parade following the 2016 Stanley Cup championship for the Penguins. *Author's collection.*

Along the way, several teams would pop out of thin air, thanks to the help of the many other fans who have crossed my path in the quest. There was fellow Duquesne alumnus Bob Healy, who came across the list on my website. Many times over the years, I'd get an email with another Pittsburgh champion that he had come across. There was Christina Torok, a fine person who I've known for the past decade and a proud graduate of the University of Pittsburgh at Greensburg, who happily made me aware that the Bobcats hockey team would be the first squad from the school (which has a Finoli Drive on its map) to make this vaunted list by winning its national club championship in 2014. When Bob called out on Facebook for any additions from his friend base, the reminder that Erie fielded some great minor league baseball champions came through loud and clear.

Those are just a few stories of how teams were added to the list, a list that has grown to 204 teams after the Pittsburgh Penguins won their fifth Stanley Cup championship. With the list now hopefully complete until the next banner is raised, the challenge was to rank the top fifty Steel City champions—a daunting task, indeed.

While it's difficult to compare teams in different sports, I began by ranking the teams that had multiple championships within their own team histories

before looking at them in a broader context within the league and sport. It was a somewhat labor-intensive process, but like compiling the list itself, it was nothing less than a labor of love.

As much research as went into this book, the bottom line is that, like any other list, it is only the opinion of the person putting it together. As I recall looking at the barren rafters at the Civic Arena in the mid-1970s, it is also a list that, forty years ago, never would have seemed imaginable.

All-American Ave Daniell (*second from left*) was a key member of two national championships for Pitt. *University of Pittsburgh Athletics*.

1

THE OTHER GREATS

TEAMS 50-41

50. THE 2015 CALIFORNIA UNIVERSITY OF PENNSYLVANIA VULCANS

NCAA Division II Women's Basketball National Champions
Record: 32-4

Perhaps the most difficult challenge for a college sports program is playing in a National Collegiate Athletic Association (NCAA) basketball tournament and winning a national championship. Before 2004, when the California (PA) Vulcan women's basketball team captured its first crown, it had only happened once for western Pennsylvania basketball fans. In 1955, Duquesne won the National Invitational Tournament (NIT), although that tourney had only twelve schools and required the champion to win just three games. When they qualified for the NCAAs, the 2015 Vulcans had to go through sixty-four teams and six difficult rounds if they wanted to repeat their performance. Eleven years to the day after they won the title in 2004, this team overcame those challenges to become the only area team to win a national basketball championship in a tournament on two occasions.

To say this team had to go through difficult obstacles would be an understatement. First, they entered the Pennsylvania State Athletic Conference (PSAC) tournament facing a team in the quarterfinals that had beaten them twice during the season, Gannon University. Second, as

tough as that was, the players had to deal with the death of a teammate in the middle of the season. It was a tragic burden beyond comprehension.

Twenty-one-year-old Shanice Clark was taking a redshirt in 2014–15 after playing twenty-four games the year before. The six-foot forward was found unresponsive on January 18 in her room and died a few hours later from complications of a blood disorder called sickle cell trait—the same disorder that Steelers safety Ryan Clark suffered from in the high altitude of Denver during the 2007 season that resulted in his spleen and gallbladder being removed. The team was crushed. When Cal defeated Emporia State in the national semifinals, coach Jess Strom stated, "We always say she's with us. We probably shouldn't have won today's game, and we probably shouldn't have won our regional final game, either. But somehow, someway, she's helping us out."[1]

It was Strom, who had been a star at Penn State, who kept the team focused after the tragedy. A member of the Western Pennsylvania Interscholastic Athletic League (WPIAL) Hall of Fame, Strom was hired as an assistant by Cal in 2006 and was given the head coaching reins after Mark Swasey was surprisingly relieved of his duties six games into the 2011–12 campaign. She finished the season 14-7 and improved to 22-9 the next year, winning the PSAC Tournament and garnering a bid to the NCAAs, where they lost in the second round. The team was 18-9 in 2013–14 before embarking on its championship run a season later.

Cal finished the 2014–15 regular season at 23-4, but two of those losses were to Gannon, whom they faced in the quarterfinals of the PSAC tourney. The Lady Knights pulled out to a quick 10–2 lead and had a 22–20 advantage as the teams went into the locker room at half. Led by Honorable Mention All-American Miki Glenn and Irina Kukolj, who each scored 18 points, the Vulcans forced three quick turnovers in the second half to take a 27–22 lead en route to a 66–53 win. They won easily in the next round before defeating West Chester, 86–70, in the finals to secure a bid to the NCAA Tournament.

The Vulcans hosted the Atlantic Regional and, following a decisive 86–75 win in the first round over Virginia State, won close games against West Liberty and Bloomsburg. Against the latter, the Vulcans overcame a late 67–63 deficit to beat the Huskies on the strength of Glenn's 23 points and senior Kaitlynn Frantz's 20.

In the Elite Eight, Cal traveled to Sioux Falls, where they defeated Nova Southeastern, 84–79, before slipping by Emporia State, 51–46, in a back-and-forth game that was tied at 42 with less than ten minutes left before the Vulcans ended the game on a 9–4 run.

Facing California Baptist in the national championship game, Cal played arguably its best game of the season. After falling behind early, 11–2, the Vulcans went on an impressive 21–0 run on their way to a 48–28 halftime lead. Glenn continued her impressive season with 31 points. Emma Mahada had 19 points, and Fratz, who was named the outstanding player in the tournament with a 16.7 average, contributed 15 in a game that was never in doubt, despite the fact that the Lancers cut the deficit to 9 at one point. Cal won the national championship with an easy 86–69 victory. The win may have been lost in the heartbreak of a fallen teammate, but it was one that was memorable nonetheless, considering the courage of the players to overcome such a tragedy.

49: THE 1975 PITTSBURGH TRIANGLES

World Team Tennis Champions
Record: 36-8

Raising the Bancroft Trophy was not exactly a similar experience to hoisting that of Lord Stanley's, but in the sport's first foray into making tennis an official team sport, it gave those involved every bit the same thrill. The players experiencing such excitement wore the green and yellow uniforms of the Pittsburgh Triangles in 1975.

Formed by men including Larry King, the ex-husband of Billie Jean King, and Chuck Reichblum, who considers himself the father of the sport as he conceived it in Pittsburgh in 1973, World Team Tennis was an attempt to turn an individual sport into a team experience. The WTT, as it turned out, was ahead of its time. It mixed men and women on the roster and made scoring easier to follow by instituting a simpler scoring system. Among other things, the system eliminated ad-scoring. (In this traditional system, a player must win by two points after getting to three points, or 40 in a system in which the first point is called 15, the second 30 and the third 40. If there is a one-point lead after that, it is called "advantage"; if it is tied, it is called "deuce.") In its place was instituted a point system in which the first team to four wins the game. The city of Pittsburgh was awarded a team and named it after one of its more notable landmarks: the triangle formed where the Monongahela and Allegheny Rivers meet to become the Ohio River.

The Triangles, owned by famed Pittsburgh businessman Frank Fuhrer, attorney Bill Sutton and Reichblum, were a vastly talented team led by player/coach Ken Rosewall, an eight-time winner of Grand Slam tournaments, including four Australian Opens, two French Opens and two U.S. Opens. Also on the roster were Evonne Goolagong, who at twenty-three had French and Wimbledon titles on her résumé, and a young Vitas Gerulaitis, who became a Steel City heartthrob (as did Goolagong) and who went on to a great career before tragically dying in 1994, the victim of carbon monoxide poisoning. "We thought we'd have trouble getting players, but summer was a perfect time for us. We took off for Wimbledon and finished by the U.S. Open," Reichblum recalled.[2] Pittsburgh ended that first season in 1974, 30-14, before losing to Philadelphia in the division finals, 52–45.

While the 1974 campaign ended in a disappointing way for this immensely talented squad, the powers that be in the Triangles' front office were determined to win the Bancroft Trophy. They dropped Rosewall in favor of the coach who taught Goolagong to be a champion, Vic Edwards. Joining Goolagong and Gerulaitis on the 1975 roster were future Intercollegiate Tennis Association hall of famer Peggy Michel, Mark Cox, Rayni Fox and Australian Kim Warwick. The group took the WTT and the city by storm. Singer Kenny Rogers was a huge fan, as was a group of women called the G-Men, who were infatuated with the team's male star, Gerulaitis.

Pittsburgh bolted to a 36-8 record, two games ahead of the New York Sets, and took on the Boston Lobsters in the division championship after the Lobsters upset the Sets, 25–24. With their most serious rivals for the crown out of the mix, Pittsburgh easily dispatched Boston, 25–16 and 23–14, in the best-of-three series. They would face the San Francisco Golden Gaters, the Western Division champions, led by tennis stars Tom Okker and Betty Stove.

The series started at the Cow Place in San Francisco. Pittsburgh was about to capture the first game of the best-of-three series with a 24–20 advantage going into the last set. Warwick and Michel were facing Stove and player/coach Frew McMillan in mixed doubles. If the Triangles duo could win two more points, they would clinch the opening victory. Warwick was known as a powerful server, but his serve deserted him in this set. Stove and McMillan waltzed to a 6–1 win, giving the Golden Gaters the opening contest, 26–25.

Coming back to the Civic Arena for game two, the Gaters pushed hard, but Goolagong, who was now known as Evonne Goolagong-Cawley after marrying British businessman Roger Cawley in the offseason, won tiebreakers in both women's singles and women's doubles, which helped

propel Pittsburgh to a 28–25 victory and sent the team to a third and deciding contest.

A large throng for the circuit, 6,882, showed up at the Igloo for the last game in what would be a classic match until Gerulaitis took control. Rogers was in the crowd enthusiastically rooting on his new favorite team, and the conservative Furher came in a G-Men T-shirt. The raucous crowd was quickly quieted when Stove and Ilana Kloss tripped up Michel and Cawley in the opening set, 6–2. Evonne Goolagong-Cawley, one of the best players in the world, was clearly frustrated after the opening loss. She took that irritation out on Stove in the women's singles with a dominant 6–2 win to tie the match at eight games apiece. When the G-Man and Cox topped McMillan and Okker, 7–5, Pittsburgh led, 15–13. Gerulaitis then took on Okker in the men's singles. While Okker had won the singles sets in the previous two games of the finals, he was beaten soundly by the G-Man in this one. Gerulaitis so dominated his opponent that an angry Okker tossed his racquet into the crowd at one point. The young heartthrob played his best tennis of the season in a 6–1 win that gave Pittsburgh an insurmountable 21–14 lead, rendering the mixed doubles moot as the Triangles triumphantly raised their first and last Bancroft Trophy.

It was the beginning of the end for the franchise. Roger Cawley insisted that Furher fire Edwards, as his wife was now at odds with her former coach. Cawley and Gerulaitis constantly argued with Furher, and the team was losing money in a very aggressive manner. It folded following a 24-20 mark in 1976 as Pittsburgh spent one more season in the WTT, splitting time between the Steel City and Cleveland as the Pittsburgh/Cleveland Nets. It was a quick demise to what had been the most talented team in the circuit. Luckily, the fall came after the city had a chance to raise the most forgettable trophy in Steel City history.

48: THE 1936 DUQUESNE UNIVERSITY DUKES

Orange Bowl Champions
Record: 8-2-0

If you were a college football fan in the 1930s, the city of Pittsburgh is the place you wanted to be. A 2.6-mile stretch of Forbes Avenue allowed a fan to see three of the best college football teams in the land. There

was the University of Pittsburgh, which by 1937 had won eight national championships; Carnegie Tech (now known as Carnegie Mellon University), the 1938 Lambert Cup Trophy winners, who almost upset no. 1 TCU in the Sugar Bowl; and a Catholic university that was the farthest point from the two other schools, Duquesne University, which shocked the college football world not only by defeating the soon-to-be national champion Pitt Panthers but also by winning one of the most exciting Orange Bowls in the history of the illustrious event.

One of the famed "Four Horsemen" from Knute Rockne's legendary Notre Dame backfield, Elmer Layden built the foundation for championship football on the Bluff before he left to take over the helm of his alma mater following the 1933 campaign. After two years of searching for a proper successor, the administration tabbed another Fighting Irish alum to lead the football program. John "Clipper" Smith had been an assistant under Rockne in 1928 before taking over as head coach of the North Carolina State Wolfpack in 1931. After three years in Raleigh, he accepted a position as assistant coach for the Dukes in 1935 before taking over the reins a year later.

Duquesne was coming off a season (1935) in which it had a solid 6-3 mark, including a season-ending five-game winning streak with shutout victories against Carnegie Tech, West Virginia and Oklahoma A&M (Oklahoma State). Still, 1936 brought with it no thoughts of a national ranking and a major bowl bid. The team, led by quarterback Boyd Brumbaugh, Frank Zoppetti, George Matsik, Ernie Hefferle and Mike Basrak, was solid, if unspectacular. They had the chance to show just how good they were by facing their neighbors and perennial national champion contenders, the University of Pittsburgh, for the first time since a 7–0 loss in 1933. They hadn't beaten or even scored on the Panthers since 1903 and would be prohibitive underdogs in this contest despite the fact that they came into it 3-0, outscoring their first three opponents by a 61–0 margin. The Panthers had rendered their first three opponents scoreless while scoring 93 points themselves; the difference was that their quality of opponent was superior, with two of the wins coming against West Virginia and Ohio State.

Two major injuries to the Dukes, running backs Beto Vairo and Johnny Kerrs, would certainly hurt their chances even more. Both would play in reserve but do so at a reduced level of performance—or so the favored Panthers thought. Pitt certainly was the dominant team on paper, but overconfidence going into this contest would hurt them. Both defenses were playing well as the game turned into a punting contest. Late in the first half, Brumbaugh, who had been replaced by Zoppetti at the beginning of the

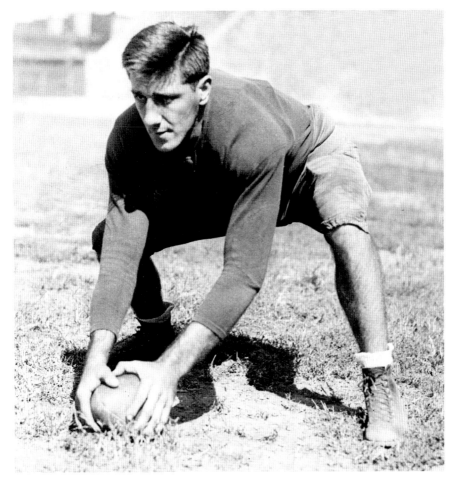

Center Mike Basrak was Duquesne University's first All-American and the MVP of the 1937 Orange Bowl. *Duquesne University Athletics.*

game, ran the ball twice to his own 29 before Matsik took the third-down snap around left end. He looked like he would be stopped by the stout Pitt defensive line but somehow broke through and rambled downfield. Panther great Bobby LaRue tried to run down Matsik, but it was to no avail as he went into the end zone for the touchdown. Brumbaugh converted the extra point to make the game 7–0. The Dukes would hold on in the driving rain to upset the Panthers after a scoreless second half.

Following the amazing victory, Duquesne suffered from overconfidence themselves, losing consecutive contests to West Virginia Wesleyan and

Detroit—two very winnable games—and their hopes for national prominence were reduced to a disappointing 4-2 record. Great sports stories are sometimes made of second chances. In this tale, the Dukes took advantage of theirs.

They ended the regular season defeating Washington University, Carnegie Tech (to capture the city championship) and Marquette, all by way of a shutout. With their season once again considered a success, the Dukes turned down three postseason bowl bids to accept a trip to Miami and a spot in the Orange Bowl to play a tough Mississippi State team (7-2-1) that lost only to national powers Alabama and LSU.

Excited to hopefully show the nation they were every bit as good as they were at Pitt Stadium when they defeated the Panthers, the Dukes played tough against the Bulldogs, leading 7–6 in the second quarter after Brumbaugh burst in from the 1-yard line. Unfortunately, they fell behind, 12–7, as the teams went into the locker room at the half. The contest remained that way as time was running out, and it looked like the Dukes' season would end with a well-played yet disappointing loss. With hope running out, Brumbaugh went back for what would turn out to be the greatest moment in Duquesne football history. From his own 25, he launched a 45-yard pass to Hefferle, who took it the remaining 30 yards for the touchdown to give the Dukes a 13–12 lead. The great Duquesne secondary, which picked off four Mississippi State passes in the game, continued to excel as it held the Bulldogs out of the end zone to preserve the victory.

It was a win that got the Dukes the fourteenth spot on the final Associated Press poll and, according to the Duquesne football media guide, saw them finish the year ranked second in the Massey computer college football rankings. The victory also increased the college football legacy that was the 2.6-mile stretch on Forbes Avenue in the 1930s.

47: THE 1954–55 PITTSBURGH HORNETS

American Hockey League Champions
Record: 31-25-8

The mid-1950s was not exactly a golden era for Steel City fans. The two major franchises, the Steelers and Pirates, fielded some of the worst teams in the history of each club. Eventually, in 1979, they both won championships,

and Pittsburgh could finally lay claim to being the "City of Champions," a title the Steel City proudly proclaimed again in 2009 when the Steelers and Penguins were each league champions. While those two years are certainly foremost in area sports aficionados' minds when considering western Pennsylvania sports history, the dark days of the mid-1950s were, surprisingly, the first time the town could lay claim to that honor. In 1955, the Duquesne University Dukes won their lone national championship in the National Invitation Tournament. A month later, the city's American Hockey League franchise, the Pittsburgh Hornets, captured its second Calder Cup championship. This was the year the "City of Champions" was born.

They started the season by getting rid of their black and gold uniforms in favor of the more traditional red and white ones they had worn for sixteen years before switching. They also had a new coach in Howie Meeker. Meeker once seemed on the way to having a very bright career as a player in the National Hockey League. He scored 17 goals in his rookie campaign in 1946–47, winning the NHL's version of the Calder Trophy, given to the top rookie in the league. He continued his success as part of four Stanley Cup championship squads with the Maple Leafs in his first five seasons, but a collarbone injury in 1948–49 would affect him the rest of his playing days, cutting short what might have been a hall of fame career. While he eventually became an icon in Canada, enjoying a thirty-year career as an analyst for *Hockey Night in Canada* and the Sports Network, in the mid-1950s, he was beginning his short-lived coaching career with the Hornets after a season at the helm of the Stratford Indians in the Ontario Hockey Association senior league.

Meeker's squad was led by Willie Marshall, who led the team in points (48) and goals (23) in only 46 games, as well as Earl Balfour, the team's co-leader in points. Frank Mathers was a thirty-year-old defenseman who had had an abbreviated career with the Maple Leafs but enjoyed a long one in the AHL before his eighteen-year career as a coach with the Hershey Bears, where he won three Calder Cup championships. Mathers had one of his best seasons with the Hornets in 1954–55, scoring 40 points while being named a first-team all-star.

As good as the others were, perhaps the best player on the team was goaltender Gil Mayer. Playing all sixty-four games between the pipes, Mayer had a stellar 2.80 goals-against average, joining Mathers as a first-team all-star selection as well as being awarded his third consecutive Harry "Hap" Holmes Award as the top goaltender in the circuit.

It was a talented team, but by the halfway point it looked far from a Calder Cup contender. After going through a 2-6-1 streak in late

December, the team's record stood at 13-12-8 in early January. They improved slightly but stumbled toward the end until they won five of their final six contests. Luckily for the Hornets, parity was the order of the day in the AHL, and they captured the regular-season crown despite a fairly mediocre 31-25-8 mark.

Pittsburgh faced the fourth-place Springfield Indians in the semifinals, defeating them three games to one as right winger Jerry Foley netted a goal 17:33 seconds into overtime of the fourth and final contest. They would face the Buffalo Bisons, who pulled a slight upset over the Cleveland Barons in the semifinals. Led by Ken Wharram, who finished second in the circuit with 82 points, the Bisons were a much more efficient offensive team, scoring 248 goals compared to the Hornets' league-worst 187. If Pittsburgh was to emerge victorious, it would be because of Mayer and their dominant defense, which limited opponents to a league-low 180 goals against, 48 less than Buffalo.

In the first game, the offenses took control. Normally, this would benefit Buffalo. The Bisons opened the scoring to take a quick 1–0 lead before the Hornets showed an unusual burst with Ray Timgren, Marshall and Bob Hassard scoring to give Pittsburgh a 3–1 lead at the end of the first period. It was a back-and-forth affair until Hassard netted his second goal of the game, giving the home team a 5–3 lead, which they held on to in a 5–4 victory.

The Bisons evened the series in game two to take home-ice advantage as the teams headed to Buffalo. Pittsburgh was at a disadvantage, as center Bob Bailey was suspended indefinitely for attacking the referee in game two. Despite being shorthanded, the Hornets battled in a close contest that was tied 3–3 late in the game. Finally, at the 12:06 mark of the final period, Gordie Hannigan sped with the puck down the ice, was tripped at the goal mouth but saw Marshall trailing the play before he went down and got him the puck. Marshall buried it from six feet to give Pittsburgh the 4–3 lead, which they held on to for the win. The teams played another close contest the following game, which was won in the third period on a fluke goal. Mathers ripped a slap shot that hit off the cage behind the Buffalo goal then bounced off Bob Solinger's head into the net for a 3–2 win and a three-games-to-one lead for the visitors.

Buffalo won the fifth game, 5–4, in overtime and was home for game six, hoping to get even with Pittsburgh. Luckily for Hornet fans, they would return to the Steel City with the cup in hand after Timgren scored the game's first goal in the second period before Solinger netted two to take a

3–0 lead going into the third. The Bisons made it close, 3–2, but Marshall, who was selected as the playoff MVP with 9 goals and 16 points, ended the proceedings with an empty-net goal late in the game for a 4–2 win.

While the team only lasted one more season before taking a five-year hiatus after the Duquesne Gardens was demolished, at this point, the Hornets were heroes in the Steel City. Fred Landucci of the *Pittsburgh Press* exclaimed, "Thus they join Duquesne University, McKeesport and Wampum High Schools basketball teams [state champions] and Pitt track star Arnie Sowell to give the district its most titled winter in recent memory."[3] In other words, he was declaring Pittsburgh the "City of Champions."

46: THE 1938 CARNEGIE TECH TARTANS

Lambert Trophy Winners
Record: 7-2

Bill Kern was a winner. A player for Pitt in the mid-1920s, Kern learned football from the master, his coach Jock Sutherland, before going on to the National Football League, where he was a second-team all-pro at tackle in his two years with Green Bay (1929 and 1930). Kern returned to Pitt, becoming an assistant under his mentor in 1936. When perhaps the best player in Carnegie Tech/Carnegie Mellon University history, Howard Harpster, could not bring the Tech program to the level of local rivals Duquesne and Pitt, the school came calling for Kern. Within twelve months, he would make Sutherland proud.

It would not be easy. The Tartans finished 2-5-1 in his first season in 1937, and the administration at the school decided to downgrade the program while keeping the same difficult national schedule. Normally, that is a recipe for disaster, but every so often in sports, victories happen in situations where it's illogical to expect them. For Carnegie Tech in 1938, every week seemed to call for another illogical win.

The season began innocently enough with dominant victories against two relatively easy opponents. Tech defeated Davis & Elkins and Wittenberg by a combined 81–13 score. These wins were expected, but when the team faced the nationally renowned Holy Cross Crusaders, victory was anything but a certainty. Holy Cross had an outstanding season, eventually finishing ninth in the final Associated Press poll while dominating eight of its nine

opponents. It was the opponent on the third Saturday of the college football season that they had difficulty with.

Holy Cross was on a fourteen-game winning streak. The Tartans had not only never beaten them in the past, they also had never scored against them. Ray Carnelly ended that streak in the second quarter with a 42-yard ramble to put Carnegie Tech ahead, 7–0. William Osmanski took the ensuing kickoff 91 yards to cut the lead to one (after the missed extra-point attempt). The Crusaders pushed hard the rest of the game but could not add to their total as Tech held on for the upset win.

The victory saw them ranked thirteen in the initial Associated Press poll as they faced the Fighting Irish of Notre Dame. The hard-fought game came down to a mistake by the referee that eventually cost Carnegie Tech an undefeated regular season. With the game scoreless, Tech had the ball at the 46-yard line, 1 yard away from a first down. Carnelly forgot whether it was third or fourth down and asked referee John Getchell. Getchell told him third, even though it should have been fourth. Tech unsuccessfully ran a play and then was told Getchell was incorrect and they would lose the ball on downs. The ball was given to the Irish. Unfortunately, Notre Dame scored in three plays for the game's only points in a 7–0 loss. Tartan Mel Cratsley remembered: "After the running play didn't pick up the first down we went into our huddle getting ready to punt, but the Notre Dame players were in their huddle getting ready to run an offensive play. None of us knew what was going on, but that call did cost us a scoreless tie."[4]

Carnegie Tech beat undermanned Akron, 27–13, before facing top-ranked Pitt at Pitt Stadium. The Panthers had dominated the Tartans for the previous ten seasons, and it looked like the eleventh would go the same way when Curly Stebbins scored on the opening kickoff for a 7–0 Pitt lead. Tech came back to tie it when Merlyn Condit hit George Muha with a 25-yard pass for a touchdown. Bill Daddio knocked in a 22-yard field goal to end the first quarter with Pitt leading, 10–7. The season of illogical victories was about to continue. With time running out in the first half and Pitt hanging on to a three-point lead, Carnelly launched a Hail Mary pass that found its way into receiver Karl Striegel's hands. As he was about to score the go-ahead touchdown, the Panthers' John Chickerneo blasted Striegel, knocking the ball from his hands. Fortunately for Tech, the ball bounced back into Striegel's hands in the end zone. The teams went into their locker rooms with the Tartans up, 14–10. When Muha scored in the fourth quarter, this team that wasn't supposed to be a national power had somehow defeated the top-ranked team in the country and found themselves vaulting into the top ten at no. 6.

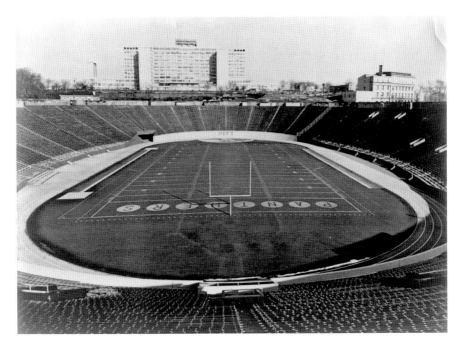

Pitt Stadium, the home of the Panthers for seventy-four years, was also where the 1938 Carnegie Tech Tartans played. *University of Pittsburgh Athletics.*

Tech defeated Duquesne and North Carolina State to end the season 7-1 and accepted a bid to play no. 2 Texas Christian in the Sugar Bowl. Tech went into the contest as the Lambert Trophy winners, symbolic of the best team in the east, and Kern was named coach of the year. TCU was a tough team, though, and their quarterback, Davey O'Brien, was the Heisman Trophy winner. The Tartans were underdogs, but they had played that way all season. After falling behind 6–0, Muha snagged a long pass to give the Tartans a 7–6 lead, which they held at the half. Their good fortune would come to an end as the Horned Frogs scored the only points in the second half for a 15–7 victory. The win gave the Horned Frogs the national championship, but it also was the end of a very proud season for the Tartans.

The 1938 campaign would prove to be the last great season for this proud program. The team never came close to achieving this success again, and by the mid-1940s, the university had dropped the program to non-major status, eventually taking it to Division III, where it plays today. For one season, though, it was among the best teams in the nation, winning one illogical game after another.

45: The 1956 Harmarville Hurricanes

United States Open Cup Champions

Between the 1930s and 1950s, the hub of soccer in the United States was located on the pitches of western Pennsylvania. Clubs like W.W. Riehl, Morgan Strasser, Gallatin, Morgan, Heidelberg and Beadling captured U.S. Amateur and U.S. Open Cup championships. At the end of this era, another club came to the forefront, one named the Harmarville Hurricanes. They dominated play during this period and captured the last national title a western Pennsylvania club would win.

While most credit the steel mills for igniting the toughness that spawned the legendary football legacy the area is noted for, it was the local coal mines that were responsible for the championship play in the world's most popular sport. Towns in western Pennsylvania recruited some of the best players in the country, using jobs in the mines that would pay them handsomely to entice them here if they also agreed to play for local teams. The results were remarkable. In the 1940s and '50s, area teams won the U.S. Open Cup, the country's elite tournament at the time, four times while finishing runner-up another four times. On top of that, between 1926 and 1958, seven western Pennsylvania soccer clubs captured the National Amateur Cup, with fourteen others losing in the finals. And it was the last of the eleven championships that brought the most fame, with pictures in *Sports Illustrated*.

The Hamarville Hurricanes were in the middle of their second title run, facing a team from Cecil, Pennsylvania, when *Sports Illustrated*, in its February 27, 1956 issue, captured not only a snow-covered pitch in Harmarville, where the Hurricanes advanced to the quarterfinals with a 4–3 victory over Cecil, but also the connection between the team and the mines as the team lined the field with the fine black coal dust.

After the victory against Cecil, the Hurricanes took on a team from Philadelphia, the Uhrik Truckers. The talented Hurricane team was led by defender Lou Yakopec, a Pitt grad who was a fullback on the football team as well as a semipro baseball player; goaltender Donald "Pug" Malinowski, who played for the USA national team; and fullback Raymond Bernabei, a future member of the National Soccer Hall of Fame. Despite the team's edge in talent, having to go to Philadelphia in less than stellar weather caused concern for coach Jack Pasanac.

It was a windy day, but that held no advantage for the home team. Bob Craddock and Don Utchel quickly gave the visitors a 2–0 lead. After the

Uhriks beat Malinowski, who misplayed the ball, to make the score 2–1, the two Craddocks gave Harmarville the comfortable win, as Tom made it 3–1 before Bob notched his second goal of the game for the easy 4–1 victory.

The win put the Hurricanes in the Eastern region championship against Brooklyn's Hakoah Soccer club in a home-and-home series. The first game would be in Harmarville. Hakoah dominated play in the first half. Luckily, the Hurricanes withstood the onslaught as goaltender Malinowski kept the game scoreless with some fine saves. The home team finally settled down in the second half, getting the better of the play as Yakopec pushed forward more than he would normally have, netting the winning goal late in the game for a 1–0 win.

The second contest in Brooklyn was postponed due to an early April snowstorm that hit New York. A week later, on a soggy field, Hakoah gave Harmarville all it could handle, scoring twenty minutes into the game to tie the aggregate at one. Tom Craddock came through for the visitors, tipping in a shot by Utchel from 10 yards out to tie the second contest, which gave the Hurricanes the 2–1 aggregate lead, one they held on to for the Eastern championship and a spot in the Open Cup finals against the Western champion Schwaben Soccer Club out of Chicago.

The Schwabens were a professional team playing in the National Soccer League, based in Chicago, and defeated the amateur Harmarville club in the first game of the two aggregate contests, 1–0. The second contest was played at Harmarville's Consumer Field a week later. Approximately five thousand fans jammed that facility, standing four deep around the field to see if, somehow, the home team could come back for a victory. Ten minutes into the game, the Chicago club scored, seemingly dashing the Hurricanes' hopes as they were down by two in the aggregate score. This team was tough, though, and wouldn't be counted out. Harry Pitchock and Tom Craddock each scored for Harmarville, tying the aggregate at two and sending the huge throng into a frenzy. The contest was going into overtime. The teams were scoreless in the extra frame for fifty-two minutes before George Resavage saved the day for the Hurricanes, ripping a 20-yard blast into the corner past Chicago's goalie, William Benesch. This score gave the Hurricanes their second championship.

Almost fifty years later, Resavage remembered his remarkable goal clearly. "Buddy Utchel was playing outside right. He retrieved the ball and crossed it over. I'm over on the outside lip and hit it without stopping it. I put it in the right-hand corner. You don't forget moments like that." He went on to say, "It froze the goalie. He never expected me to hit it without stopping it. Sometimes,

you get lucky."[5] It was a remarkable goal that was most satisfying because of the abuse the amateur Hurricanes took from their professional opponents. "Chicago called us a bunch of coal miners and amateurs. Those guys couldn't believe it when we beat them. They were pros," Resavage recalled.[6]

Unfortunately, the coal industry soon declined and with it the high-paying jobs that the mines used to recruit players. This ultimately caused the end of soccer dominance that the city of Pittsburgh had enjoyed. It was an incredible era that ended with a remarkable goal that produced the last national championship a western Pennsylvania team has won to date.

44: The 1925 Pittsburgh Yellow Jackets

United States Amateur Hockey Association Champions
Record: 25-11-5

While hockey fans in western Pennsylvania celebrate the joy of winning five Stanley Cup championships in a twenty-five-year period by the Penguins, championship hockey began long before Mario Lemieux came to town.

The Pens took over from the American Hockey League's Hornets, who took the mantle from the first NHL franchise in the Steel City, the Pirates. That team was born from the first truly great hockey franchise the city had seen, the Pittsburgh Yellow Jackets.

Founded in 1915 by former Pittsburgh politician Roy Schooley, the Yellow Jackets joined the United States Amateur Hockey Association (USAHA) in 1920, when the organization took control of the sport in the country. The team labored in mediocrity its first two seasons before Schooley decided to look to Canada to take his team to the next level. First, he hired Dick Carroll as coach, the same man who guided the Toronto Arenas to the 1918 Stanley Cup championship. He then began to pull an impressive array of talent from the homeland of hockey.

His first recruit was the best, future hall of famer Lionel Conacher. One of the great all-around athletes, Conacher was named one of Canada's greatest athletes in the first half of the twentieth century. He was also one of the best hockey players of the time. He had turned down several offers to turn professional in order to keep his amateur status. He was given a scholarship to the Bellefonte Academy in Pittsburgh and quickly joined the Yellow Jackets, where he was named captain for the 1923–24 campaign.

Having Conacher would have been enough to make the Jackets a competitive team, but thanks to his recruiting efforts, the team landed an impressive array of talent that included goaltender Roy Worters, Hib Milks, Duke McCurry, Harold Cotton, Tex White, Harold Darragh, Roger Smith and Herb Drury. The new players proved to be a boon for Pittsburgh, but the team was met with fierce criticism from some of its competitors in the USAHA. The team representing Boston boasted that its club, the defending league champions, was built with local players while Pittsburgh had to import its players. While the criticism might have been true, no one in the Steel City seemed to mind, as the Yellow Jackets went 15-5-0 in 1923–24 while defeating the Boston Athletic Association in five games to capture their first league title.

The imported players were loving their team and their town. Conacher stated, "This here's a real hockey town for sure. The boys up north think they're in heaven after they get here."[7] It was a great hockey town with one of the best facilities in the country. The Duquesne Gardens was home to the finest artificial ice surfaces at the time. The Jackets was one of two teams in the USAHA to use an artificial surface. The success of the team brought huge crowds to the legendary facility, usually putting three thousand to four thousand fans into the five-thousand-seat arena, large throngs that would see an even better team in 1925 than the one that had just captured its first title.

Pittsburgh jumped off to a quick 15-3-2 start en route to a fine 25-11-5 season that saw it win the Eastern Division crown. Finding themselves in their second Fellowes Cup championship series (named for the trophy awarded to the USAHA champion), the Yellow Jackets faced their inner-city rivals, the Fort Pitt Hornets, in the championship tilt. The teams shared the same facility, so the finals promised to be a rough, close, physical series. Everything went according to script. In game one, Conacher scored the winning goal ten minutes into the extra period, giving the Jackets a 2–1 victory. The second game saw him tally another with his club down 1–0 to tie the contest. It was a game that the Hornets dominated from the onset, but the future hall of famer's goal sent the contest once again into overtime. Drury and McCurry netted goals at that point, leading the Yellow Jackets to the 3–1 victory. After a third consecutive overtime contest ended in a 2–2 tie, the two combatants moved into a game four encounter at the Gardens with the defending champions needing one more win to capture the best-of-five series.

Wanting to avoid yet another overtime game, the Jackets came out aggressive, with Conacher netting a goal 4:25 into the game before Cotton

put one past the Hornets' stalwart goaltender Joe Miller to lead the champions to a 2–0 lead after the first twenty minutes.

The onslaught looked like it would continue in the second period with the Jackets peppering Miller early on with great scoring chances, but the Hornets had played tough the whole series and would continue to do so when Patty Sullivan beat Worters at the 5:15 mark to cut the Pittsburgh advantage in half.

Even though the defending champions continued to dominate, the score remained 2–1 going into the final frame. Fort Pitt picked up their intensity; the last twenty minutes were described as "fast and furious to the final bell."[8] Worters was able to withstand the pressure, keeping the Hornets scoreless the rest of the contest and giving the Yellow Jackets the 2–1 victory and their championship.

Despite the great victory and the tremendous support the team received, the league folded following this victory. The Jackets were sold to James Callahan, who renamed them the Pirates. The team became Pittsburgh's first entry into the National Hockey League in 1926.

43: THE 1966–67 PITTSBURGH HORNETS

American Hockey League Champions
Record: 41-21-10

When the Pittsburgh Hornets took to the ice for the 1966–67 campaign, their twenty-sixth year in the American Hockey League, there was an inordinate amount of pressure on the team. After years as a six-team circuit, the National Hockey League decided to expand in the fall of 1967 and would double in size. Pittsburgh was chosen as one of the new expansion cities that would, for all intents and purposes, signal the end of the Hornets franchise. The question was how this memorable Steel City team would be remembered: as one that quit, as had the 1995 Cleveland Browns, or as champions? As the season began to wind down, coach Baz Bastien and his gritty players answered that question in a resounding way.

They had been the kings on ice in Pittsburgh for such a long time, winning two Calder Cup championships. After a successful twenty-year run, the Hornets had to fold for five years when their home, the Duquesne Gardens, was torn down and no suitable facility for professional hockey was available.

Five years later, the Civic Arena was constructed. The second coming of the Pittsburgh Hornets had begun.

When they left the AHL in 1956, they were the second-best team in the circuit, two points behind the Providence Reds. When they returned in 1961, they were a shell of themselves, with a meager 10-58-2 mark. They struggled for one more season, then finally qualified for the playoffs in 1964 before bowing out in the first round. For the next two years, they continued to be a postseason participant, never getting past the opening series. Before the franchise began its twenty-sixth season, NHL president Clarence Campbell announced that Pittsburgh would be one of the six new franchises in the circuit beginning play in 1967–68. The writing was on the wall for the Hornets; while the franchise would do what it could to remain in the league in another city, odds were against them doing so. This would most likely be their last season. Three consecutive first-round exits would give no indication that their final season would meet with a different result.

Pittsburgh was a well-balanced offensive machine. Billy Harris led the way with 34 goals as seven Hornets eclipsed the 20-goal plateau. The team was third in the nine-team circuit with 282 goals while leading in goals against, surrendering only 209. It was a tough, grinding defense led by Bob McCord, who captured the Eddie Shore Award, symbolic of the best defenseman in the American Hockey League. Their talented roster led the league in points with 92 while capturing the Western Division title. Their reward for such an excellent season was a first-round encounter with the team that had the second-best record, the Hershey Bears.

The first two games of the best-of-seven series were at the Civic Arena, where the Hornets drew well during the regular season by averaging an AHL second-best 5,740 fans per game. The games were close, but Pittsburgh won both, 4–2 and 3–2. They acquired an almost insurmountable three-games-to-none lead after another 3–2 win in Hershey. The Bears won the fourth contest, but the Hornets closed it out at the Igloo in game five with a dominant 4–0 victory.

With Hershey out of the way, Pittsburgh received a bye in the second round as Rochester and Baltimore faced each other to see who would take on the Hornets in the Calder Cup final. After the teams split the first two games, the Americans captured the final two contests in the best-of-five series and, with it, a spot in the championship.

The storybook finale for the franchise began in Pittsburgh, and the Hornets left little doubt who the best team on this evening was. After Ted Taylor opened the scoring for the home team, it took only four minutes to put the game out

of hand when Gary Jarrett and Terry Gray gave the Hornets a quick 3–0 lead. Future Penguin Val Fonteyne added to the rout with two goals, the second of which was shorthanded, for the easy 7–1 win. While the team celebrated the victory, the fate of the franchise had been decided earlier in the day, when the powers that be in the circuit turned down Bastien's proposal of either suspending the franchise with the thought that it would relocate or giving it a one-year suspension so it could basically do the same thing.

Now that its fate was sealed, the club could focus on the end of its story. Game two took place in front of a standing room–only crowd at the War Memorial Auditorium in Rochester. Pittsburgh took an early lead when Doug McKenney put a rebound past Bob Perreault for the 1–0 lead. The Americans tied the score at 1–1 before Taylor netted the game winner at 12:42 of the second period with a fifteen-foot backhander. The staunch Pittsburgh defense kept Rochester off the board in the final period to hold on for the 2–1 win.

The next two games would be in Pittsburgh before returning to Rochester if the Americans could split the games in Pittsburgh. Game three was more like the first, with the Hornets ripping the visitors, 5–1. Up three games to none, the team looked to close out the series and the history of the franchise in front of their adoring fans; 5,169 came to see history. While it was history they wanted, it looked for most of the game like they'd have to wait. Six minutes into the final period, Rochester led, 2–0. Another Penguin in waiting, Ab McDonald, scored twice in nineteen seconds before Rochester's Wayne Carleton pushed the visitors back ahead, 3–2. As time was running out, Pittsburgh pulled goalie Hank Bassen in a desperate attempt to tie the game. Finally, with thirty-five seconds left, Terry Grey beat Perreault in front of the net to send the contest into overtime.

It wouldn't take long, as Harris netted the final goal in franchise history only twenty-six seconds into the extra frame to give the Hornets the exciting 4–3 win and, with it, the Calder Cup. Of the eight professional championships the Hornets and Penguins would win, this would be the only time the championship trophy was hoisted on home ice.

The game and the franchise's existence were now over. It was a small yet loyal throng that wanted this franchise to keep going on. It was not to be, of course. NHL hockey would now be the city's future, but by winning the championship in their last game, the Hornets gave those loyal fans a defining moment that would forever be etched in their memories.

42: THE 1934 UNIVERSITY OF PITTSBURGH PANTHERS

NCAA Football National Champions
Record: 8-1-0

In Pittsburgh history, it is perhaps the most disputed championship that was ever won, a title awarded by a man who had been dead for almost a year. For decades, people made fun of the University of Pittsburgh for claiming it. In retrospect, it turned out to be one that was fairly won and a championship the university can proudly claim as its own.

The story of this forgotten team actually began thirty-three years after their championship season ended. It was a year where legendary coach Jock Sutherland fielded one of the greatest teams in the country. A deep and talented backfield of Izzy Weinstock, Heinie Weisenbaugh, Mike Nicksick, Bobby Larue and Leon Shedlosky was guided down the field by a dynamic line led by team captain Doc Hartwig. The team steamrolled through three opponents, Washington & Jefferson, West Virginia University and perennial national power USC, which had dismantled the Panthers in the 1930 and 1932 Rose Bowls by a combined 73–18 score. It had been a difficult schedule to this point, but the Panthers won with ease as they set to host another highly ranked opponent, the Minnesota Golden Gophers. A win against Minnesota, and there would be no question as to who was the best team in the country.

Pitt took the lead, 7–0, after Nicksick took a lateral from Weinstock and rambled 55 yards for the score. The team held on to the lead as the first half came to an end. The second half was controlled by Minnesota, which scored twice for the 13–7 victory in front of sixty-five thousand disappointed fans at Pitt Stadium.

With a record of 3-1, and the team hoping to find a way to rekindle its fading national championship aspirations, the Panthers traveled to Westminster College to take on the Titans. The Pitt administration had replaced Duquesne on the schedule with Westminster so that the Panthers could take on USC. Pitt rebounded with a 30–0 victory to begin a five-game winning streak that included some huge wins. The next week, they hosted the Fighting Irish of Notre Dame and its new coach, former Duquesne boss Elmer Layden. He had left the Bluff to take over his alma mater. The great Panther backfield, led by Shedlosky and Nicksick, helped the home team to an impressive 19–0 win.

Sutherland's men traveled next to Nebraska to take on the Cornhuskers, hoping to improve on their 5-1 mark. Dana X. Bible, the head coach of

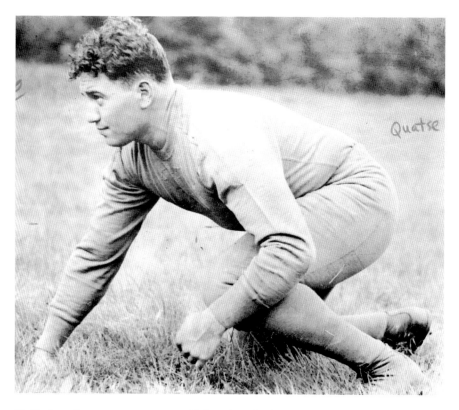

Quatse

Tackle Jesse Quatse was a consensus All-American for the University of Pittsburgh in its championship season of 1931. *University of Pittsburgh Athletics.*

Nebraska, was successful at the school—except when he faced Sutherland. This contest was no different. Nicksick had arguably his best game of the season, tying Warren Heller's school record with four touchdowns in a one-sided 25–6 victory.

Once again lurking at the top of the college football world, the university ended its successful campaign with one-sided wins at Navy, 31–7, and at home against neighbor Carnegie Tech, 20–0. The Panthers ended the season 8-1-0, outscoring their opponents 205–44. Hartwig, George Shotwell and Weinstock were all named first-team All-Americans. With no bowl berth on the horizon and Minnesota winning the Associated Press poll (Pitt finished third), the championship they had hoped to win was lost. That is, until 1967.

That year, the great journalist Dan Jenkins and his group of college football historians researched what they hoped to be the definitive list

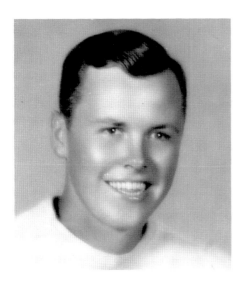

All-American Ave Daniell, a tackle for Pitt, was elected to the College Football Hall of Fame in 1975. *University of Pittsburgh Athletics.*

of national champions in the history of the game. Their article was published in *Sports Illustrated* and seemed to be a response to the interest generated by the disputed national championship in 1966 by Notre Dame over Michigan State. It was a much-heralded article that many schools, including the University of Pittsburgh, used to claim national championships. In Pitt's case, the Panthers now claimed eight titles, including one in 1934 that was given to them by the great historian Parke H. Davis. Davis created his list for the nation's preeminent football annual at the time, *The Spalding Football Guide*, first published in 1934. In the 1935 guide, Pitt was listed by Davis as his pick for the championship in 1934. Everything appeared fine at the time; Parke H. Davis was one of the great football historians of his day, and his list certainly carried legitimacy. The problem was that Davis died before the 1934 season began, which prompted many experts over the course of the next few decades to question the Panthers for claiming it. One website that covers the history of national champions extensively, Tiptop25, ridiculed the school, stating, "Curiously, Pitt also claims an MNC [Mythical National Championship] for 1934, even though they lost 8–0 to Minnesota, and no organization listed in the NCAA Records Book, human or computer, selected them for this season. Their media guide lists Parke Davis as the selector who chose them for 1934, but he died in June of 1934, before the season had even started. Whoops."[9]

When doing the research for the book *When Pitt Ruled the Gridiron*, Jenkins was questioned about his findings. He responded confidently that his fact

checkers got it correct, going on to claim that "one of our top editors was a man named Jack Tibby, and a Pitt grad, and he would have approved [the research]."[10] Eventually, the evidence was found in *The 1936 Spalding Football Guide.* In their list of national champions, the staff had continued to choose champions after Davis had passed away and, in 1934, picked Pitt for the award. The list still had Davis's name at the top, as it had since its first edition, but Pitt was chosen by their staff, in essence making them the Spalding Guide champions and not the champions selected by a man who passed away before the season began.

The bottom line is that they were chosen champions by the most reputable guide there was at the time, which in the end legitimizes Pitt's claim, regardless of the criticism.

41: THE 1992–93 PITTSBURGH PENGUINS

President's Trophy winners
Record: 56-21-7

Winning the President's Trophy as the league's best team in the regular season is impressive; after all, it's a feat the Pittsburgh Penguins have only accomplished once in their fifty-year history. Nobody hoists the President's Trophy; they don't sip champagne from it or have every player take it for a day to celebrate in their various hometowns. Yes, winning the President's Trophy is a fine achievement, but without capturing a Stanley Cup on top of it, the trophy is rendered almost meaningless. It's why the best team the Penguins have ever produced is rated only forty-first on this list.

In 1992, the Pens were coming off back-to-back Stanley Cup championships. With a collection of some of the best talent the NHL has ever seen, coupled with one of the best coaches of all time in Scotty Bowman, the odds were good that a third cup was within reach. It was also a season in which the franchise traded in its warm, likable logo for a more rough-and-tumble one, remaking their brand for what was hoped to be one of the great dynasties in the history of the league.

As Mario Lemieux and company got underway, everything looked like it was coming into place. After tying two of their first three games, they went on a seven-game win streak before a 6–4 loss to St. Louis. Following wins against the Lightning, Islanders and Blues, the team stood at an almost perfect 11-1-2. Lemieux had been particularly impressive, scoring 19 goals

and registering 23 assists for 41 points in that fourteen-game streak. It was an incredible run that included three 5-point games and two more 4-point contests. Pittsburgh couldn't keep up that pace for sure, but after a 3–2 loss at Winnipeg on January 10, they were still an impressive 29-11-4. They stood 14 points ahead of the Washington Capitals in the Patrick Division race a little more than halfway through the regular season. Lemieux led the league with 39 goals and 104 points and looked like he may become the first player in team history to eclipse 200 points. The season was going too perfect; two days later, it would all cave in. On January 12, 1993, the Penguins made an announcement that would rock the sports world: Mario Lemieux had cancer. He had Hodgkin's lymphoma and would begin chemotherapy. It had been only a year since the franchise had lost its beloved head coach, Bob Johnson, to cancer. Having to go through it again was almost too much to bear.

Forward Dave Tippett put the team's feelings into perspective: "He was always battling injuries so we were kind of used to him being out for games at times, but when we found out and he had the press conference it was a shock to everyone. So much is unknown, even more at that time, when you hear the word 'cancer.' Everyone was taken aback, especially when you see

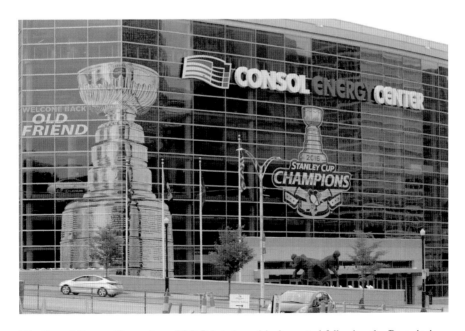

The Consol Energy Center (now PPG Paints Arena) is decorated following the Penguins' 2016 Stanley Cup championship. *Author's collection.*

this big, strong, superior athlete in the prime of his career."[11] The team was stunned, and it showed in their play during the next game, which they lost to the Boston Bruins, 7–0.

This was a veteran team that had been through adversity many times and overcame it. They would do so here, too. Kevin Stevens had an incredible campaign, with 55 goals and 111 points. Rick Tocchet and Ron Francis also reached 100 points (109 and 100, respectively). And twenty-year-old budding superstar Jaromir Jagr chipped in 94. Despite losing five of six games at the end of February, the talented group played well together without their leader. The Penguins stood at 39-19-6 at that point.

Talented as they were, without Lemieux, a third Stanley Cup did not seem to be in the cards. As quickly as the team's hopes were in question, they seemed to solve their issues just as fast. The Pens announced that, remarkably, Mario would return—on the same day he had his last chemotherapy session. It was unheard of for an athlete to resume such a physical career the day he had his final chemotherapy treatment. But Lemieux was no ordinary athlete. The great Pens announcer Mike Lange was stunned.

> *There was an incredible amount of anticipation. I think we were all surprised that he was able to jump right back into the fray after all he had gone through, especially with the* [treatment] *and everything involved. Pretty much it was like, "Is this guy for real?" That was stunning, really, that he would finish up and just get on an airplane to join the team. Really nobody had any idea that he was going to play a game. It was kind of the biggest surprise. He just walked right in and it wasn't the first time that had happened. There were instances when Mario would go across the street to the hospital in Pittsburgh during a game and then come back later in the contest after, almost like riding a white horse into the Civic Arena. It wasn't a giant surprise considering his character, but it was especially because of* [the treatment] *and what he had gone through.*[12]

As amazing as it was, Mario was on the ice for a March 12 contest at Philadelphia. Even though they lost to the Flyers, 5–4, Lemieux scored a goal and chipped in an assist. They lost again the next night to the Rangers but would lose no more in the regular season, winning an NHL-record seventeen games in a row to end the campaign. The record streak propelled them to their only President's Trophy.

The Pens won their first-round series against the New Jersey Devils, running their postseason winning streak to fourteen (a record). It was at that

point, however, that their season came to a shocking halt. Losing a three-games-to-two lead against the New York Islanders in the second round, the Pens fell in game seven in overtime on a David Volek goal, one of the low moments in franchise history. Montreal would have the honor of hoisting the Stanley Cup; the Pens only had the President's Trophy to look at. While it certainly was disappointing, considering what this team accomplished in 1992–93, especially with the serious illness their captain had battled through, the season was anything but a failure for the Pittsburgh Penguins.

One of the greatest players in baseball history was slugger Josh Gibson, who played for both the Homestead Grays and Pittsburgh Crawfords. *Pittsburgh Pirates*.

2

THE CLASSIC CLUBS

TEAMS 40–31

40: THE 1897 GREENSBURG ATHLETIC ASSOCIATION

Western Pennsylvania Independent Champions
Record: 10-1-0

The seeds of pro football were planted on the gridirons of western Pennsylvania in the late nineteenth century with early legends like Pudge Heffelfinger and John Brallier, but it was 1897 when the professional version of the sport really began to take hold. The Latrobe Athletic Association became the first team to have all professional players over the course of a season, while the nearby Greensburg Athletic Association (GAA) also made the claim, although a book written by football historians Bob Carroll and Bob Braunwart discounted its declaration. It would be difficult to believe the GAA's claim, since it used so many players on its roster that season. "There certainly must have been times when the eleven players on the field were all professionals, but it's hard to believe that 27 different men were paid during the season."[13] Whether or not Greensburg paid twenty-seven players during the 1897 campaign, the best pro football teams of the era played right here and met one another in two classic games to determine the best professional team in the land.

Going into the season, probably the best player to don a maroon-and-white Greensburg uniform, Lawson Fiscus, retired. Luckily, coach George

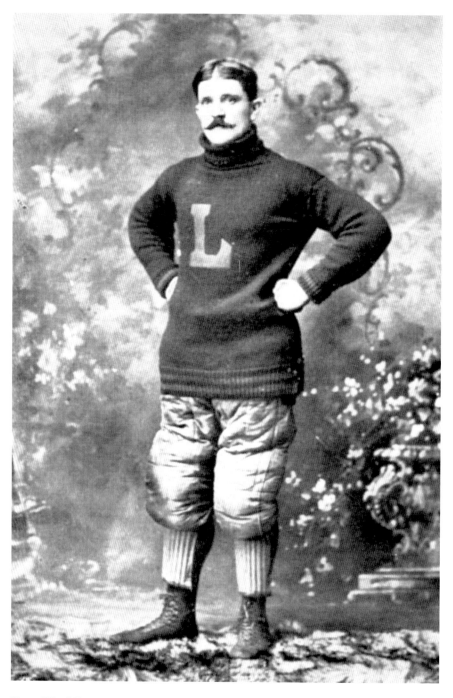

Harry "Cap" Ryan was the captain of the Latrobe Athletic Association when it faced and lost to Greensburg in 1897. *Latrobe Historical Society*.

Barclay, who was brought in from Lafayette before the season as a coach/player, and manager Dr. J.E. Mitinger recruited aggressively to fill the void. They signed Alfred Sigman, also from Lafayette, Penn State's Fred Robison, W.A. Sterrett, Bo Thomas, Adam Wyant, R.H.M. MacKenzie and Tiger McFarland, who all helped form a powerhouse team that handily beat eight consecutive opponents, including the powerful Duquesne Country and Athletic Club, by a combined 349–12 score going into a November 20 contest against their main rivals from Latrobe. Latrobe also was having a great season, but a loss to the same Duquesne Country and Athletic Club and a scoreless tie against Altoona had famed manager Dave Barry and his squad at 8-1-1 going into the anticipated matchup.

The two would battle in a home-and-home series over three games for not only the championship of western Pennsylvania and Westmoreland County but also the best professional team in the country. The game was actually scheduled for a week earlier, but Greensburg had suffered many injuries and asked for a postponement. If Carroll and Braunwart's assertion is correct, that Greensburg most likely at certain times put eleven professional players on the field at once, it is probable that the first contest played at Greensburg's Athletic Park, the current site of Offut Field, where Greensburg-Salem High School and Seton Hill University play, can be considered the first all-professional football contest. Led by such early football greats as Brallier, Walter Okeson, Harry Ryan and Pittsburgh Pirates infielder Ed Abbatticchio, Latrobe withstood an early touchdown by Barclay with scores by Jack Gass and Okeson to win this historic game, 12–6, in front of a disappointed five thousand fans.

After this hard-fought game, both teams played Thanksgiving contests, with Latrobe defeating West Virginia University, 16–6, and Greensburg topping the Pittsburgh Athletic Club, 16–0, before facing each other in the season finale for the western Pennsylvania championship.

The game was played in Latrobe, and a substandard two thousand patrons showed up to see this battle of titans. Before the game even began, a few controversies cropped up, threatening to give Latrobe the championship in a forfeit. The Greensburg club was missing when kickoff was scheduled. When the team still hadn't come an hour and twenty minutes later, Latrobe was directed to kick off to an empty end of the field. With a forfeit looking like the probable outcome, Greensburg showed up, including three players—Judson Crookston, Jack Flowers and P.A.A. Core—who Latrobe protested were not eligible. The rule stated that players who had been in uniform the Saturday before at Greensburg's Athletic Park wouldn't be

able to play. Finally, after a lengthy argument, Cranston and Flowers were permitted to play. Core was forced to sit out the contest.

As the two teams took the field, the officials decided to shorten the game to a twenty-minute first half and a fifteen-minute second due to the lateness of the day. At a rival field and down a player, things did not look good for the visitors, but when Abbatticchio fumbled a punt deep in his own territory, Greensburg took advantage, driving close to the end zone in two plays. McFarland finally finished the job on the third run with an end-around to give Greensburg a 5–0 lead (touchdowns were five points at the time). Joe Donohue kicked the extra point, making it 6–0 as the first half was coming to an end. Both defenses were strong in the second half as neither team scored to end the contest with the maroon and white still up, 6–0. With the win, Greenburg secured the championship. While it would have been more romantic for the first confirmed all-professional team over the course of a season to win the title, it was the one that had the unsubstantiated claim that ended up victorious.

39: THE 1937 HOMESTEAD GRAYS

Negro National League Champions
Record: 37-17

After playing second fiddle to the Pittsburgh Crawfords for four consecutive seasons, the tide finally seemed to be turning for the Homestead Grays in 1937. They once again secured the services of the great Josh Gibson as their rivals lost an incredible array of talent. The results were astounding. Being declared the champions of the Eastern Independent teams in 1930 and 1931 (according to the baseball-reference.com bullpen site among others), their fortunes were reversed when Gus Greenlee, owner of the Crawfords, decided to aggressively pursue the best talent in the circuit. Between 1933 and 1936, the Crawfords won three of four league championships, while the Grays had fallen, finishing a combined three games under .500 during the same period.

In 1937, the great Satchel Paige recruited most of the Crawfords' best players to the Dominican Republic to play for a team owned by the country's dictator, Rafael Trujillo. Pittsburgh collapsed as the Grays ascended back to the top of the Negro National League. Led by Vic Harris, whom owner Cum Posey hired to replace him as manager in 1936, the team once again was a force.

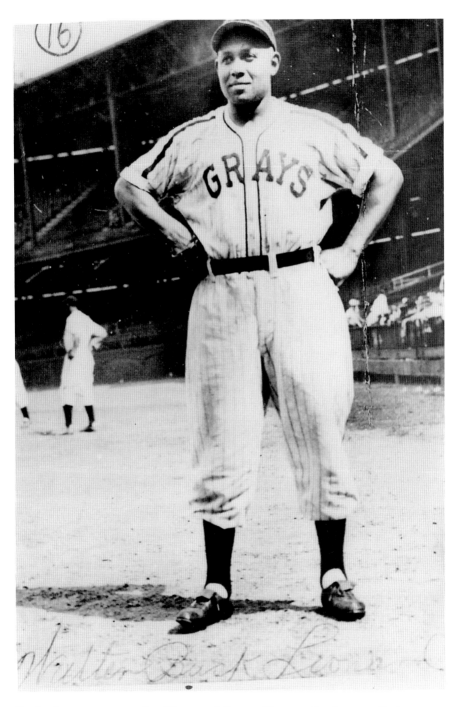

Playing for seventeen years in a Homestead Grays uniform was first baseman Buck
Leonard. He was part of three Grays World Series championship teams. *Pittsburgh Pirates*.

An outfielder who spent twenty of his twenty-seven seasons with Homestead, Harris had incredible bat control with his compact swing. In today's game, he would have been difficult to use a shift against, as he was equally effective going to all fields. A good defensive player, Harris was not known to be the cleanest player in the circuit. He often went after opposing players with his overaggressive style on the base paths and was equally disruptive to umpires, often arguing and, one time, even spitting at one he disagreed with. A .301 lifetime hitter, the Homestead manager treated his players in a different manner, choosing to be a good example with his hustle on the field rather than being verbally aggressive toward them.

The players Paige recruited to play in the Dominican Republic included arguably the greatest hitter in Negro league history in Gibson. While Greenlee suspended his players when they returned, the Crawford owner was losing a considerable amount of money and sold the future hall of fame catcher back to the Grays for $2,500. With Homestead battling the Newark Eagles for the league crown, he lifted the team with his incredible play down the stretch. Gibson had perhaps his best Negro league campaign, winning the triple crown while leading the league in just about every major category. He won the batting title with a .436 average and led in home runs (10), RBIs (44), OPS (1.488), slugging (.979) and on-base percentage (.509).

Joining Gibson in the potent lineup was future hall of fame first baseman Buck Leonard. Leonard hit .388 for the season, and the twenty-nine-year-old first baseman finished right behind Gibson in homers (9), RBIs (38), OPS (1.271), slugging (.796) and on-base percentage (.475).

With the two future hall of famers in its lineup, Homestead led the Negro National League in every major hitting category, including a .309 team average. With so much team success, there was obviously more than just Leonard and Gibson contributing. The thirty-two-year-old Harris not only deftly handled the club from the bench but also proved to be a great example for his team in the field with a .309 average and a team-high twelve doubles. Joining Harris in the outfield was switch-hitting Jerry Benjamin and his .296 average, as well as Jimmy Williams, who was tenth in the circuit in batting with a .331 mark. At six feet, one inch and two hundred pounds, Williams was a big, aggressive player in the mold of Harris, who was also considered to be a dirty player. A .297 hitter over the course of his career, Williams was quite a threat offensively, with good power, the ability to hit for average and above-average speed. While a good offensive player, Williams lacked defensive skills and had a weak arm.

The infield included Leonard, second baseman Matt Carlisle (.266), shortstop Jelly Jackson—who hit a team low .240—and thirty-four-year-

old Javier Perez. The Cuban-born third baseman was more known for his defensive skills at the hot corner than for his hitting prowess. This is not to suggest that he was poor offensively, especially in 1937, when the contact hitter had a .285 average for the Grays.

Edsall Walker (7-1, 4.26 ERA) and Ray Brown (6-3, ERA 3.87) were the Grays' two biggest winners on the mound and led a staff that finished at the top of the league in ERA (3.96), opponents' batting average (.242), home run percentage allowed (0.7 percent) and WHIP (1.31). The future hall-of-fame hurler Brown dominated opposing hitters with his incredible control. He fashioned an outstanding curveball and sinker to go along with his effective fastball and fine knuckleball, the latter of which Brown developed later in his career. Nicknamed the "Catskill Wild Man," the southpaw Walker was unlike Brown in the fact that he had one pitch he utilized the majority of the time. The six-foot, two-hundred-pound hurler was different from most left-handers in that he was dominant against righties and struggled with control versus left-handed hitters.

The combination of talented players for Homestead dominated the league after Gibson joined the club, which found itself in a position to clinch the pennant if it could defeat its bitter rivals, the Crawfords, when the two teams met late in the season. Pittsburgh was not going to make it easy for their city rivals, breaking out to a 5–0 lead in the first inning. For four seasons, they had made Homestead look bad, and the Grays wanted to end that streak on this day. Battling back, Homestead tied the contest, finally winning in the fifteenth inning. The 10–9 victory put an end to the dominance the Crawfords had had over the Grays, who re-emerged as the best team in the Steel City with the pennant-clinching win.

38: THE 1918 UNIVERSITY OF PITTSBURGH PANTHERS

NCAA Football National Champions
Record: 4-1-0

In 1918, while people tried to go on with their normal lives, a health epidemic never seen before or since was gripping the globe, with catastrophic results. The flu pandemic of 1918 struck 500 million people worldwide and killed an estimated 20 to 50 million people in its wake. In the United States, 675,000 citizens perished. Without any medicines or

Pop Warner began the championship era at Pitt, winning three national championships in 1915, 1916 and 1918. *University of Pittsburgh Athletics.*

vaccines to help prevent or cure the illness, the results were devastating. As bad as it was, the country tried to move on.

Sports was an important vehicle in trying to keep the country's morale up, but with many quarantines implemented due to the pandemic, plus the fact that World War I was coming to an end with many of America's great athletes still serving their country, college football and most other sports were extremely limited in the games that could be played. For the championship

football program at the University of Pittsburgh, just five games would be held that campaign. Luckily, the powerful Panthers made the most of their limited opportunities to show the country that they were, in fact, the best team in the land (at least as good as Michigan, also recognized as a national champion that season).

Despite all of the issues facing the country at the time, when it came to football at the University of Pittsburgh, the team was loaded, starting with its future hall-of-fame coach, Glenn "Pop" Warner. When it comes to the greatest all-time college football coaches, no list is complete without Warner at or near the top. He made an impact no matter where his career took him. Whether at Georgia, Cornell, Carlisle, Pitt, Stanford or Temple, Warner made the programs championship caliber. He was an offensive genius whose techniques influenced the game well beyond his forty-four-year career. He even has the honor of having his name attached to the country's most prominent youth football organization. At Pitt, he was at his best, winning national championships in 1915 and 1916 before coming into this abbreviated campaign.

At Warner's disposal were three All-American players: Tom Davies, George McClaren and Leonard Hilty (Davies and McClaren achieved the status twice in their illustrious careers). Davies was a consensus All-American in 1918 and 1920 before becoming a successful collegiate coach over the next twenty-six years. The young sophomore led the 1918 Panthers in rushing with 361 yards. It would be the first of three consecutive Pitt teams he led in that category. Davies received the ultimate honor for a college football player in 1976, when he was elected to the College Football Hall of Fame.

A fullback for Warner, McClaren was an All-American in 1917 and 1918 and became a successful college coach. After his career, he was elected to the College Football Hall of Fame (1965). McClaren had the distinction of never being tackled for a loss during his career at Pitt. While Hilty was not as successful as his other two teammates, Davies and McClaren, they could never have achieved what they did without the likes of consensus All-American tackle Leonard Hilty in front of them.

The group got off to a late start in 1918, playing their first game on November 9. As they got ready to face the nearby rivals from Washington and Jefferson College, Warner was hoping to improve his own personal twenty-six-game winning streak; he had yet to lose in his three-year stint at the university. The school itself was on a twenty-eight-game streak, having captured its last two games under Coach Joseph Duff in 1914. They went

on to increase it to thirty after crushing W&J, 34–0, before a thrashing of state rival University of Pennsylvania, 37–0. The title, for all intents and purposes, would be played the next week against the defending national champions, Georgia Tech Yellow Jackets.

Called the Golden Tornado at that point in their history, Georgia Tech was magnificent in 1917, outscoring their opponents 491–17 in their nine games while being named consensus national champions. With the legendary coach John Heisman at the helm (for whom the famed award is named), they had come into this contest at 5-0, with his team unscored upon while racking up 425 points, eclipsing 100 points in three of the five games they played. Traveling to Pittsburgh to take on Warner and his Panthers, Heisman had to be confident of adding another title to his résumé. Like Pitt, Georgia Tech hadn't lost a game since 1914.

Tech employed the jump shift rushing attack (which relied on precise shifts before the ball was snapped) that had devastated so many opponents. Pitt's defense turned out to be not only its equal but also clearly superior, frustrating the vaunted Golden Tornado backfield time and time again. On offense, Davies and McClaren were at their best, with Davies returning a punt for 55 yards and a score before rushing for a 50-yard touchdown. Pitt wasn't just dominant on the ground, it was impressive through the air, too, as Davies hit R.A. Easterday with a 20-yard touchdown toss. The duo combined with McClaren on a triple pass that saw Easterday cross the goal line on the 35-yard play. McClaren was not left out—his 1-yard plunge gave Pitt yet another touchdown.

By the time the dust had settled, the Panthers put Davies on their shoulder, taking him off the field in front of a record crowd in the amazing 32–0 victory. While Pitt was successful on the field, it was anything but financially, as the United War Fund committee took the entire receipts from the contest to help defray the war costs.

After the impressive victory, Pitt handily beat Penn State, 28–0, before a startling loss to the Cleveland Naval Reserves. In that contest, which was scoreless for three quarters, the Reserves scored late in the game to win, 10–9. Despite the loss, Pitt's previous four victories, especially the Georgia Tech win, gave them the national championship in this abbreviated season.

37: THE 1929–30 UNIVERSITY OF PITTSBURGH PANTHERS

NCAA Basketball National Champions
Record: 23-2

It's an iconic American sports tradition every March into early April: March Madness. A collection of sixty-eight champions and at-large teams begins the fight to claim the college basketball national championship in a series of heart-pounding, win-or-go-home contests. There can be no controversies as to who the true champion is; the winner has battled through many tough rounds and deserves the adulation it receives. Some of the greatest teams ever produced by the University of Pittsburgh have gone through those battles, sometimes coming close, but never getting to the end unscathed. The problem with Pitt is that its arguably best teams (1927–28 and 1929–30) played before 1939, the first year of the tournament. The school was thus unable to have that memorable moment when it cuts down the nets in the wake of a championship. Thanks to the Helms Athletic Foundation, the school at least got to hang two banners in the Peterson Events Center celebrating these two exceptional teams.

Created in 1936 by philanthropist Bill Schroeder in conjunction with Paul Hoy Helms, who owned the Helms Bakery Company, as a place to display his vast sports memorabilia collection, the Helms Athletic Foundation became so much more than a glorified man cave. It opened a museum and, with a group of renowned and respected experts, created All-Americans and awarded the Helms World Trophy, honoring the greatest amateur athletes in the country. What meant the most to the alumni and fans of the University of Pittsburgh was its creation of a list of national champions in basketball from 1901 that would celebrate these teams that played before the inception of March Madness. Both the undefeated club of 1927–28 and this team, the last Panther basketball team to claim a title, found themselves on the vaunted list.

The leader of this squad was the legendary Pitt coach Henry Clifford "Doc" Carlson. Many claim that Ben Howland and Jamie Dixon are the premier coaches in the program's history, but they stand significantly behind Carlson. Born in Murray City, Ohio, in 1894, Carlson was innovative, and his colorful personality was combined with an ability to irritate opponents with his antics from the bench. While most coaches may have been better sportsmen at the time when it came to questioning referees, Doc would openly criticize them when he disagreed with their calls. While those issues

An All-American on the football team, Doc Carlson went on to be the winningest coach in Pitt basketball history with 367 wins. *University of Pittsburgh Athletics.*

might have been more memorable to the teams he defeated, it was his innovations that made Pitt winners. He used the double team on defense when almost no other coaches wanted to try it. Carlson was the inventor of the figure eight weave offense, one that was far ahead of its time, as well as the give-and-go. He also had players use oxygen on the sideline, was the first eastern school to travel west to play and gave his club ice cream at halftime. They were different and sometimes strange innovations, but they worked. The school won four Eastern Intercollegiate conference championships, and Carlson won 367 games during his career while being elected to the Naismith Memorial Basketball Hall of Fame. Through all his successes, these two teams were his greatest contributions to the school.

Even though the undefeated club of 1928 might have been his best, the 1929–30 team was close behind. Led by three-time All-American Charley Hyatt, who led the nation in scoring, the team showed early on that it could be the best in the country. Hyatt had a terrific cast surrounding him, including speedy guard Paul Zehfuss, one of the greatest centers the school has ever produced; Lester Cohen; and starting quarterback for the national champion football team Eddie Baker.

Pitt started the campaign with twelve impressive victories, including a 35–31 win over national powerhouse Indiana at Bloomington, where Hyatt netted 13 and Cohen contributed 8, and a 38–33 overtime defeat of the Ohio State Buckeyes on New Year's Eve at the Pitt Pavilion, which was located inside gate three of Pitt Stadium and built underneath the football stands.

After thrashing neighbors Carnegie Tech, 49–25, Pitt stood at 12-0 heading to the Archibald Gymnasium in Syracuse, where they faced the Orangemen in the first of a three-game road trip in early February. It was a game Syracuse dominated from the outset, as captain Lou Hayman and Everett Katz led a balanced attack that suffocated Hyatt with their aggressive defense on their way to the 40–29 upset victory. The Panthers rebounded by defeating Fordham and Notre Dame to end the road trip that began an eight-game streak that helped them eclipse the 20-win plateau with a 20-1 mark. The next contest was the basketball version of the Backyard Brawl, as Carlson and his team played the West Virginia Mountaineers at the WVU Fieldhouse. On a day when the nation mourned the passing of former president William H. Taft, a record 4,200 fans jammed the fieldhouse to watch their home team move out to a 17–9 halftime lead. Mountaineer captain Marshall "Little Sleepy" Glenn led the game with 17 points while limiting Hyatt to 9 as WVU was never really threatened in the 33–25 victory.

Once again, the Panthers rebounded from a disappointing loss with a winning streak. After a close call against St. Vincent, 29–28, they dominated Washington & Jefferson, 67–20, before a season-ending win at Penn State, 47–30. With no tournament on the horizon, their season ended with a spectacular 23-2 mark. Almost a decade later, this memorable squad received their just due from the Helms Athletic Foundation as they were retroactively named national champions for the second and last time in school history.

36: THE 1951–52 PITTSBURGH HORNETS

American Hockey League Champions
Record: 46-19-3

The legacy of Pittsburgh championship hockey began with the YellowJackets capturing national titles in 1924 and 1925. It would be twenty-seven years until that list could be expanded, when the city's entry in the American Hockey League, the Pittsburgh Hornets, finally captured its first Calder Cup.

Born in 1936–37 after relocating from Detroit in the old International-American Hockey League, the Hornets moved into the legendary Duquesne Gardens and enjoyed moderate success in their first fifteen seasons, finishing second in their division four times while appearing in the Calder Cup finals on four occasions, including the 1950–51 campaign, when the team made the championship despite a sub-.500 season before losing a tight seven-game series to the Cleveland Barons.

Coming so close only to be turned away so many times, the team was determined to capture that long-awaited title when they took the ice to start the 1951–52 campaign. Pittsburgh was helmed by center George Armstrong, who led the club with 30 goals. Armstrong was just twenty-one years old at the time and would go on to a fabulous twenty-one-year career with the Toronto Maple Leafs. He was elected to the Hockey Hall of Fame in 1975. Coach Francis "King" Clancy, another Hockey Hall of Fame member who has an NHL award named in his honor (given to the player who best shows leadership on and off the ice), also had the legendary defenseman Tim Horton at his disposal, as well as leading scorer Bob Hassard, who enjoyed a limited NHL career with the Maple Leafs and Blackhawks, and nineteen-year-old defenseman Leo Boivin, who not only was honored with an election to the hall of fame in 1986 but also played with the Penguins during their first two seasons.

The young Hornets took the confidence gained in the 1950–51 campaign into the new season by winning their first eight games. They captured their first F.G. "Teddy" Oke Trophy, symbolic of the Western Division crown, with a 46-19-3 mark, good enough for 95 points, two better than their bitter rivals in Cleveland. They brushed aside the Eastern Division champion Hershey Bears in five games in the first round, which gave them a bye into the finals.

Pittsburgh's opponents in the championship would be the Providence Reds, the Eastern Division runner-up squad that defeated the Barons

in a best-of-five series in the first round. The Reds then disposed of the Cincinnati Mohawks three games to one in the semifinals. The Reds were led by league MVP and leading scorer Red Powell, as well as Barry Sullivan and Paul Gladu. All three players finished in the top ten in scoring for the regular season. While relying on those three for the majority of their scoring, Providence was the equal of the Hornets in offense during the season, scoring only four fewer goals, but it was defensively where Pittsburgh had the advantage, surrendering 91 fewer goals with its stalwart defense and outstanding goalie Gil Mayer leading the way.

The championship series would begin at the Duquesne Gardens for the first two games—games that would lead the experts to believe that the series would be short after two decisive victories by the home team. In the opener, despite the fact that Clancy didn't think the forwards checked particularly well in the first two periods, most likely because of the long layoff between rounds, they found their aggressive play in the third. Boivin put the Hornets at a disadvantage early in the first with a penalty, but Rudy Migay made up for it quickly by scoring the series-opening goal soon after Boivin exited the box for a 1–0 lead. Providence dominated play in the second, only to have Mayer time and time again keep them off the board. After Clancy let his club know how he was displeased in the locker room before the third period, the Hornets came out strong. Ray Hannigan made it 2–0 early in the period. After the Reds cut the lead to one on a power-play goal, Andy Barbe and Bill Ezinicki tallied goals for the 4–1 victory.

Led by Boivin and Horton, Pittsburgh suffocated the Reds in the second contest. Migay scored twice, the second coming on a five-on-three disadvantage, to send the series to Providence with the Hornets holding on to a 2-0 series lead following another one-sided victory, 5–0. The Reds paid them back in the third game with a 5–1 victory and saw a potentially series-changing injury occur when Migay hurt his knee. He was questionable for the fourth contest. Two minutes before the teams took the ice for the next game, Migay told Clancy he was ready. It was fortuitous for the team—the injured star scored the opening goal to give the Hornets a 1–0 lead. Providence came back to take a 2–1 advantage as time was running out. With only 1:38 remaining, Bob Solinger scored for Pittsburgh to send the game into overtime. At 18:40 of the second overtime, Solinger found an open Migay in front of the net for the game winner.

While only one game from elimination, Providence did not quit, beating Pittsburgh, 5–1, in front of a disappointed throng at the Duquesne Gardens as the two teams headed back to Rhode Island for a sixth contest; it turned

out to be one for the ages. Barbe opened the scoring at 1:09 into the first for a 1–0 Hornet lead before the Reds tied it twice in the second period, which they did once again after Horton stole the puck and broke in alone for the goal and a 2–1 Hornet lead. The goalies turned aside all twenty-one combined shots in the third period, sending the contest once again into overtime. Providence dominated play in the first overtime, but Hannigan netted perhaps the greatest goal in franchise history at 6:08 of the second to send the Hornets into hysteria with the Calder Cup–winning goal.

Clancy was obviously overcome with joy after the game, saying that "this is the greatest gang of players I've ever been associated with, they're wonderful."[14] It was a sentiment that certainly the entire city of Pittsburgh agreed with.

35: THE 1929 UNIVERSITY OF PITTSBURGH PANTHERS

NCAA Football National Champions
Record: 9-1-0

When Pop Warner left the University of Pittsburgh in 1923, it was hoped that the championship program he brought to the Oakland section of Pittsburgh would somehow survive. As the administration tapped a protégé of his, a man who had been an All-American at the university in 1917 by the name of John Bain "Jock" Sutherland, their fears should have been calmed.

After a short professional career with the Massillon Tigers, Sutherland accepted the head coaching job at Lafayette and led them to a piece of the national championship in 1921 with a perfect 9-0-0 mark. Two seasons later, he was tabbed to take over for a legend. After a difficult 5-3-1 mark his first season in 1924, pressure was on the Pitt alum to figure out how to maintain that level of success with the Panthers. Questions on his ability were raised with regularity. He was shut out by his two closest rivals, Carnegie Tech and Washington & Jefferson, and a winning season was in peril when he faced a third, Penn State, to close out the season. Pitt was at their best that day, winning 24–3 to secure the winning campaign; it was the last time anyone would question his ability. Sutherland's team lost only seventeen more times in his final fourteen seasons at the helm of the program.

The team had phenomenal seasons in 1925 and 1927 but struggled with a 3–2 start in 1928. After losing to Carnegie Tech, 6–0, they went 3-0-1 in

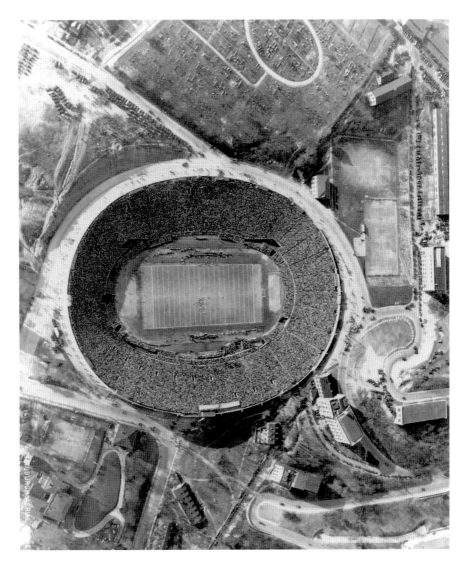

Built in 1925, Pitt Stadium was host to seven national championship seasons by the university's football program. *University of Pittsburgh Athletics.*

their final four games, outscoring their opponents by a 69–0 margin. It gave them the confidence going into the 1929 campaign. Led by Toby Uansa, they fashioned Sutherland's first undefeated regular season.

Pitt had a vast array of talent on their squad that season, including four first-team All-Americans. Uansa was a triple threat for the Panthers, leading the team in rushing, interceptions and scoring. A very fast back, the McKees

Rocks native was also an exceptional returner, scoring twice on kickoff returns in his career to win games for Pitt. Ray Montgomery led a stalwart line that helped propel the Panthers to their phenomenal record. He was a consensus All-American at guard, one who Sutherland considered the best lineman he ever produced. Thomas Parkinson was a bruising fullback who was extremely dependable in short-yardage situations and at the goal line. He saved his best for last in 1929, rambling for 182 yards in the regular season finale against Penn State. The best of the four All-Americans was Joe Donchess. The two-time All-American at end, who was later elected to the College Football Hall of Fame, became a coach at Pitt under Sutherland after his playing days were over as well as at Dartmouth while attending medical school. He eventually became an orthopedic surgeon.

The talented foursome led their team into battle in 1929, winning their first three contests by a combined 132–14 before traveling to Lincoln, Nebraska, to face the tough Cornhuskers.

Coach Dana X. Bible had revenge on his mind, as Nebraska had been unable to beat the Panthers in their last two encounters. Despite the inspiration, the legendary coach Knute Rockne stated in his newspaper column a fact that many felt to be true: "Pittsburgh has possibly one of the best teams in the east this year if not the country and they will carry too many guns for Coach Bible's men."[15] Nebraska played inspired football, but Rockne's assessment was correct: Pitt did have too many guns. Even though Pitt was short-handed when speedy running back Joe Williams left the game with an injury, his replacement, Bill Walinchus, caught a ball at the Huskers' 45-yard line and ran 53 more to the 2. Parkinson showed his toughness on the next play, bolting in to give Pitt a 6–0 lead. Before the first half ended, the Panther offense went on a long, physical drive with Parkinson scoring a second time on another tough goal-line run to increase the lead to 12–0 at the half. Nebraska made it close at 12–7, but the tough Pitt defense held firm, and the score ended the same, putting the Panthers at 4-0.

After defeating Allegheny College, 40–0, they faced another national power at Pitt Stadium in the Ohio State Buckeyes. The Buckeyes were 3-0 coming into the contest, led by three-time All American Wesley Fesler. Donchess would be responsible for neutralizing Fesler and showed in this game to be his superior. With Fesler ineffective, the Buckeye offense could not find its footing. Uansa opened the scoring with a 68-yard touchdown ramble. After a safety by the Panther defense to make it 8–0, Uansa was tackled in his end zone for an Ohio State safety after securing a fumble, cutting the lead to 8–2. Jimmy Rooney then connected on a 32-yard

field goal to increase the Pitt lead to 9 points before a heavy rain made it impossible for the offenses to move effectively. Even though the Panthers drove to the Ohio State 25, on fourth down they chose to punt and pin the Buckeyes deep in their territory. Instead of punting, Rooney threw a pass to Uansa at the 13. The All-American ran in the rest of the way to complete the impressive 18–2 win.

Winning their first six games, a confident Pitt squad easily won their final three games against Carnegie Tech, Washington & Jefferson and Penn State to complete the season undefeated. They received a bid to play in the Rose Bowl against the University of Southern California. In the first part of the twentieth century, bowl games were considered nothing more than exhibition contests. Pitt was crushed by USC, 47–14, in the game, but since it was only an exhibition in most experts' eyes, college football historian Parke H. Davis named Pitt as the national champion for 1929 on his famed list first published in *The Spalding Guide* in 1933.

34: THE 1912 MONTICELLO ATHLETIC ASSOCIATION

Black Five World Basketball Champions

Like most sports leagues in the early to mid-twentieth century, basketball was a segregated sport. Some of the greatest players in the era went almost unnoticed as they played the best basketball at the time. Like the Grays and the Crawfords in the Negro Baseball League, Pittsburgh was at the forefront of basketball in the country with the Monticello Athletic Association. The team, which morphed into the Loendi Big Five in the 1920s, won five African American basketball world championships in a ten-year period.

Back at the turn of the twentieth century, basketball teams were known as "fives," for the five players on the floor for a given team. At the time, African American teams were called "Negro Cagers," "Color Quints" or, as they are more commonly referred to today, "Black Fives." Games played between the African American teams were also part of bigger social events. Places where the games were played would often be advertised along with dances simultaneously taking place at the facility. There were never any championship contests per se, but in 1907, a sports editor for the *New York Age* named Lester Walton came up with the concept of a "Colored Basketball World's Champion," and experts from the top African American newspapers

at the time chose a champion each season through 1925. The Smart Set Athletic Club of Brooklyn captured the first two titles in 1908 and 1909, and the Washington Twelfth Street Colored YMCA and Howard University captured championships the next two years. In 1911–12, Howard was once again favored to win the world title, not expecting a team from Pittsburgh to pull off one of the great upsets of the era and steal the championship from underneath them; that club was the Monticello Athletic Club.

The club was newly formed in 1911 by one of the great icons of Pittsburgh sports history, Cumberland "Cum" Posey. More known to area sports aficionados as the owner of the legendary Homestead Grays, Posey was so renowned for his part with the Grays that he eventually was elected to the National Baseball Hall of Fame in 2006 for the job he did creating a Negro league dynasty with the team. What most people don't realize was that he was a tremendous athlete. An African American pioneer at Penn State and Duquesne University, where he was a star on the basketball court and baseball field, Posey was also a renowned player with the team he owned for so many years, the Grays. As great a career as he had at each place, it was perhaps his time with Monticello and then Loendi where he excelled the most.

The team was named after a street in Pittsburgh and played most of its games at an all-white facility called the Phipps Gymnasium located on the north side. The five-foot, nine-inch Posey, who was also elected to the Naismith Memorial Basketball Hall of Fame in 2016, was the star of the team that included his brother Seward, Walter Clark, Sell Hall, Israel Lee (another member of the Homestead Grays) and the janitor of the Phipps gym, Jim Dorsey. They had been successful against most of the teams they played, mainly all-white competition, and wanted to move on to greater opportunities, so Posey challenged the best team there was, Howard University, the defending world champions.

Howard was unimpressed with Monticello but accepted the invitation to play them in Pittsburgh. It was billed as the "first colored game ever played in Pittsburgh."[16] The contest was at the Washington Park Fieldhouse, which stood approximately where the Civic Arena was built a half century later. Howard thought they would be coming in for a relatively easy contest. As the official website of the Black Five Foundation states about the game, "The Monticellos got no respect and were considered 'a huge joke' by Howard, who thought they would show the steel town 'just how basketball is played in polite circles.'"[17] As they soon found out, playing against Cum Posey and his squad would be no joke.

At the time, outside shots were not done in basketball. Posey, however, was very adept at the technique. Only losing twice in three years, Howard was confused when the future hall of famer started making his outside shots and they fell behind Monticello. Posey was the epitome of a one-man team, scoring 15 of the team's 24 points in a defeat that sent shockwaves through the African American basketball community. With the victory, Posey and his players were declared the Black Five World Champions. While it would be eight more years before a Steel City team again raised a Black Five banner, it was the first in 1912 that began the tradition in the sport for Pittsburgh teams. It was a tradition that can be traced back to one of the great upsets Black Five basketball would ever see.

33: THE 1933 PITTSBURGH CRAWFORDS

Negro National League Champions
Record: 35-20-2

It's appropriate for the 1933 Pittsburgh Crawfords to be included in this list. After all, for the short time they were on the Negro league landscape, they produced many of the circuit's greatest teams, 1933 being the first of that championship legacy. No fewer than five hall-of-fame players dotted their roster, including Oscar Charleston, Judy Johnson, Cool Papa Bell, Satchel Paige and the great Josh Gibson. Yes, it was a great collection of players that, according to seamheads.com, the most renowned website on Negro league stats, were 35-20-2 during the Negro National League season and had tied for the second-half title. The problem is that their owner, Gus Greenlee, was the founder and president of the new Negro National League, and he controversially named them league champions for the entire season.

The Negro National League was the first organized circuit in the Negro league, formed in 1920 by one of the most legendary figures in the circuit's history, Rube Foster. It lasted until 1931, when it folded. Two years later, one of the numbers kings in the city of Pittsburgh, Greenlee, had decided to invest in sports entities, having many boxers under his management. He had also purchased a local semipro team and named it the Crawfords, after the famed Crawford Grill in the Hill District section of the city, which Greenlee also owned. An aggressive businessman, he was intent on making his team, and the Negro leagues in general, the home of arguably the best baseball

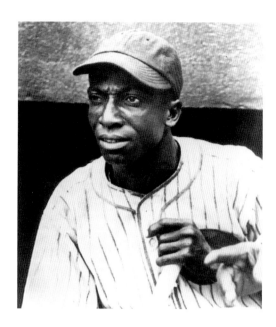

One of the fastest players in baseball history was hall of famer James "Cool Papa" Bell. He was a member of the 1935 Pittsburgh Crawfords. *Pittsburgh Pirates*.

played in the country. He signed many of the best players in the league, who turned out to be among the best players ever to step on the diamond, and he was the catalyst in reviving the Negro National League, becoming its president and running it with the same authoritarian style that Kenesaw Mountain Landis did for Major League Baseball.

The 1933 campaign was the league's first, and it had a pennant race that was close and memorable—unfortunately, for all the wrong reasons. After posting a spectacular 99-36 mark as an independent in their first season as a full professional ball club in 1932, Greenlee's impressive squad entered the Negro National League a year later, hoping to run through opponents in an equally dominant manner. To give his team their own facility, he constructed the first stadium built specifically for a Negro league team. It was a concrete-and-steel facility that cost $100,000 to build, half of which he financed from his own account. He named it Greenlee Field, and it accommodated 7,500 fans. Opening in time for the 1932 campaign, it often hosted great crowds wanting to see his magnificent team.

For years, the Homestead Grays dominated the Negro league baseball landscape, not only in Pittsburgh, but also in the country itself. It was only two years earlier when they fielded what was considered the best team in the history of the circuit. As the 1933 season unfolded, it was clear they were now number two in the Steel City. The Crawfords were either second or third in most major pitching and hitting statistical categories.

While Paige had a disappointing losing record (4-6), the rest of his statistics were spectacular. He led the league in WHIP with a miniscule 0.85 and an equally impressive ERA (2.03). Luckily for manager Oscar Charleston, he had an impressive array of starters around him who had much better records, including Leroy Matlock (8-5), Bert Hunter (8-2), William Bell (6-5) and thirty-two-year-old Sam Streeter (8-2). Offensively, the Crawford stars played at the high level Greenlee expected from them. Gibson was only twenty-one at the time but showed why many consider him among the best catchers ever to play the game. He hit .395 with 14 home runs in 205 at bats to complement the thirty-six-year-old manager's exceptional campaign, as Charleston wasn't far behind with 13 long balls of his own and a .344 average. Despite Jimmy Crutchfield, who eventually became a very notable player in his own right, hitting only .216, Bell and Ted Page made a very dangerous outfield by hitting .308 and .351, respectively. Pittsburgh finished the first half with a fine 20-9 mark but trailed the Chicago American Giants by a half game. They hoped to continue their impressive play in the second half to capture at least a share of the league championship.

As Negro league historian John Holway tells in his book *The Complete Book of Baseball's Negro Leagues*, the second half of the season was declared a tie between Pittsburgh and the Nashville Elite Giants. There was a three-game playoff to determine the second-half champions. After losing the first game, there was a doubleheader in Cleveland on October 1. In the first game, Paige gave up two runs in the top of the ninth to blow a 4–2 lead. Matlock shut out the Elite Giants in the final three innings as the Crawfords won in the bottom of the twelfth, 5–4. In the nightcap, Hunter held Nashville to three hits in a 3–1 victory to give Pittsburgh the championship.

It would be easy to say that Chicago and Pittsburgh were co-champions and declare the season done. According to the Negro League Museum's official website, the American Giants claimed the title on the grounds that the second half of the season wasn't played to completion and they finished in front of Pittsburgh in the full-season standings. In a perfect example of conflict of interest, the league president, Greenlee, officially declared it as a fact that the Crawfords were the season champions. Over the years, the decision was not overturned despite the American Giants' protests, so the official records today indicate that Pittsburgh was the rightful champion of the Negro National League in 1933. No matter how controversially it ended, they are still one of the greatest teams in the history of Pittsburgh sports.

32: THE 1931 UNIVERSITY OF PITTSBURGH PANTHERS

NCAA Football National Champions
Record: 8-1-0

As the 1931 collegiate football season was beginning, fans of the University of Pittsburgh had to wonder exactly where their national championship program was headed. After showing themselves to be among the best, if not the best team in the land during the 1929 regular season, the program seemed to be going in the wrong direction. They had been thrashed by the USC Trojans in the 1930 Rose Bowl and followed that up with a very disappointing 6-2-1 campaign in 1930. It was a very youthful Panther squad in 1930 that was still relatively inexperienced a year later. With hopes that the team could possibly be back to contender status in 1932, if at all, the Panther fans and students found out it wouldn't take that long. The 1931 season would show them all that coach Jock Sutherland was the master of the quick rebuilding process.

After years of many stars, Sutherland had one this season, tackle Jesse Quatse. A star high school player from nearby Greensburg, Pennsylvania, Jesse was a three-year letterman who would be a consensus All-American by year's end. As the season began, he wasn't even assured of a starting spot. Quatse was in a tight battle for the starting spot at tackle opposite Ralph Daugherty. The All-American eventually won the starting nod, and the teams on the Panthers' schedule were sorry he did. The five-foot, ten-inch tackle was incredibly strong and one of the best defenders in the country. His style was to come in low on the offensive line, making him next to impossible to block. He turned out to be one of the main reasons Pitt's defense was among the best in the country.

In the opener against Miami (Ohio) at Pitt Stadium, they sent a message to the rest of the college football world that they were back to national contender status. In beating the Redskins, 61–0, halfback Warren Heller set a school record—rambling for 250 yards on fifteen carries—that stood until 1975, when Tony Dorsett eclipsed it against Notre Dame. The defense led by Quatse allowed only 1 yard rushing and 50 overall while giving up a mere three first downs. They maintained their momentum throughout their first four games, as they were undefeated and unscored upon, beating their opponents by a combined 147–0. They had a similar streak in 1930 before being routed by Notre Dame, which sent their season spiraling downward. They would face the Fighting Irish in week five and hoped for a different outcome; unfortunately, the result would be the same.

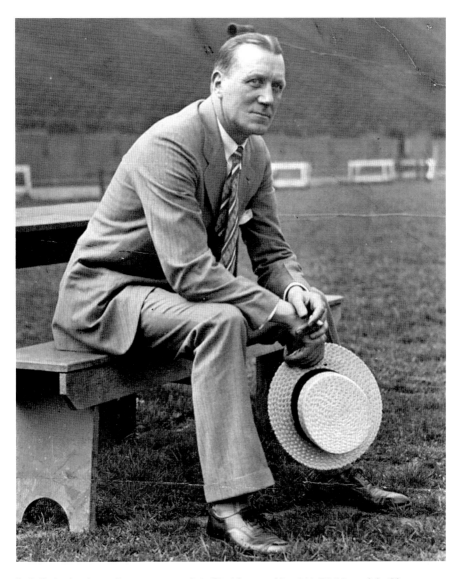

Jock Sutherland was the greatest coach in Pitt history with a 111-20-12 mark in fifteen seasons that included five national titles. *University of Pittsburgh Athletics.*

While the results were very similar to the year before, it was a very different atmosphere at Notre Dame. Earlier in the year, their coach, Knute Rockne, had been killed in a plane crash in Kansas while on his way to Los Angeles to be a consultant on a film about Notre Dame football. The administration turned to Heartly "Hunk" Anderson to lead their

program in the wake of the tragedy. The team played flawlessly against the Panthers, rushing out to a 25–6 lead on the way to an impressive 25–12 victory. The year before, the team had struggled after the Irish loss, going 2-1-1 down the stretch, with one of their victories being an unusually close 7–6 win against underdog Carnegie Tech.

This year, there would be no such downturn. Pitt rebounded with a 41–6 thrashing of Penn State before once again playing a hard-fought game against the Tartans in a 14–6 win. That left two very tough games remaining on the schedule, against Army and their annual rivals from Nebraska. When they needed to be, the Panthers were at their best. Over sixty-five thousand fans jammed Pitt Stadium to see the pageantry that a contest against a service academy team brings. Even though the game's final score was 26–0, it was never that close, as Pitt outgained the Cadets, 494–67.

Remarkably, after the loss in South Bend, the Panthers had bounced back and were once again in the upper echelon of teams in the country. Pitt needed some help, though, if they were to put themselves in position to be considered for the national championship. As the final week began to unfold, they were getting the help they needed. A dropkick late in the game by All-American Albie Booth propelled Yale to a 3–0 upset of Harvard, and USC scored the last 16 points of the game to overcome a 14–0 Notre Dame lead in a 16–14 victory. Pitt still needed to have a convincing win against the Cornhuskers at Pitt Stadium to have a shot; they would get that and more.

It was Thanksgiving Day when Pitt would annually take on Penn State. The Nittany Lions no longer wanted to make the trek down to the Steel City on the holiday, so the Panthers were able to talk the Cornhuskers into replacing Penn State so they could carry on their Thanksgiving tradition. The teams came into the game with matching 7-1 records, but the hard-fought, anticipated contest never took place. Pitt scored early and often, leading at the half, 13–0, on two touchdowns by Heller. The star halfback made it four scores quickly in the second half to stretch the lead to 27–0. Sutherland pulled out the starters, but the Panthers didn't stop the scoring. Mike Sebastian scored the game's final two touchdowns in what would be a one-sided 40–0 victory.

With their newfound power, Pitt was hoping to secure a third bid to the Rose Bowl against Southern California. Unfortunately, undefeated Tulane got the call and lost to USC, 21–12. The Trojans went on to win many national championship honors following the victory, but a few years later, when Parke Davis made his selections, he put the Panthers on top, giving the school its fifth national title and second under Sutherland, all in what was supposed to be a rebuilding year.

31: THE 1921 WASHINGTON & JEFFERSON COLLEGE PRESIDENTS

NCAA Football National Champions
Record: 10-0-1

Every sports story needs its David, the legendary team that slayed its own Goliath. In western Pennsylvania sports lore, that David would be the 1921 Washington & Jefferson College football team.

A tiny college approximately twenty-eight miles outside the city of Pittsburgh with an enrollment of 1,362 students, Washington & Jefferson, or W&J, as it is referred to, is a successful Division III program. It has won twenty-four conference championships since 1970 and has made an equal number of trips to the Division III playoffs in the last thirty-two years, including two appearances in the championship game. As impressive as that has been, in the early part of the twentieth century, the Presidents were among the best teams in the land regardless of division. The 1921 campaign turned out to be that magical one, the season that fans and alumni alike will always point to and proudly say, "We were the best team in the land."

The unique thing about this team was that it had no true stars, just a deep, tough roster that got the best of every school it played. The man on the sidelines coaching the school was indeed a star, perhaps its only true one: hall of famer Earle "Greasy" Neale. An intense coach who hated to lose, he once said: "Who the hell likes to lose? Sure I'm a tough loser. Who isn't? If you don't want to win all the time, you've got no business holding a job in sports."[18] Eventually elected to the Pro Football Hall of Fame after a stellar career at the head of the Philadelphia Eagles (including a stint with the famed Steagles in 1943), as well as having the honor of the Maxwell Football Club's pro football Coach of the Year award named after him, the Parkersburg, West Virginia native also enjoyed a short career in Major League Baseball as an outfielder for both the Cincinnati Reds and the Philadelphia Phillies. It was while he played with the Phillies in 1921 that he also coached the Presidents.

Neale may not have had any superstars, but he did have some fine players, including the captain, Russ Stein. Stein was the team's best player and was selected to the Walter Camp All-American team along with his brother Herb, who played for Pitt, becoming the first brothers to ever be selected to an All-American team in the same year. The Warren, Ohio native went on

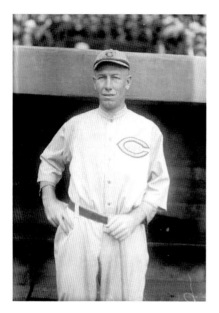

A baseball player for the Cincinnati Reds, Greasy Neale also was the coach for Washington & Jefferson football in 1921. *Library of Congress, Prints and Photographs Division, LC-B2-4992-14.*

to a career in the NFL. He was joined by a teammate, Charlie "Pruner" West, who was a true pioneer, leading the way for African Americans in major college football as the first to ever play in the Rose Bowl. West was a quarterback who took over the starting nod late in 1921 and eventually had a successful career as a physician in the nation's capital. He faced prejudice when he played. Author Dana Brooks told a particular story about it: "In 1923, Washington and Lee's team [from Lexington, Virginia] came to W&J to play. Charles West was on that team. Coach 'Mother' Murphy, refused to bench West, even though he knew he had a sprained ankle and probably couldn't play."[19]

They started the season by defeating their first four teams, including Carnegie Tech, 14–0. Not allowing a point, they faced their two toughest opponents to date, Lehigh and Syracuse, winning 14–7 and 17–10, respectively. Following an easy victory over Westminster, they played their bitter rivals from Pitt. It had been seven seasons since W&J defeated the Panthers, and in the pouring rain at Forbes Field, it was a hard-fought battle on the muddy gridiron. Blocking a field goal attempt by Pitt in a scoreless battle set up the game's only score when the Presidents' Wayne Brenkert hit Herbert Kopf on the 15-yard line with Kopf taking it the rest of the way for the 7–0 victory. The college was so overjoyed, it gave the students the day off the Monday following the game.

Confident, W&J won its final two games over Detroit and West Virginia, finishing with a perfect 10-0 mark. It was considered one of the best teams in the east. W&J wasn't the first pick for the region's representative to the Rose Bowl to face the defending national champion Cal Bears, as Iowa, Cornell, Penn State, Princeton, Yale, Harvard and Centre College (having a David-like season themselves) all declined bids before W&J was extended and then accepted the one given to them.

It wasn't easy for the Presidents to get to Pasadena. Athletic director Bob "Mother" Murphy mortgaged his home to help pay expenses. To say they were underdogs against Cal is an understatement. The Bears were called the "wonder team" and were full of something the Presidents weren't: All-Americans and superstars. W&J was the smallest school to ever participate in the Rose Bowl, with only 350 students at the time. Only nineteen players made the trip for the game; eleven played both offense and defense, the last time that was done in the famed game, and somehow, even with the heavy rain that hit Pasadena that morning, W&J outplayed the heavy favorites. They held California to only 49 yards of offense and scored what appeared to be the winning score as Brenkert ran for a 35-yard touchdown out of a punt formation. Unfortunately, there was an offside penalty called on Stein, which negated the play. The contest ended in a scoreless tie. Stein was named the game's MVP and was elected to the Rose Bowl Hall of Fame in 1991.

While not named as national champions that season, when William F. Boand developed his mathematical system for selecting national champions in 1930, he proclaimed Washington & Jefferson as the best team in the land in 1921 along with Lafayette and California. This is recognized in the *N.C.A.A. Records Manual*. Giving up only six first downs in its final four games, it was an exceptional season for the David-sized school in its magical season.

Part of the impenetrable 1980 Pitt defense was linebacker Ricky Jackson. He went on to be elected to the Pro Football Hall of Fame. *University of Pittsburgh Athletics*.

3

THE STORIED TEAMS

TEAMS 30–21

30: THE 1967–68 PITTSBURGH PIPERS

American Basketball Association Champions
Record: 54-24

It's rare when a champion of a newly created league can be so heralded as the 1967–68 Pittsburgh Pipers. After all, not many people remember that the Birmingham Americans were champions of the World Football League in 1974—not even folks from Birmingham. Birmingham wasn't a team with one of the greats of the game in his prime, as the Pipers had with Connie Hawkins. It made for one of the most memorable campaigns in the history of sports in the Steel City.

Prior to the 1960s, the four major sports in the country existed with minimal franchises. With professional sports becoming more and more popular, the leagues needed to expand in other markets or rival leagues would begin to take hold. Only baseball and hockey had any type of meaningful expansion, which prompted the creation of the American Football League (AFL) and the American Basketball Association (ABA). Pittsburgh was never much of a professional basketball city, but when the ABA announced its franchises before the start of the 1967–68 campaign, the city got another opportunity to succeed with the Pipers.

The ABA was a new breed of basketball, a glimpse of what the game would evolve into twenty-five years down the road. While the more

established NBA played a more disciplined type of basketball, the American Basketball Association was an exciting, up-tempo style that is in vogue today. The league had a red, white and blue basketball and ushered in the three-point shot. The dunks were flamboyant, and the games were high scoring.

Pipers owner Gabe Rubin hired Vince Cazzetta to coach the team. Cazzetta had been a phenomenal coach with Seattle University in the late 1950s and early '60s. He did a great job over five seasons with Seattle, posting a 96-39 mark. They were rated thirteenth in the nation his first year and made the Western regional in the NCAA tournament his final three campaigns. Former player Charley Brown said about Cazzetta, "He was one of the most likable guys you'll ever meet. He was a friend to all the ballplayers. He was a guy we could always talk to, even after leaving the university and the kind of guy you always want to relate to."[20] He got his shot to coach professional basketball this season and made the most of it.

If not for an unfortunate circumstance, Connie Hawkins may have never been part of this memorable team. One of the top high school players in the country, Hawkins, out of Brooklyn, chose to continue his career at the University of Iowa where, unfortunately, he never made it on the court. He wasn't arrested or even implicated in a point-shaving scandal in 1961, but it was suggested that he had introduced the gamblers to the players. While he always denied the charges, Hawkins was expelled from Iowa and, for all intents and purposes, banned from playing in the NBA.

Hawkins was a star with no league. He joined the Rens, winning the American Basketball League's (ABL) Most Valuable Player award, and then played with the Harlem Globetrotters for a time. The ABA didn't care about his past and gave him a shot to play with the Pipers. Led by this former playground legend, the Pipers embraced the new style of play the league was looking for. They led the circuit in points per game with 111.9 while not paying much attention to the other end, allowing 108.7 defensively. They had a well-balanced attack led by Hawkins's league-leading 26.8 points per game, while Art Heyman had 20.1, Charles Williams pitched in 20.8 and Chico Vaughn just missed the 20-point level with a 19.9 average.

The foursome led Pittsburgh to a 54-24 mark, four games better than the Minnesota Muskies for the Eastern Division title. After sweeping the Indiana Pacers in the division semifinals three games to none, they took on the Muskies for the division championship. Settling for a split in the first two games at the Civic Arena, the Pipers opened up in Minnesota, winning both contests by 8 and 9 points, respectively. Coming back to Pittsburgh, they closed out the series, and with it a spot in the finals with a

114–105 win as Hawkins poured in 24 while Vaughn and Heyman scored 22 and 21, respectively.

In the finals, they faced the New Orleans Buccaneers, and things did not look good as the series went on. The two teams split the first two games at the Arena, as they did the two contests in New Orleans. The Pipers lost game five, 111–108, as they were going back to the Crescent City and needed to win to stay alive. Hawkins, despite the fact he had torn the medial tendon in his knee in game four and missed the fifth contest, refused to lose and showed his magnificence in a 41-point effort in a 118–112 game six victory, setting up a winner-take-all seventh game at the arena.

It was a perfect background for the city that never could support professional basketball. A big crowd for the time, 11,457 fans were loud and waiting for a chance to celebrate. It was a tightly fought game seven with Pittsburgh clinging to a 2-point lead going into the final quarter. While future NBA coaches Doug Moe and Larry Brown led the way for New Orleans with 28 and 19 points, respectively, Williams and Hawkins would not let the Pipers lose. Williams played incredibly, netting 35, and a hobbled Hawkins scored 20 in the 122–113 victory.

It looked like basketball in the Steel City had a chance—until Rubin sold the team and it was moved to Minnesota. They returned a year later and played one more season as the Pipers before changing their name to the Pittsburgh Condors. The Condors became one of the worst franchises in the league and were disbanded in 1972. Hawkins was eventually accepted into the NBA and became a hall of famer, but it was his MVP season in 1968 when it all turned around. As far as the team goes, they have become memorable in Pittsburgh lore, as the 1967–68 Pittsburgh Pipers remain one of the most cherished teams to those who experienced them.

29: THE 1936 UNIVERSITY OF PITTSBURGH PANTHERS

NCAA Football National Champions
Record: 8-1-1

For many, the Rose Bowl has been a highlight, a cherished memory that players and fans look back at fondly. For the University of Pittsburgh in the first half of the twentieth century, it was a shop of horrors. There was a gut-wrenching, controversial 7–6 loss to Stanford in 1928, followed by

humiliating defeats administered by the University of Southern California in 1930 and 1933. It is no wonder that all involved with the University of Pittsburgh football squad looked at the invitation to the 1937 Rose Bowl against the University of Washington with trepidation. Luckily, this would be a different Pitt team that would have a much more positive experience. New Year's Day 1937 is when the heartache and nightmares of Pasadena days gone by died.

The year 1935 was a fine season, but it brought some disappointment following the team's national championship campaign in 1934. A 9–6 loss to the Fighting Irish of Notre Dame, followed by scoreless ties against Fordham and Carnegie Tech, ruined what could have been a special season. Over the years, with the help of one of the most aggressive booster groups of their time, the Golden Panthers, Jock Sutherland was able to secure the finest talent in the area. The group would help take care of them with housing and stipends as well as finding them well-paying jobs after their careers at Pitt. It was something that other schools that competed for national titles criticized them for, but for the Panthers, it was a system that worked well, especially in 1935, when the school was able to beat out its rivals at Notre Dame for the services of a young running back from Elkins, West Virginia, by the name of Marshall Goldberg. Goldberg, who next to Tony Dorsett is the greatest running back ever produced at the school, emerged in 1936 as a budding superstar in his sophomore season and helped lead a potent attack by Pitt that would roll over eight opponents.

While Goldberg was phenomenal in his first varsity campaign, there were two other Panthers who would achieve first-team All-American status by year's end. Guard Bill Glassford helped anchor the line that allowed Goldberg to have such success. The All-American went on to have a great run as a coach with the University of New Hampshire after serving in the U.S. Navy during World War II. His record at the university was 19-5-1 with three conference championships before he moved on to Nebraska, where he wasn't as impressive with a 31-35-3 mark in seven seasons, taking the Cornhuskers to the Orange Bowl in 1955. Perhaps the thing Glassford is most noted for is longevity. When he passed away in September 2016, he was 102 years old. The other great member of the Pitt line was Averell Daniell. When the season began, he was in a fight for a starting spot with George Delich; by year's end, he was a consensus All-American. The six-foot, three-inch tackle started his career in Oakland as a walk-on and went on to a career in the NFL before being elected to the College Football Hall of Fame in 1975.

Celebrating by kissing the football after a win was Pitt All-American running back Marshall Goldberg *(far left)*. *University of Pittsburgh Athletics.*

Pitt took on Ohio Wesleyan in its first contest of the season, and Goldberg showed the nation exactly why he was a coveted recruit, rambling for 203 yards in a 53–0 rout that saw the Panthers outgain their opponents, 801–44. After beating West Virginia, 34–0, they traveled to Columbus to take on Ohio State. On a gusty day, halfback Harold Stebbins scored the game's lone touchdown in a 6–0 victory that put Pitt at 3-0.

As the team prepared to play its Forbes Avenue rivals from Duquesne University, they seemed to be looking beyond Duquesne to matchups against the Fighting Irish of Notre Dame and the Fordham Rams, who had the famed "Seven Blocks of Granite" line that included arguably the greatest coach in the history of the NFL, Vince Lombardi. The team that Pitt should have been focused on was the Dukes. Halfback George Matsik ran for a 71-yard touchdown in the second quarter that held up in the 7–0 Duquesne upset. An angry Pitt squad took it out on the Irish the next week, crushing them, 26–0, before the second of what would be

three consecutive scoreless ties against Fordham at the Polo Grounds in New York.

Sitting at a 4-1-1 mark, which was not acceptable for a Jock Sutherland–coached team, the Panthers rolled over Penn State, Carnegie Tech and Nebraska to end the campaign 7-1-1. They captured the first Lambert Trophy ever awarded, symbolic of the best college football team in the east, and waited to see if they had done enough for a Rose Bowl bid.

It was rumored that Pitt was given a bid to the Sugar Bowl before accepting a bid to Pasadena. One of the youngest teams in the country with an average age of twenty-one years and two months, these Panthers had no recollection of the past. Sutherland practiced them hard on the way to California, and the experts thought that they would be tired when game time arrived. Pitt was anything but tired and took a quick 7–0 lead when Frank Patrick scored from the 10. After a long run by Bobby LaRue, Patrick scored his second touchdown of the afternoon, bolting in from the 3 to pull ahead by two touchdowns in the third quarter.

The game wasn't over at that point, as the Huskies began a drive that went deep into Pitt territory. At the Panther 37-yard line, Tony Matisi tipped a lateral that fell into Bill Daddio's hands. Daddio ran downfield untouched 63 yards into the end zone for the touchdown that clinched the phenomenal victory for Pitt, 21–0. As young as the team was, it was thought there would be more bowl victories for this squad. The victory, which erased the jinx of Rose Bowls past and gave them a share of the national championship, would be the last bowl win at the school for thirty-nine years.

28: THE 1915 UNIVERSITY OF PITTSBURGH PANTHERS

NCAA Football National Champions
Record: 8-0

In 1915, the University of Pittsburgh was beginning a new era in its football program when athletic director A.R. Hamilton tabbed Glenn "Pop" Warner to be the new coach. It wasn't as if the program had been suffering. Joseph H. Thompson had been a phenomenal coach and was the architect of a memorable season in 1910, when the Panthers were undefeated and unscored upon. He also had a lot of other interests

other than football. He was going to law school at the same time he was coaching Pitt. Soon after leaving his position as coach, he was elected to the Pennsylvania State Senate representing the Forty-Seventh District. He then headed off to Europe to fight in World War I, eventually being awarded the Medal of Honor for his service.

His replacement, Joseph Duff, was also attending the school of law at the university when he was coaching the Panthers and led them to two solid seasons until graduating and heading off to Europe himself to fight in the Great War. Unfortunately, his story did not end happily. Duff was killed in action in France in 1918. After Duff left, the administration brought in Warner. Unlike his predecessors, Pop was not coaching the team while he was attending school; his primary focus was winning football games. The man who is credited with coming up with the single- and double-wing offenses as well as the three-point stance was something of a coaching nomad. He started as the head coach at Georgia before moving on to the Iowa Agricultural College and Model Farm (Iowa State), where he actually had a deal to coach both schools for two seasons before coaching exclusively in Iowa. After four years, he came home to take on the challenge of leading his alma mater, Cornell. His stay there did not go well despite success on the field. An assistant coach led a revolt against his leadership technique, which led him to take a job at a small school called the Carlisle Indian Industrial School. It was there he showed his genius by turning the team, led by Jim Thorpe, into a national power. Returning to his alma mater in 1904 for two seasons before heading back to Carlisle, he then became the Panthers coach. It would not take him long to build the Pitt program into the premier one in the country. It happened in his first season.

Led by the school's first All-American, Robert Peck, who was selected for the honor three consecutive times between 1914 and 1916, the Panthers rolled over their opponents. Peck was an outstanding center and anchor of the Pitt line who went on to become an outstanding pro player with Youngstown, Massillon and Fort Wayne. After his football career, he became the longtime athletic director at the Culver Military Academy before sadly passing away in 1932. Peck was elected to the College Football Hall of Fame in 1954.

The Warner era started off well. The squad beat Westminster in the opener at Forbes Field before traveling to Annapolis to crush the Naval Academy, 47–12. A third thrashing, this time against his old school, Carlisle, 45–0, gave the team momentum as it faced arguably its toughest opponent of the season, Penn, at Franklin Field in Philadelphia.

The cover of a program for the national champion Pitt Panther football team. The Panthers were 8-0-0 in 1915. *University of Pittsburgh Athletics*.

Pitt played well in the first quarter but was unable to finish the drives in the end zone. Finally, with the half coming to an end, C.E. Hastings bolted in from the 2-yard line for a 7–0 Panther lead. Clinging to the slim lead early in the fourth quarter, James DeHart picked up his own fumble at the Quaker 7 and ran around left end for the score. Penn scored late, but the Panthers left the other end of the state with the 14–7 win.

Perfect at 4-0, the final four Pitt games were at home. They defeated Allegheny College, 42–0, before hosting a very difficult local rival from Washington & Jefferson College. Over thirty-five thousand excited fans jammed Forbes Field and were treated to a fiercely fought scoreless first half. It would take four plays in the second half to break the tie. After Pitt got a first down at its own 41, Hastings went toward the left end for 59 yards and a 7–0 Panther lead. It went quickly downhill at that point for the Presidents. Two series later, Pat Herron picked off a lateral and rambled 76 yards for a 13-point advantage. If that wasn't bad enough, on the next series, future Pitt legendary coach Jock Sutherland intercepted a pass deep in W&J's territory. G.K. Fry took it in from the 1-yard line a couple plays later to put the final touches on what would be a dominant 19–0 win.

With so much confidence and only two games left, the Panthers rolled over Carnegie Tech, 28–0, before defeating the Nittany Lions of Penn State, 20–0, to finish the season a perfect 8-0-0, outscoring their opponents by a 247–19 margin. When historian Parke H. Davis created his famous list of national champions, Pop Warner's first Pitt team would get its just due with the school's first national championship.

27: THE 1901 PITTSBURGH PIRATES

National League Champions
Record: 90-49

Back when the city was spelled without an "h," baseball in the Steel City was anything but championship quality. The city's name would continue to be spelled "Pittsburg" until 1911, but its championship drought would end ten years earlier after one of the greatest "trades" in the history of the game set up the beginning of baseball's first dynasty of the modern era.

In 1899, the National League was a twelve-team circuit. It had been at that number since taking in some of the American Association teams

Jack Chesbro set the all-time modern franchise record for wins in a season when he collected twenty-eight victories for the 1902 Pirates. *Pittsburgh Pirates.*

after it folded in 1891. By the end of the nineteenth century, some of the teams were not drawing well, so the circuit decided to contract four of its less profitable teams, Baltimore, Cleveland, Washington and the Louisville Colonels, reducing it to the eight-team league that held firm until expansion in 1961.

The owner of the Colonels at that time was a man born in Freiberg, Germany, by the name of Barney Dreyfuss. His fortunes in Louisville were not good, both on the field and on the business end of the team. By 1899, the team had collected a fine array of young talent and was within two games of .500 at 75-77.

As part of the agreement, he was given an opportunity to invest in the Pittsburgh Pirates. Not wanting to lose his budding superstars, he arranged a trade with the Bucs before the contraction became official. The Bucs gave up Jack Chesbro, George Fox, Art Madison, John O'Brien and $25,000; in return, Pittsburgh received a dynasty. Bert Cunningham, Mike Kelley, Tacks Latimer, Tom Messitt and Jack Wadsworth were included in the deal. If that was all, this would have been one of the more forgettable trades ever. Thankfully, they received a little more. Tommy Leach, Deacon Phillippe, Claude Ritchey, Rube Waddell and Chief Zimmer would contribute to the team's success while future hall of famers Fred Clarke and the man who is considered the greatest player ever to don a Pirates uniform, Honus Wagner, made them champions. The results of the deal were extraordinary and instantaneous. In 1900, the team finished in second place behind the Brooklyn Superbas, losing to the Superbas three games to one in the Chronicle-Telegraph Cup, a precursor to the World Series. The young squad went into the 1901 campaign as one of the favorites in the National League.

The lineup was devastating to their opponents in the senior circuit. Seven of the eight starters hit .295 or better, with only catcher Chief Zimmer hitting below that mark, at .220. Wagner, who is arguably the greatest shortstop in the history of the game, led the way, finishing fourth in the league in

batting with a .353 average while leading the circuit in RBIs (126) and stolen bases (49). Nicknamed the "Flying Dutchman," Wagner was a hometown product, born in Carnegie, Pennsylvania, only a few miles outside of the city of Pittsburgh. He was a tremendous fielder no matter where he played, but it was shortstop where Honus was at his best. He went on to win eight batting titles and amass 3,420 hits in his twenty-one-year career. Legendary statistician Bill James ranks him as the second-greatest player, behind Babe Ruth. James said simply, "There is no one who has ever played the game that I would be more anxious to have on a baseball team."[21] The great John McGraw stated that Wagner was "the nearest thing to a perfect player no matter where his manager chose to play him."[22]

Joining Wagner was a wonderful outfield that included the player/manager of the team, Fred Clarke, who hit .324; Lefty Davis (.313); and Ginger Beaumont, who smacked a team-high eight home runs while knocking in 72 runs and hitting .332. The infield was equally as dangerous, with third baseman Tommy Leach, who would be a pivotal part of four Pirate pennants, and second baseman Claude Ritchey joining Wagner. Ritchey would hit .296, while Leach topped the .300 plateau at .305. Kitty Bransfield rounded out the infield with a fine rookie campaign, contributing 91 RBIs and a .295 average.

As good as their offense was, the Pirates' pitching staff was even more troublesome for opponents. In the early 1900s, the Bucs' starting rotation of Chesbro (who was given back to Pittsburgh after the demise of Louisville), Leever, Jesse Tannehill and Phillippe formed perhaps the most dominant group in the game. The staff's 2.58 ERA was a full .29 below the second-best team in the majors, while their 1.159 WHIP was the best in the circuit. Phillippe led the group with 22 wins, and Chesbro also topped the 20-win plateau with 21. Tannehill had a solid 18-10 mark with a miniscule 2.18 ERA, and Leever, who only started 21 contests due to his recurring sore arm issues, was 14-5. While not a factor in the season, the quirky future hall of famer Waddell was also on the staff, starting only two contests before being sold to the Chicago Orphans (Cubs). Waddell was a loose cannon, and Clarke was a strict manager. Predictably, their personalities never meshed, necessitating the move.

The team did not get off to an auspicious start and stood at only 16-15 on June 1. It was at that point that they soundly defeated Chicago, 6–1, to send them on a stretch in which they won seven of their next nine games. Following a 4–0 shutout of the New York Giants on June 11, they vaulted over the Giants into first place and never relinquished that position for the

rest of the season. Finally, on September 26, the fans who had suffered so long got to see something they had dreamt of since the team was established in 1882. By defeating Brooklyn, 4–3, Pittsburg clinched its first pennant, as the team was able to extend its lead to nine games over second-place Philadelphia with eight contests left to play. It was a joyous day in the city, one that could only have been realized by the trade of the century.

26: THE 2015–16 PITTSBURGH PENGUINS

Stanley Cup Champions
Record: 48-26-8

It was a season of change for the Pittsburgh Penguins as 2015 was turning into a new year—and it wasn't a change that would make hockey fans in the Steel City happy. Since the Mario Lemieux and Ron Burkle group took over in 1999, they had seemingly made one great decision after another. In 2014, with their team unable to capture a second Stanley Cup since winning their first as an ownership group in 2009, they made changes that rocked the organization and appeared destined to fail. They brought back the retired general manager Jim Rutherford of the Carolina Hurricanes. A former goalie with the franchise, Rutherford made some very quizzical moves, the main one being the hiring of Mike Johnston, who had only junior hockey head coaching experience and after a quick start in 2014–15 seemed unequipped to handle an NHL roster. One move Rutherford did make that went under the radar was naming the former coach of the Boston Bruins, Mike Sullivan, to head their top farm club in Wilkes-Barre/Scranton.

The forty-seven-year-old coach had been extremely successful in his first season with the Bruins, where he went 41-19-15-7. Instead of his getting a chance to improve on that record a year later, the league was shut down with a lockout. When the league returned in 2005–06, Boston struggled. Sullivan was fired, and after a decade with no offers, it looked like his NHL head-coaching days were over.

Pittsburgh was hurting in December 2015. It looked as if not only their second championship era was coming to a grinding halt but also that of their impressive playoff streak of nine consecutive seasons. Sidney Crosby appeared to be an old man at twenty-nine, and the fortunes of the franchise looked as done as Crosby's career. If nothing else, Rutherford is an honest

man and seemingly can admit mistakes. He fired Johnston on December 12 and replaced him with the Penguins' minor league coach, who was performing miracles in Wilkes-Barre/Scranton despite having a roster that would make winning difficult. A rebuilding process seemed in order; as it turned out, part of the process was taken care of by Sullivan's restoring the confidence of the veteran players. The other part was taken care of by the GM, who deftly turned the roster from a slow one to one with a faster, youthful look—all in the span of a few weeks. If rebuilding processes took years, this one defied logic. In a matter of weeks, the Penguins' championship era was strong once again.

Players like David Perron, Rob Scuderi, David Warsofsky and Adam Clendening were gone. Those who would make this team faster and younger—Carl Hagelin, Tom Kuhnhackl, Conor Sheary, Bryan Rust, Justin Schultz and Scott Wilson, along with veteran defenseman Trevor Daley—were brought in by Rutherford. They made a dramatic difference, but not at first.

The team lost each contest under Sullivan in his first four games and was a mere 6-8-3 in his first 17 contests. Finally, the roster started to jell and

Conor Sheary was the toast of Pittsburgh after scoring an overtime goal in game two of the Stanley Cup finals to beat San Jose, 2–1. *University of Massachusetts Athletics.*

play better. But as the season was winding to an end, Evgeni Malkin was felled with a serious elbow injury. Rather than collapse once again, Sullivan adjusted lines, putting together Hagelin, Patric Hornqvist and Phil Kessel, which became one of the most dangerous lines in the league. Crosby found a second wind no one thought he had and went from a bitter disappointment to his familiar role as the best in the league.

Pittsburgh reeled off four wins in a row as they traveled cross-state to play the hottest team in the league in the Philadelphia Flyers, who were 8-1-1 in the previous ten games. Pittsburgh gave up the first score of the contest, but Daley, Hagelin and Chris Kunitz scored second-period goals. Kris Letang finished the scoring with an empty-net goal in the third for a dominant 4–1 victory that gave the club the momentum for a phenomenal finish to the season.

Unfortunately, another serious injury threatened to derail their playoff quest when Marc-André Fleury, who had been the team's MVP thus far, went down with a severe concussion. But this team had an answer to every issue that cropped up, the result of a minor league system that was thought to be ineffective by most experts; enter rookie Matt Murray.

Murray showed he had potential to be a star, leading the Pens to a 9-1 finish. The season that had looked lost turned into one in which every team in the east was afraid to face the Penguins in the postseason. Murray was out with a concussion of his own, suffered in the season finale against the Flyers. Enter third-string goalie Jeff Zatkoff to face the Rangers in the first round. He was phenomenal in a 5–2 game one victory, and when Murray came back in game three, he picked up where he left off, as Pittsburgh easily defeated New York in five games.

Facing the President Cup–winning Washington Capitals in the second round proved to be a much tougher chore, but in a hard-fought six-game series, with five of the contests decided by one goal, the Penguins upset the heavily favored Capitals to move on to the Eastern Conference finals.

Pittsburgh once again struggled in the series, falling behind three games to two while traveling to Tampa for game six. With their season on the line, the Pens played their best game of the series and came home with a 5–2 win. The rookie Bryan Rust had a game that would prove to be one of the most memorable in franchise history, scoring both goals in a dramatic 2–1 win to give the team the conference championship and a spot in the finals against the San Jose Sharks.

Winning the first two games, including a dramatic overtime goal by Sheary in game two, Pittsburgh held a three-games-to-two lead as they flew to San

Bryan Rust became a hero in 2016, scoring both goals in a 2–1 victory against Tampa Bay that gave Pittsburgh the Eastern Conference title. *University of Notre Dame Athletics.*

Jose for the sixth contest. Seven years to the day after their last Stanley Cup–clinching victory, the one that led many to believe more would follow, the Pens beat the Sharks, 3–1, and finally lifted the long-awaited cup, a moment that only a few months before had seemed so illogical.

25: THE 2005 PITTSBURGH STEELERS

Super Bowl XL Champions
Record: 11-5-0

When Terry Bradshaw and company put the final touches on a 31–19 Super Bowl XIV championship over the Los Angeles Rams, it gave the Pittsburgh Steelers four titles in a six-year period; a ring for every finger except the thumb. It created one of the great mantras in Pittsburgh sports history, one every Steelers fan in January 1980 was claiming would happen a year later. "One for the Thumb" was heard all around the city, and around the country for that matter, as Steeler Nation famously stretches far and wide. The only problem

was that the team was aging and failed to qualify for the postseason. "One for the Thumb" would have to wait another year. The years kept passing by, and calls for a fifth ring would go unfulfilled. When Pittsburgh fashioned a remarkable 15-1 campaign with a rookie quarterback by the name of Ben Roethlisberger in 2004, the twenty-five-year wait for the elusive "One" appeared to be coming to an end. Unfortunately, a dynasty was brewing in New England that would quell the Steelers' fans' hopes. The Patriots soundly defeated Pittsburgh at Heinz Field in the AFC championship game, 41–27.

It was an emotional loss that the team felt particularly devastated by. Running back Jerome Bettis was in the twilight of what would turn out to be a hall-of-fame career. After twelve seasons, he was rumored to be retiring at the end of the 2004 campaign. Wanting desperately to add a Super Bowl title to his résumé, the team was inspired to give their popular teammate this fitting sendoff. When they fell to New England, the players felt they let Bettis down. A tearful Hines Ward let the nation know how horrible he felt in the postgame press conference: "It hurts. It hurts. It hurts. I wanted to win more for Jerome than anything. He deserves to be a champion."[23] Bettis had a decision to make: come back for one more try or retire as planned without a ring. "I was done. I was getting old. Twelve years in the league. My body was starting to break down. It was difficult. I didn't think I had another year in me."[24] Yet, somehow, he mustered the strength for one more try. To the joy of his teammates and Steeler Nation alike, he came back in 2005.

Bettis would be reduced to a backup role. A college free agent from North Carolina who came out of a Tar Heel program where he didn't start, Willie Parker took over the starting spot in his second season. It was controversial, but it turned out to be a great move by Steelers coach Bill Cowher, as the speedy Parker would ramble for 1,202 yards, more than his entire output in four seasons at Chapel Hill. Bettis came in for short-yardage plays and in a closer role when the game was out of hand. It might not have been the perfect ending scenario for the future hall of famer, but it seemed like it was the proper decision for the team as a whole. With the season going perfectly with a 7-2 mark following a 34–21 triumph over Cleveland, things began to stumble. A three-game losing streak that included an embarrassing 26–7 loss at Indianapolis, as well as two defeats at the hands of division rivals Baltimore and Cincinnati, made the gift of a ring for Bettis look remote. A game against a fine Chicago Bears team the next week would either end their postseason ambitions or give them life for another week.

It was a snowy day at Heinz Field. With the Steelers in front only 7–3 at the half, they would need a spark to pull this one out; that spark would be the

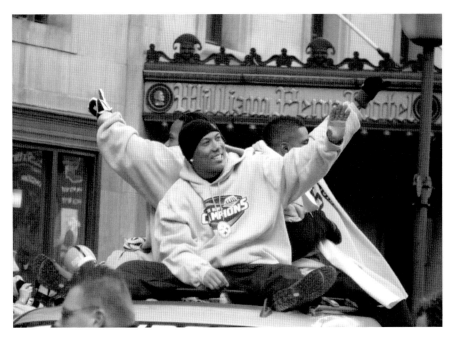

The MVP of Super Bowl XL, Hines Ward, waves to the crowd three years later following the team's Super Bowl XLIII victory. *Author's collection.*

running back they were playing this season for. Bettis ripped off 101 yards in the snow with two touchdowns, including a memorable one in which he plowed over All-Pro linebacker Brian Urlacher for the 21–9 win. It was a victory that gave the Steelers the momentum to capture their final three games of the season to finish 11-5 and secure the sixth and final playoff spot in the AFC. Never before had a sixth seed captured a Super Bowl. As the second quarter was running out at Cincinnati in their first-round game, it looked like that fact would remain true.

Down 17–7 at Paul Brown Stadium, the team somehow battled back, scoring the game's last 24 points in a 31–17 win that would send them to their previous house of horrors, the RCA Dome in Indianapolis, where they had been soundly defeated earlier in the season. Expecting Pittsburgh to run, the Colts defense was not prepared to stop the passing attack of the second-year quarterback, as two Roethlisberger touchdown tosses led the Steelers to a 21–3 third-quarter lead. When Troy Polamalu looked to have the game clinched with an interception, the team celebrated what appeared to be a win. The referees inexplicably and erroneously overturned the play and gave the ball to the Colts. Indianapolis scored to

Running while at North Carolina is Willie Parker. He ran for a Super Bowl record 75-yard touchdown in Super Bowl XL. *University of North Carolina Athletics.*

cut the once-insurmountable lead to only 3 points.

Pittsburgh still seemed in control when they were deep in Colts territory as time was running out. At that point, Bettis did something he rarely did: fumble the ball. If not for a game-saving tackle by Roethlisberger, the Steelers' hopes would have been ended. Peyton Manning drove the Colts down the field, setting up a game-tying 46-yard field goal attempt for the league's most accurate kicker. Mike Vanderjagt surprisingly missed the kick, and Pittsburgh was on their way to the AFC championship, where they defeated the Broncos, 34–17. "One for the Thumb" was still alive.

The Steelers played the Seattle Seahawks in the Super Bowl and, in a closely fought game, clinched the win with a trick play as receiver Antwaan Randle-El tossed a perfect 43-yard pass to Ward, who waltzed in with the touchdown in a 21–10 victory. The wait was over for both Bettis and Steeler Nation. He had his long-awaited title, and the fans could finally have their "One for the Thumb" that had seemed so certain twenty-six years earlier.

24: THE 1960 PITTSBURGH PIRATES

World Series Champions
Record: 95-59

For those who think the worst era of Pirates baseball came in the record streak of futility between 1993 and 2012, they are incorrect. Fans need to look a half century earlier. While it didn't last twenty years, between 1946 and 1957, Pittsburgh fielded only one winning season (1948). The other

campaigns were not only some of the worst in franchise history but also of the sport as a whole. When general manager Joe L. Brown replaced manager Bobby Bragan with former Pirates second baseman Danny Murtaugh midway through the 1957 campaign, he had no way of knowing that the team's fortunes would turn around immediately.

After finishing 26-25 in his short time that first season, Murtaugh helped his young club fashion a second-place finish a year later. They slipped in an injury-riddled 1959 campaign to 78-76, and not much more was hoped as the 1960s began. Through some deft trades and young players maturing into stars, 1960 went well beyond everyone's wildest imaginations. It became perhaps the most remarkable season this franchise has ever produced.

The son of famed comedian and actor Joe E. Brown, Joe L. worked in minor league front offices until he was hired by the Waco Pirates in 1950 before becoming the president of the Bucs' AA franchise in New Orleans. When the legendary Branch Rickey became Pittsburgh's board chairman in 1955, Brown was the chosen replacement to hopefully end the doldrums for the Pirates. Rickey had built the team with a core of young players, including Dick Groat, Bill Mazeroski, Bob Friend, Vern Law and two of the great Rule V draft picks in the history of the game, Roy Face and a right fielder by the name of Roberto Clemente. Brown would need to add more pieces if the club was to get to the next level.

Following the first and most important maneuver, hiring Murtaugh, Brown added talent to the team. In 1958, he picked up utility infielder Dick Schofield, an unsung hero of the 1960 title run. A year later, he made one of the greatest trades in the annals of Pirates baseball, dealing Frank Thomas and three other players to the Cincinnati Reds for three players who would make a big contribution: Smoky Burgess, Harvey Haddix and third baseman Don Hoak. Finally, in late May, the young general manager added the final piece to the championship puzzle, picking up veteran hurler Vinegar Bend Mizell from the St. Louis Cardinals for Julian Javier.

The mix of veteran and young players seemed to fit together nicely. After losing an opening day game to the Milwaukee Braves, 4–3, the Bucs got on a roll, starting the season at 9-3. They continued to battle back and forth in first place for the first two months of the season until Haddix shut out the Braves over the first eight innings of a contest against the Braves on May 30. Dick Groat contributed four hits, and reserve outfielder Gino Cimoli knocked in four runs in a dominant 8–3 victory that put the Pirates back in first place; it would be a position they held throughout the rest of the season. Finally, on September 25, despite the fact that they lost to Milwaukee, 4–3,

Catcher Smoky Burgess dives into the stands to catch a foul ball during the 1960 World Series against the New York Yankees. *Pittsburgh Pirates.*

the Pirates clinched their first National League pennant in thirty-three years when the Cubs defeated the second-place St. Louis Cardinals, 5–0.

The city and team were joyous with the unexpected title. Groat led the senior circuit in hitting with a .325 average and was named the league's MVP, despite missing most of the final month of the campaign with an injured wrist. Schofield played marvelously in a utility role, hitting .333 for the season, including a .397 mark as the starter while filling in for Groat. Law became the franchise's first Cy Young Award recipient with a 20-9 mark, while Clemente hit .314 with a team-best 94 RBIs. He finished only eighth in the MVP voting, behind three of his own teammates (Groat, Hoak and Law). He was bitter about the lack of respect he received from the voters, claiming racial bias, and he reportedly never wore his 1960 championship ring because of it.

The reward for the Bucs' impressive pennant was a date with one of the best teams in the history of the game: the American League champion New York Yankees. The Yankees of the era were most likely the greatest

Bob Friend was one of the great Pirate hurlers in franchise history. In 1960, he was fabulous, winning eighteen games for the world champions. *Pittsburgh Pirates.*

dynasty in the history of professional sports in North America. In the twenty-eight years leading up to this Fall Classic, they had been in eighteen World Series, winning fifteen of them, including nine in the previous eleven seasons, in which they captured seven championships. Led by the likes of Mickey Mantle, Roger Maris, Yogi Berra and Whitey Ford, the Bronx Bombers were heavy favorites coming into the series, a fact that was magnified when Law hurt his ankle in the celebration following the National League pennant clincher. One wondered if the Pirates could win a game. Despite the fact they were humiliated by a combined 38–3 score in New York's three wins, Pittsburgh somehow won three close games to send the Fall Classic to a seventh and deciding contest at Forbes Field on October 13.

It was a back-and-forth contest that saw the Yanks rally from a 4–0 deficit before the Bucs plated five runs in the bottom of the eighth, three on reserve catcher Hal Smith's homer, to give the Pirates a 9–7 lead going into the ninth. New York somehow scratched out two runs in the top of the frame to tie the game. Two pitches into the bottom of the ninth, it would be tied no more. Two days earlier, *The Andy Griffith Show* had premiered on TV. Later

that evening, Nixon and Kennedy would face each other in their memorable debate. But at 3:37 p.m. on this day, the only thing that mattered to the people of Pittsburgh was that Bill Mazeroski slammed a one-ball, no-strike Ralph Terry pitch over the left-field wall with Yankee left fielder Yogi Berra looking up hopelessly. Mazeroski ended the contest with the only game-seven World Series walk-off home run in the history of the sport. It was an illogical win for this memorable team.

23: THE 1916 UNIVERSITY OF PITTSBURGH PANTHERS

NCAA Football National Champions
Record: 8-0

If 1915 was the start of the championship era at the University of Pittsburgh for its football program, 1916 was when it became one of the sport's great powers. Coach Glenn "Pop" Warner was perfect in his first season at the helm of the Panthers in 1915. While remaining undefeated would be tough two years in a row, it was something Warner would find a way to do.

His first team had one All-American in Bob Peck; this year's very talented squad had no fewer than six players achieve All-American status. Peck was the captain of the team his senior year and earned the status for the third consecutive season, the final two as a consensus All-American. Quarterback James DeHart earned first-team status on the squad, selected by former great Walter Eckersall, who chose his team for the *Chicago Tribune* (an elector who is not recognized by the university in its official records). DeHart Served in the U.S. Army during World War I and would go on to fame as the head coach at Washington & Lee and at Duke.

End Clifford Carlson would earn second-team All-American honors on the Paul Purman team, but that wouldn't be his biggest contribution to the University of Pittsburgh. "Doc" Carlson, the greatest basketball coach in the history of the school, won two national championships for the Panthers and was elected to the Naismith Memorial Basketball Hall of Fame.

Halfback Andy Hastings was a master of many things in his playing days at Pitt, leading the team in rushing for two seasons and in passing, as well as in interceptions in 1916. His 255 points still ranks fifth on the all-time Pitt scoring list. Hastings would go on to play for Cleveland in the inaugural National Football League season in 1920.

The statue of the Pitt Panther outside of the Peterson's Event Center occupies the grounds where Pitt Stadium once stood. *Author's collection.*

Claude "Tiny" Thornhill was on the first-team list of the International News Service. He was an extraordinary guard who also was a player in the first NFL campaign, playing for both Cleveland and Buffalo. He would go on to greater glory as a head coach, leading Stanford to three consecutive postseason appearances in his first three years, including the 1936 Rose Bowl, where they defeated SMU, 7–0.

The final All-American was a consensus one in James "Pat" Herron. A great end with the Panthers, Herron followed DeHart and was head coach for both Washington & Lee as well as Duke. He did his former teammate one better by also taking over the reins of the program at Indiana University. He wasn't a success on the sidelines, garnering a 15-24-5 mark, but he received a law degree from the university and was a hero in the aviation service during World War I, downing two German planes.

With all this talent, Warner sent them into battle to begin the season on October 7. They made very quick work of the Westminster Titans at Forbes Field that day with a very convincing victory, 57–0, before taking off for the team's only road trip of the season. For the two-game sojourn, they headed to Annapolis to face the Naval Academy and then to Archibald Stadium, where the Syracuse Orangemen were waiting. On the first leg of the road trip, their undefeated season, and the glory that went with it, would be in danger.

Traveling to Annapolis to play Navy, Pitt was the heavy favorite, and for most of the contest the team showed that they were deserving of it. The only problems were turnovers and unusually poor punting by Hastings, making what should have been a one-sided affair a very close one. Early into the contest, on the second series of the game, George McLaren fumbled a punt at the Midshipmen's 43, and Navy ran it 57 yards to put them ahead, 6–0. The Panthers wasted little time making up for their mistake, quickly moving on a 55-yard drive that culminated in a burst from the 1-yard line by Hastings to put the Panthers up, 7–6. Pitt quickly ripped through the Midshipmen's defense on another long drive, which McLaren finished with a short run up the middle to give the Panthers a 14–6 lead early in the second quarter. As the second half began, Pitt looked in control when Hastings kicked a short punt that Navy returned to the 1. Two plays later, the home team cut the lead to two, frustrating the heavily favored visitors. An angry Pitt squad once again went through the overmatched Navy defense, finishing the drive with a touchdown pass from McLaren to DeHart to put the Panthers up, 20–12. The Midshipmen once again made the game close after Pitt's

W.E. Miller fumbled a punt late in the game deep in his own territory. Navy quickly scored to make it 20–19 but could not get the ball back as Pitt retained possession until the final gun.

Warner's team escaped with the close victory and wanted to make sure the team never put itself in position to lose again with so many mistakes. They dominated their next four opponents, not allowing a score, as they defeated Syracuse, Penn, Allegheny College and Washington & Jefferson by a combined 133–0 to head into their contest against neighbors Carnegie Tech. As with many fierce rivalries, this game was close. The Tech defense devised a game plan to stop the Panthers' devastating end runs and, for the most part, was successful. Pitt scored twice in the first half on touchdowns by McLaren and Miller. The Tartans scored early in the fourth quarter to cut the Panther advantage to 14–6. Despite the fact that Tech had driven deep into Panther territory late in the game, time ran out on them, and Pitt held on, improving their record to 7-0 with one game left.

Pitt defeated Penn State, 31–0, on Thanksgiving Day to complete Warner's second consecutive undefeated campaign and was named national champions by the majority of selectors. It was a great ending to a campaign in which Pitt truly became a power in college football.

22: THE 1991–92 PITTSBURGH PENGUINS

Stanley Cup Champions
Record: 39-32-9

The previous season had been a dream for the Penguin franchise and its fans. For most of their twenty-four-year existence, the Pens had been nothing more than a mockery to the rest of the hockey world, either finishing in the lower half of the standings or having so many financial disasters surrounding them that most folks were amazed there was still NHL hockey being played in the Steel City. That all seemed to change in 1984, when they selected Mario Lemieux with the first pick in the entry draft. The team still lost as his phenomenal career was beginning, but there was at least a light at the end of the tunnel. That light came into full view when the Penguins remarkably captured their first Stanley Cup championship in 1991.

It was an incredible journey that the triumvirate of GM Craig Patrick, director of player development Scotty Bowman and coach "Badger" Bob

Left-winger Kevin Stevens was at his best in 1992, scoring 54 goals and 123 points for the Penguins. *Boston College Athletics*.

Johnson finally brought to fruition. With an incredible core in the front office and a young team full of budding superstars, the thought of many more Stanley Cup championships in the near future seemed very probable. That is, until tragedy struck this franchise, and the thoughts of titles were replaced with mourning and despair.

Johnson had an infectious, positive attitude, but sadly, he was diagnosed with an inoperable brain tumor in August before the season began and passed away three months later. Former Wisconsin athletic director and celebrated Badger football player Elroy "Crazy Legs" Hirsh, who was Johnson's athletic director when he was the hockey coach there, said about Johnson, "He was the most enthusiastic person and coach I've ever been associated with."[25] Johnson coined the phrase that the franchise has used as its mantra for the twenty-five years since he passed: "It's a Great Day for Hockey."[26] Everyone was devastated. Bowman went behind the bench to try and take his place. While he is considered by many as the greatest coach in league history, Bowman wanted to take the approach that he would do what he felt "Badger Bob" would do and dedicated the season to him.

First came the announcement of the tragic news, then the ceremony where the team received its 1990–91 Stanley Cup championship rings that was broadcast back to Johnson at the hospital in which each player had emotional comments for their stricken leader. Then came Johnson's death. The team flew back to attend his funeral before the emotional ceremony the day after at the Civic Arena preceding an 8–4 victory over the New Jersey Devils. The season was supposed to be a celebratory one, but it was already feeling far too long only two months in.

The team had been embarrassed by Washington, 8–0, in the first shutout they suffered since 1989. Lemieux missed several games due to various injuries, and the Pens seemed to be stuck in neutral following a three-game losing streak to end January. Standing at only 25-20-5, thoughts of repeating seemed to be far from everyone's minds. Despite all the team had suffered, Patrick knew he needed to make some moves if the Penguins had any hopes of repeating.

The Pens general manager dealt aggressively, sending thirty-year-old future hall-of-fame defenseman Paul Coffey to Los Angeles for a first-round pick, Brian Benning and Jeff Chychrun. On the same day, he looked to the other end of the state and sent Benning, Mark Recchi and the first-round pick he had just acquired to the Flyers for tall, tough defenseman Kjell Samuelsson, Rick Tocchet, goalie Ken Wregget and a condition third-

round pick. The moves added toughness to the team, and Tocchet was a gritty scorer. While the trades didn't completely turn things around in the regular season, the team did finish the season on a high note, going 7-3-1 in its last ten games to finish third in the Patrick Division and qualified for the postseason. They now gave themselves a chance. The playoffs would not start off well, but by the time they were done, the Penguins finished with a run of record proportions.

The team was stacked offensively going into the postseason after leading the NHL with 342 goals during the regular campaign. Despite the fact he missed sixteen games, Lemieux still won the league scoring title with 131 points, and Kevin Stevens netted 54 goals with 123 points. Joe Mullen contributed 42 goals, Tocchet had 14 goals and 30 points in nineteen games with the club. And nineteen-year-old Jaromir Jagr broke the 30-goal plateau for the first time with 32. Even though they seemed to have what it took offensively, the Pens struggled in the first round against the Capitals, falling behind three games to one before rallying to win the series in seven. Against the New York Rangers in the division championship, Adam Graves cheaply slashed Lemieux, breaking his wrist and seemingly giving New York control of the series, two games to one. The Pens, without their star and captain, trailed 3–1 in the second period of game four. All looked lost. Enter Ron Francis, who scored a remarkable goal from outside the blue line with only six seconds left in the period to resuscitate the team. Pittsburgh went on to win, 5–4, in overtime. The team would lose no more in these playoffs.

Remarkably, Lemieux returned quickly, and the team not only beat New York in six but also swept the Bruins to take the Wales Conference title. Facing the club in the finals would be Mike Keenan and the Chicago Blackhawks. In game one, Pittsburgh found itself down, 4–1, in the second. The team battled back to within one before Jagr danced through the defense in one of the franchise's greatest goals to tie it at four. The great Mario Lemieux then tossed in a rebound with thirteen seconds remaining in the contest to win, 5–4. It was the catalyst for a sweep of Chicago that gave them their coveted second consecutive Stanley Cup title. They won it in honor of the man who meant so much to them but, sadly, couldn't be there to enjoy the moment.

21: THE 1954–55 DUQUESNE UNIVERSITY DUKES

National Invitation Tournament Champions
Record: 22-4

Relevance; it's what Duquesne University men's basketball and the National Invitation Tournament used to have but currently lack. While the Dukes have struggled for the better part of forty years, receiving their last NCAA tournament bid in 1977, and the NIT has been reduced to a consolation prize, in the mid-1950s, both were at the top of the college basketball world.

The NCAA tournament was restrictive at the time regarding who it would invite. Only certain conference champions were included, and only one team from the conference could be extended a bid. In addition, the NCAA was regularly unable to secure the top independent teams, which made up the majority of college basketball. The National Invitation Tournament, on the other hand, was able to secure the best of the independents as well as some top conference teams. Both tournaments seemed to be on equal footing, and the winners of each legitimately could claim national championships.

One of the giants of the college basketball landscape between 1939 and 1954, Duquesne had been invited to nine tourneys and made one final four and one elite eight appearance in the NCAAs as well as three semifinal and two final appearances in the NITs while never emerging with the crown. They would be the Buffalo Bills of their sport, if you will. Entering the 1954–55 campaign, they had lost several key components of a club that went 26-3 while being ranked number one by the Associated Press for the only time in school history, only to be upset in the NIT finals by Tommy Heinsohn and the Holy Cross Crusaders. Dick Ricketts and Sihugo Green were the only players of substance to return to the Bluff in 1954–55, and it appeared before the season began that their quest for a national championship might go unfulfilled.

Ricketts and Green would be joined by Dick's brother Dave, Jim Fallon, Mickey Winograd and Lou Severine, all solid players, but none in the class of the two superstars. Two players of a high magnitude can make more of a difference in the overall outcome of a game in basketball than in any other sport. In the case of Ricketts and Green, the difference would be huge. When they were healthy, the team was unbeatable, arguably the best in the nation; when one or the other was less than healthy, the drop-off was steep.

After winning their first two games of the year, the Dukes faced George Washington in the championship of the Steel Bowl Tournament at the

Fitzgerald Field House at Pitt. Green was out with appendicitis, and the Dukes suffered their first defeat of the season. They then played in the prestigious Holiday Festival at Madison Square Garden against some of the best competition college basketball had to offer in 1954. They comfortably beat Villanova and then nationally ranked Dayton before facing the defending national champions LaSalle Explorers in the final. They beat the Explorers, 67–65, with Green and Ricketts both leading the way with 23 points apiece. Winning the Holiday Festival was a tremendous accomplishment, one that brought with it a number-two ranking in the Associated Press poll. Unfortunately, Ricketts sprained his ankle in the contest. He played the next few games, but it was obvious that the ankle was bad. With the All-American not at his best, Duquesne dropped the next two games and stood at 7-3. Any championship aspirations now seemed gone.

Just when it seemed the campaign was over, Ricketts and Green began to show just how special they were. With both players healthy, Duquesne

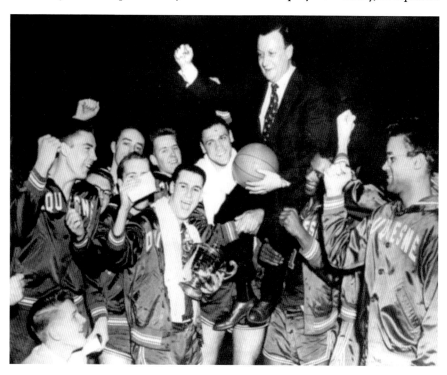

Coach Dudey Moore is carried off the floor after winning Duquesne's lone national championship. He was 191-70 in ten years at the school. *Duquesne University Athletics.*

went on an eleven-game winning streak and stood at 18-3 as they traveled to Dayton to play the second of back-to-back games against Cincinnati and the Flyers. After defeating the seventeenth-ranked Bearcats, 68–60, an exhausted Dukes team fell to the Flyers once again, the only time they would lose with both players healthy. Duquesne finished the season with a victory over St. Bonaventure and accepted a bid to play at Madison Square Garden in the NIT.

Losing in the finals the year before with a much deeper and presumably better team, Duquesne nonetheless went to New York as the number-one seed in the tournament. Unfortunately, right before the team went to New York, Green fell ill, and it was feared he had appendicitis again. Luckily, it was only a minor stomach ailment. The forward would be permitted to travel with the team.

Before they took the court in the quarterfinals against Louisville, it was announced that both Ricketts and Green were named as consensus All-Americans, the first duo to be so honored from one school at that point. After a close first half that saw Duquesne hold a 1-point lead, the Dukes pulled away for a 74–66 win. As they prepared for Cincinnati in the semifinals, Green complained of a toothache. While he played arguably his worst game of the season with only 14 points, the game was never in doubt. The Dukes won, 65–51.

If coach Dudey Moore was to win the school's first national championship, he would have to do so against the Dayton Flyers, the team that had defeated the Dukes twice in the regular season. In what had become almost a daily occurrence in the NIT, Green was suffering from another malady—this time, he had his foot stepped on. Unlike the toothache in the semifinals, this did not affect his play. Green and Ricketts had been dominant forces for Duquesne all season, and in this game, they would show one last time just how good they were. They scored all of the Dukes' points in a 35–30 first half and would produce 56 of 70 for the game. The injured Sihugo Green netted 33 in the 70–58 victory.

The pressure was finally off as Duquesne did what no other Pittsburgh Division I school has done before or since—win a national title in a tournament.

Embracing after defeating Cincinnati for the 1979 National League crown
are Dave Parker (*left*) and Willie Stargell. *Pittsburgh Pirates.*

4

THE ELITE SQUADS

TEAMS 20-11

20: The 1979 Pittsburgh Pirates

World Series Champions
Record: 98-64

When the Pittsburgh Pirates won their other four World Series, they did so with great players and great performances, and the memories for the fans who followed the Pirates were of those players and moments. In 1979, the Bucs had enough incredible comeback games and superb players, such as Willie Stargell, Dave Parker and John Candelaria, but this world championship had something the others didn't: flair and personality.

There were the nineteenth-century-style pillbox hats, the Stargell stars affixed to players' hats when a tremendous contribution was made, a combination of nine colorful uniforms the team wore and that Sister Sledge song, the one that made the Steel City celebrate and that irritated the rest of the baseball world, "We Are Family." The song turned this ballclub into what it continues to be known as today: the Fam-A-Lee.

In the first half of the 1970s, the Pirates were of championship quality, winning one World Series and five Eastern Division titles. They continued to play well as the decade was coming to an end, but the Philadelphia Phillies had become the kings of the east; the Bucs needed some retooling if they were going to ascend to the top again. They dealt Manny Sanguillen to Oakland

Pitcher Bert Blyleven gets doused with beer after winning the third game of the 1979 National League Championship Series. *Pittsburgh Pirates.*

for manager Chuck Tanner, and general manager Harding Peterson then emptied his fruitful farm system. He got Bert Blyleven and John Milner in a three-way trade late in 1977 and signed Jim Bibby to a free-agent contract two months later. Tim Foli came from the Mets for Frank Tavares in April 1979, and former batting champion Bill Madlock and unsung hero Dave Roberts came from the Giants midway through the 1979 campaign. With

all the new talent Peterson had secured, it would take the resurgence of an aging veteran to be his final piece.

Willie Stargell had been a superstar for the team until the mid-1970s, when injuries appeared to end his great career. He returned to play well in 1978, but at thirty-nine years of age, no one could have imagined he would have a season for the ages a year later. Stargell was a tremendous leader on and off the field. Called "Pops" by his teammates, Stargell hit 32 home runs and knocked in 87 runs in what turned out to be an MVP campaign. It was the season in which Stargell went from a borderline hall-of-fame candidate to a first-ballot one. He inspired his teammates to always believe that they could win, no matter the obstacle.

There was the walk-off, grand slam, pinch-hit home run by John Milner in the first game of a doubleheader to beat the Phillies, 12–8. There was the nineteen-inning affair in San Diego on August 25, in which Roberts got out of bases-loaded situations in the seventeenth and eighteenth innings (inspired when he looked back and saw opponent Dave Winfield giving him the choke sign). And then there were the two dominant wins against the Pirates' closest rivals, the Montreal Expos, late in September to help clinch the division for the first time since 1975. It had all been wonderful, but to get to the next level they would have to get by a team they had lost to in the National League Championship Series all three times they had played: the Cincinnati Reds.

Opening the series at Riverfront Stadium in Cincinnati, the Reds battled hard, including tying the game in the bottom of the ninth in game two. Both times, the games were close and went into extra innings, with Pittsburgh emerging victorious in each contest. In game one, Stargell continued his magical ride with a three-run homer in the top of the eleventh inning to win, 5–2. In game two, a single by Parker scored center fielder Omar Moreno, who led the National League in steals for the second consecutive season with 77, for a 3–2 victory and a two-games-to-none lead in the best-of-three-series. As the series switched to Three Rivers Stadium, there were no assurances that the Bucs could close it out against their rivals. They ended the Reds' dominance with authority, however, which is what a team with so much flair is supposed to do. Thanks to early home runs by Stargell and Madlock, the Bucs shot out to a 6–0 lead by the end of the fourth inning. The team held on to the six-run advantage in the 7–1 victory, vaulting them back to the Fall Classic against another familiar foe, the Baltimore Orioles.

They had come back from the brink of defeat in the 1971 series and would have to overcome a more challenging obstacle in 1979 if they were to

Kent Tekulve (*left*) and catcher Steve Nicosia embrace after winning the 1979 World Series. *Pittsburgh Pirates.*

complete this special campaign. After blowing a 6–3 lead against Baltimore in game four at Three Rivers, giving up six in the eighth to lose, 9–6, they found themselves down three games to one. Tanner, whose mother passed away before game five, decided to manage the contest, believing that's what she would have wanted. Surprisingly, he chose thirty-seven-year-old Jim Rooker to start in what amounted to an elimination game. Rooker was superb, although he exited the game down 1–0. Inspired by his performance, his teammates came back for seven runs in their last three innings for the 7–1 win.

Two nights later in Baltimore, Candelaria and Kent Tekulve combined to shut out the Orioles, 4–0, to send the series to an unexpected seventh and deciding game.

Once again, Baltimore led early, 1–0, but this was Stargell's season and series. He hit a two-run homer in the sixth to put the Bucs up, 2–1, and the team plated two more in the ninth for what would be a championship-clinching 4–1 victory. The city was ecstatic, as was Stargell, who took a clean sweep of the regular season, NLCS and World Series MVP awards. It was a fabulous championship season, one that only a team with such personality and flair could pull off.

19: THE 1979 PITTSBURGH STEELERS

Super Bowl XIV Champions
Record: 12-4-0

The year 1979 was a special time in the city of Pittsburgh. The Pirates had surprised the baseball world by coming from behind to win the World Series.

Pitt football was 11-1 and a top ten football program. Duquesne University was even enjoying a revival of its once-successful basketball team. The town was truly in the process of becoming the "City of Champions." If the three-time Super Bowl champion Pittsburgh Steelers could add a fourth title, it would end a truly magical year.

The Steelers had become a model franchise in the National Football League. After forty years of the team being mostly a laughingstock, Art Rooney and his son Dan hired the defensive coordinator from the Baltimore Colts following the 1968 campaign. It turned out to be the end of failed coaching hires, as Chuck Noll was the right man to turn around their fortunes—although it didn't seem that way after a 1-13 record in his first season. Noll eventually drafted his players and put in his system, and the results were extraordinary. By 1972, his team rebounded with an 11-3 season, qualifying for the postseason for the first time since 1947 while winning the franchise's first division championship. His offense seemed conservative, but according to the best coach in the NFL today, Bill Belichick, it was innovative. Belichick felt that Noll was "a very good fundamental coach, the trapping scheme they ran on offense was very innovative—coach [Tom] Landry had some of that in Dallas but not to the extent Pittsburgh had it."[27]

It was such innovation that led the Pittsburgh Steelers to their first two Super Bowl championships in 1974 and 1975. Injuries cost them a shot at a third straight title as running backs Rocky Bleier and Franco Harris were unable to play in the 1976 AFC Championship. A year later, they also fell short of reaching another Super Bowl, which prompted Noll to open up his innovative trap-oriented offense and let quarterback Terry Bradshaw loose. Once again, the Steelers were the kings of the National Football League, capturing that elusive third title. In 1979, they had a chance to do what no other team had done before or since: win back-to-back Super Bowls on two occasions.

The season began in a difficult manner as the Steelers found themselves down to the New England Patriots, 13−6, in the fourth quarter of a Monday night game in Foxboro. Pittsburgh running back Sidney Thornton caught a 21-yard TD pass to tie the game, and Matt Bahr nailed a 41-yard field goal to win it in overtime. While they continued to win, they weren't dominating games as they had before, with close victories over St. Louis and Baltimore before losing at Philadelphia, 17−14. They stood at 4-1 heading into a contest against their bitter rivals from Cleveland. Noll's classic trap offense was on display as Pittsburgh ripped through the Browns' defense to the tune of 361 yards rushing, led by Harris's 153 and Thornton's 98 while Bleier

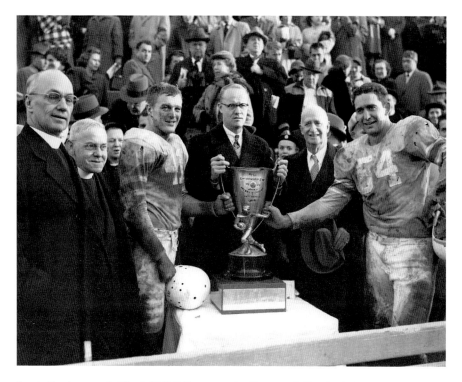

Iconic Steelers coach Chuck Noll (41) accepts the Governor's Trophy in his college football days after Dayton beat Xavier. *University of Dayton Athletics.*

rambled for 81 more, 70 on one play. They won the exciting game, 51–35, but it was the first signs that their once-impenetrable defense was starting to crack, allowing 365 yards in the air.

They went on to a 12-4 campaign and captured another Central Division crown, but they had allowed more than 30 points in three more games. They were still the odds-on favorite to win the conference championship, but it wouldn't be as easy as in years past. In the first round of the playoffs, the Steelers hosted the Miami Dolphins. They scored early and often, building a 20–0 first-quarter lead on the strength of two Bradshaw touchdown passes. Pittsburgh scored twice more in a one-sided 34–14 win. The victory put them in the AFC title game once again, to face perhaps the second-best team in the game, the Houston Oilers. On a frigid Steel City day, Pittsburgh would play a much closer contest than it had the year before when it beat Houston, 34–5.

The contest came down to a play that perhaps prompted the development of instant replay. The Oilers got off to a quick start when

defensive back Vernon Perry picked off a Bradshaw pass and returned it 75 yards to give Houston a 7–0 lead. The two teams exchanged field goals before the Steelers' future hall-of-fame quarterback hit tight end Bennie Cunningham and receiver John Stallworth to put Pittsburgh ahead, 17–10, at the half. The play in question occurred late in the third quarter as Oilers quarterback Dan Pastorini apparently found Mike Renfro deep in the end zone for the game-tying score as he took the ball away from Steeler Ron Johnson. Suddenly, referee Donald Orr ruled the receiver was out of bounds when he secured the ball, so the TD was waved off. While instant replay would have shown the catch to be a touchdown, it was not used in 1979. The Steelers went on to win, 27–13.

With the victory, the Steelers were one step closer to securing the city its claim as the "City of Champions." They would play the ten-and-a-half-point underdog Los Angeles Rams in Super Bowl XIV. The Rams finished only 9-7 in the regular season but played their best ball of the year in the postseason to capture the NFC crown. With Jack Ham and Mike Wagner injured, Rams quarterback Vince Ferragamo was having the game of his life as Los Angeles held a surprising 19–17 lead going into the fourth quarter. As a last hurrah of the Steelers' 1970s dynasty, Bradshaw found Stallworth on a remarkable 73-yard score. With Los Angeles once again driving late in the game, Jack Lambert picked off a pass deep in their own territory. After Bradshaw once again connected with Stallworth, this time for 45 yards, Harris capped off the scoring with a 1-yard touchdown burst to give the team the victory, 31–19, and its fourth title. The win secured the nickname for the city of Pittsburgh that it still holds proudly today.

18: THE 1927–28 UNIVERSITY OF PITTSBURGH PANTHERS

NCAA Basketball National Champions
Record: 21-0

While it's true that the 1955 Duquesne Dukes are the only Pittsburgh Division I college team to capture a national basketball men's championship by winning a tournament, it doesn't necessarily make them the best college basketball team ever to grace the Steel City. Their main challenger to that throne is the 1927–28 University of Pittsburgh Panthers, who not only beat

all twenty-one opponents put in front of them but also were one of the highest-scoring teams of the era, bringing an up-tempo style of play that had rarely been seen at that time.

To be specific, the Panthers averaged just 48 points per game during the season, but in the 1920s, it was an amazing output. The team was led by sophomore Charley Hyatt, who led the nation in scoring with 292 points, 12.7 per game. A twenty-year-old guard, Hyatt was arguably the best shooter in the nation during his three-year career at Pitt. The Uniontown native, who led his high school to the state championship in 1925, was a main catalyst for the lone undefeated season in school history. Panthers coach Doc Carlson once said of his All-American: "Naturally, I say Hyatt is the greatest basketball player I ever saw. He had the most deeply ingrained desire to play of anybody I ever met. Basketball was his whole life. Nothing else mattered. He would average 30 points a game today. I've never seen anybody who could compare to him."[28] Hyatt went on to become the only three-time All-American in school history, one of only eighteen players in NCAA history to be so honored. He also was the Helms Foundation Player of the Year in 1930 and was elected to the Naismith Memorial Basketball Hall of Fame in 1959.

Joining Hyatt to form the top-scoring duo in the country was Stanley Wrobleski, who finished second to his teammate in the country with 247 points. While not as prolific a scorer, Sykes Reed joined Hyatt as a first-team All-American on the Helms Foundation squad. Named as captain of the undefeated team, Sykes had also played with Wrobleski at Braddock High School in Pittsburgh. He had a quickness that kept opponents at bay, helping to fortify a Panther defense that allowed 32 points per game.

What made this group special is that they took on one of the toughest schedules in the nation and dominated opponents to the tune of a 15.7 scoring differential per game. They began the year on a four-game road trip, easily defeating Michigan, Chicago and Northwestern before traveling to Iowa City to take on the University of Iowa. Going up against the toughest team they'd play on the trip, Pitt utilized an aggressive offensive philosophy with short, crisp passes to score 9 points in the final four minutes, tying the score at 38 to send the contest into overtime. Hyatt and Wrobleski would score 16 apiece in the game, and the Panthers outscored the Hawkeyes 6–2 in overtime for the 44–40 victory.

When the team finally returned home to the Pitt Pavilion, a basketball arena located inside Pitt Stadium, they faced the defending Eastern Collegiate champion Dartmouth Big Green. Over five thousand fans jammed the

The only three-time All-American in Pitt basketball history, Charley Hyatt helped lead the Panthers to two national titles. *University of Pittsburgh Athletics.*

facility for the home opener. After a close start, the Panthers quickly pulled away. Led by Wrobleski and Reed, who netted eight field goals apiece, as well as Hyatt (six field goals) and Lester Cohen (five), Pitt led, 33–17, at the half and continued to dominant in a 64–33 victory. The win proved to the nation just how good they were.

After beating Ohio State, 50–32, and Syracuse, 45–24, Pitt rolled over seven more opponents. Other than a 42–36 win against Army in West Point, the closest game during the streak was a 48–37 victory at Colgate. Standing at 14-0, they hosted the Fighting Irish of Notre Dame in a game that saw them come the closest to defeat that they would this season. There was a tremendous atmosphere in the Pavilion. So many fans wanted to see the contest that more than one thousand people had to be turned away. Many students tried to rush the gate to get in. Turnovers and bad shooting limited the high-powered Panthers to only 8 points in the first twenty minutes as Notre Dame opened up a 7-point lead at the half, 15–8. The home team played better in the second half, tying the score at 22 with the clock winding down. As the gun was about to go off, Paul Zehfuss tossed a perfect pass underneath the basket to Hyatt, who tossed it in for the Panthers' first lead of the game as time expired in the thrilling 24–22 win.

The perfect record still intact, Pitt won four more times and went for its twentieth victory of the season at Washington & Jefferson. The Presidents played their best game of the season, keeping the game close in a hard-fought contest. Hyatt showed why he was such a special player, scoring 20 of the Panthers' 33 points in a slim 33–32 win. With only Penn State left on the schedule, Pitt needed one more win to secure the historic season. While the previous contest had been close, this one would be one-sided. After the Nittany Lions went in front, 4–0, Pitt, led by Sykes's game-high 13 points, scored 14 in a row and never looked back in the 45–28 rout.

The season was now done and the undefeated season secured. When the Helms Athletic Foundation was formed in 1936 and retroactively selected its national champions in basketball, the 1927–28 choice was an easy one: the undefeated University of Pittsburgh Panthers. Looking back eighty-nine years later, they still just may be the best basketball team this city ever produced.

17: THE 1938 HOMESTEAD GRAYS

Negro National League Champions
Record: 34-11

At a time when Major League Baseball was taking all the headlines, it was doing so with the knowledge that only white players were allowed to take the field. In the stadium where players from the Negro league took the diamond, they did so incognito; most of the country had no idea that perhaps the

best baseball was being played there. There were many great teams over the course of its history, but perhaps the most legendary franchise played in Pittsburgh, representing the area they call Homestead. The Homestead Grays is one of the first teams baseball fans think of when the subject of the Negro leagues comes up. In 1938, they were in the second season of what would be an impressive string of nine straight titles. It would also be the last season they would call Pittsburgh their lone home.

The team was led by two of the most dynamic hitters in the history not only of the Negro leagues but also of the game itself. Catcher Josh Gibson was a potent hitter, one of the great power hitters of all time. His home runs were majestic, according to those who saw them, and his power was legendary. According to hall of famer Cool Papa Bell: "He was a hitter, one of the greatest you ever saw. The most powerful. He never swung hard at a ball either. Just a short swing. Never swung all the way around. He hit them straight. Line drives but they kept going."[29] Some experts project that he probably hit more than nine hundred home runs over the course of his career, but with most of his games coming in barnstorming exhibitions as well as leagues in other countries, where record keeping was sloppy at best, it's tough to estimate just how accurate that number is. In 1938, he had seven home runs in thirty-two league games while hitting .366.

The other part of the duo that many dubbed the black Babe Ruth and Lou Gehrig, as well as the "Thunder Twins" and the "Dynamite Twins," was first baseman Buck Leonard. If Gibson was known for his power, Leonard was recognized for his incredible all-around game. Unlike Gibson, who played for several teams during his time in the league, Leonard was a Gray throughout his entire seventeen-year career. He hit .320 over the course of his seventeen seasons, with a .527 slugging percentage. When the color barrier was broken in 1947, Leonard said he was offered a contract in the majors, but at the age of forty-five, he knew he could not succeed, so he turned it down. According to the website Seamheads.com, which does a wonderful job compiling Negro league statistics, he was credited with batting .460 while knocking in 40 runs in thirty contests. It was a duo that made the Grays almost unbeatable in 1938.

While having two of the best players was enough for dominance, the Grays, like the Yankee dynasty of the same era, had a few other pieces that added to its championship mix. Player/manager Vic Harris was a left fielder who would log twenty-three seasons in a Grays uniform. He began to play with the club in 1925 and took over the reins of manager twelve years later, winning championships in each of his first nine seasons at the helm of the

legendary franchise. Harris was also a quality outfielder who hit .327 during the team's championship campaign. Center fielder Jerry Benjamin and right fielder Jim Williams completed the explosive outfield, hitting .304 and .288, respectively.

The team was famous for its offensive firepower, but it also had quite a hurler on the mound who had one of the great Negro league seasons in 1938. Ray Brown, elected to the National Baseball Hall of Fame in 2006, was undefeated this campaign. Since Negro league statistics are still evolving, he was either 10-0 (as listed at Seamheads.com) or 15-0 (as listed in the book by famed Negro league historian John Holway, *The Complete Book of Baseball's Negro Leagues*). Regardless of which source is more accurate, if there was a Cy Young Award at the time for the Negro leagues, Brown would have won it unanimously. Historian James Riley said of him: "So confident was Ray in all his pitches that he would throw a curve with a 3-0 count on the batter. He had good control of all his pitches."[30] In an article by the *Pittsburgh Courier* during this memorable campaign, the paper, among the best at covering the circuit, claimed Brown would have been one of five Negro league players who would have made the Major Leagues had they been allowed to at that point.[31] An undefeated Edsall Walker, who was 7-0 according to Seamheads.com, completed the impressive one-two punch off the mound for Homestead.

The team was first in the league in on-base plus slugging (OPS), batting average, on-base percentage (OBP), slugging, earned run average (ERA), batting average against and walks/hits per innings pitched (WHIP). It was easy to see why Homestead so dominated the league, beating the second-place Baltimore Elite Giants by nine and a half games in a season that consisted of barely forty games.

There were teams that came after this one, including Negro League World Series winners in 1943, 1944 and 1948 (there was no World Series played in 1938, although Homestead defeated the two best Negro American League teams during the season). Beginning in 1940, they began to split their games between Pittsburgh and Washington, D.C., so while they still qualify as Pittsburgh champions, they did so with the stigma of being a D.C. champion, too. The play in the league also began to deteriorate in the 1940s. The league first lost players to leagues in Latin American countries. And beginning in 1947, its best players went to Major League Baseball. All of these factors made the titles after 1940 not of the same quality as before. The 1938 squad would be the last of the great Homestead Gray teams as a pure western Pennsylvania champion.

16: THE 2008–09 PITTSBURGH PENGUINS

Stanley Cup Champions
Record: 45-28-9

After seventeen seasons of mostly inept play, the Pittsburgh Penguins drafted Mario Lemieux in 1984. He was the rock on which the first great era of the franchise was built. Winners of two Stanley Cups, the President's Trophy and a fixture in the playoffs for over a decade, the team fell victim to financial issues and had to be broken up. There was no guarantee that this would be a quick fix, and there was the potential for many years of losing. Coupled with the prospects of the franchise being moved, thoughts of Stanley Cups past were far from the minds of Pens fans and players.

As potential bankruptcy proceedings with the team were beginning, an odd thing happened: Lemieux, who had been one of the team's biggest creditors, used the money he was owed, along with the investment of billionaire Ron Burkle, to buy the Pens. Stability was temporary, and a new arena would be needed to ensure that the Penguins would stay in town. That was something for the future. Right now, the focus was on trying to rebuild the franchise as quickly as possible.

The team started rebuilding in 2000, taking defenseman Brooks Orpik in the first round and Colby Armstrong a year later. With Jaromir Jagr now gone, the losses would increase and successful draft picks would become even more essential. Ryan Whitney was chosen with the fifth pick in 2002. After a trade with the Florida Panthers that gave them the first overall choice in 2003, the Penguins selected the first of three consecutive choices that would be the cornerstones of the franchise, Marc-André Fleury.

Evgeni Malkin came next. After solving a transfer dispute with the team he played for in Russia, Metallurg, he became a Penguin 2006. There was still one more piece missing, the man who would play the role of Mario Lemieux in the new Penguins championship era. Through the luck of gaining the first pick in the draft following the 2004–05 lockout, they got that piece in Sidney Crosby.

After selecting Jordan Staal a year later, the team was ready to win. With a stable owner, financing for a new arena secured and a collection of the best young talent in the game, the losing came to an end after four short seasons. Qualifying for the postseason in 2006–07 (the first time since 2001), Pittsburgh turned the corner a year later, winning its third conference title before losing to the Detroit Red Wings in six hard-fought games in the

Defenseman Rob Scuderi helped the Penguins win the cup in 2009, making a clutch stop in the crease to preserve a 2–1 game-six win. *Boston College Athletics*.

Stanley Cup finals. They may not have had the hall-of-fame talent that the championship squads of the early 1990s did, but this was a young, exciting team. There seemed to be no limit to what they could accomplish, although it seemed early on in the 2008–09 campaign that the limit would be of their own making.

Starting the season by splitting two games with the Ottawa Senators in Stockholm, Sweden, the Penguins got off to a fast start and stood at 12-4-3 on November 20. It was at that point that coach Michel Therrien's tough style began to wear thin on the players. The team struggled and stood at only 27-25-5 after a disturbing 6–2 loss at the hands of the Toronto Maple Leafs. Changes needed to be made if the potential of this young group was to come to fruition.

Penguin general manager Ray Shero fired Therrien, replacing him with their coach at the minor league affiliate in Wilkes-Barre/Scranton, Dan Bylsma. Shero also dealt Whitney to the Anaheim Ducks for Chris Kunitz and picked up veteran winger Bill Guerin from the New York Islanders. Bylsma gave them a more positive attitude, Kunitz more offensive firepower and Guerin the stability the team lacked. The new pieces, coupled with the outstanding young core, jelled perfectly. The team went 18-3-4 under its new coach and finished the regular season playing its best hockey of the campaign.

Defenseman Ben Lovejoy was a pivotal member of both the 2009 and 2016 Stanley Cup championship teams. *Dartmouth College Athletics.*

Their cornerstones were magnificent, as Malkin led the league in assists (78) and scoring (113 points) while Crosby finished third with 103 points. They finished second in the Atlantic Division with 99 points and faced their cross-state rivals in Philadelphia for a first-round matchup. In this round, the cornerstones were not the heroes.

Pittsburgh shot out to a quick three-games-to-one lead before the Flyers won game five, 3–0. In game six, Philadelphia bolted out to a 3–0 advantage early in the second period when the hero emerged. It wasn't a goal or a great pass that changed the momentum. A smallish Max Talbot challenged the much bigger Daniel Carcillo to a fight. Talbot was easily defeated, but when he got up off the ice, he put his finger to his mouth to quiet the boisterous crowd. The Penguins were inspired and scored the game's last five goals to move on to the second round against the Capitals in a matchup of the game's two biggest stars, Crosby and Alex Ovechkin.

Dropping the first two games in Washington, Pittsburgh battled back to win the series before sweeping the Carolina Hurricanes to capture its second consecutive Eastern Conference crown and a return matchup against the Red Wings. They lost the first two games once again and, after a 5–0 defeat in game five, stood one contest away from elimination. Unlike the year before, the Penguins won the sixth game to send the finals to a seventh and deciding contest at Joe Louis Arena in Detroit. Talbot came to the forefront once again, scoring both goals as Pittsburgh held a 2–0 lead going into the third. Crosby was injured in the second period and played only one shift in the third. The Penguins' defense held tough, allowing only one goal, and Fleury made the save of his career against Niklas Lidstrom with 1.5 seconds left to secure the 2–1 win, giving Pittsburgh the Stanley Cup to highlight its second championship era.

15: THE 1980 UNIVERSITY OF PITTSBURGH PANTHERS

NCAA Football National Champions
Record: 11-1-0

Until 1998, when the NCAA decided to use both polls and computer rankings to determine which two Division I college football teams would face each other for the national championship, the title was awarded to a team based on the opinion of the coaches in the United Press International poll or the

press in the Associated Press. Had the 1980 University of Pittsburgh football team played eighteen years later, its computer ranking would have secured it a spot in the national championship tilt. Unfortunately, the Panthers didn't, so the team that some have called the greatest ever to play at Pitt continues to not be recognized as a national champion by the school.

When the *Sporting News* wrote its book on the twenty-five greatest college football teams of all time, it had the 1980 team ranked twelfth, five spots ahead of the 1976 Panther squad. The statistical analysis website Football Outsiders used its analysis to produce the top 100 college football teams of all time. The 1980 club was the highest-ranked Pitt team, at number 59, higher than the 1937 team (67) and 1976 (not rated).

There are factors that favor the 1937 and 1976 teams, namely, that they did not lose and were considered consensus national champions. But what the 1980 Pitt Panthers accomplished, and the incredible talent they possessed, certainly qualify them to be mentioned with the best western Pennsylvania teams of all time, even if the university doesn't officially recognize their accomplishments.

After the school won the title in 1976, the fruits of the championship bore one of the greatest recruiting classes in the history of the sport. Two future members of the Pro Football Hall of Fame, Ricky Jackson and Russ Grimm, were part of it, as were two others who were elected to the College Football Hall of Fame, Hugh Green and center Mark May. Green is arguably the best player ever to don a Panther uniform. A three-time All-American who won the Lombardi, Maxwell and Walter Camp awards in 1980, he was the first defender to capture the latter. He was named to the all-time Pitt team when he was a sophomore and finished second in the Heisman Trophy voting, the highest finish for a pure defender at the time.

If that was all they had, this would have been a tremendous class. But there was more. The list of NFL players in this recruiting class is long. Along with the four players mentioned above, there was Jerry Boyarsky, Greg Meisner, Bill Neill, Benjy Pryor, Lynn Thomas, Rick Trocano, Dave Trout and Carlton Williamson. Despite all this incredible talent, it was perhaps a running back by the name of Ray "Rooster" Jones who was the MVP of the class. Considered a can't-miss prospect, Jones unfortunately missed. But it was while Pitt was looking at Jones that they noticed Green, who was playing against him. Without recruiting Jones, they may have never secured Green.

Unfortunately for Pitt's opponents, the rest of the roster was just as dangerous. It begins with one of the legendary quarterbacks in both college and pro football history, Dan Marino. Marino, a sophomore, combined

Left: Hometown product Dan Marino lived up to his potential at Pitt, becoming one of college football's greatest quarterbacks. *University of Pittsburgh Athletics*.

Right: Center Mark May won the Outland Trophy in 1980 while playing for the University of Pittsburgh. *University of Pittsburgh Athletics*.

with Trocano to throw for over three thousand yards. Bruising running back Randy McMillan, who was the first-round pick of the Colts, led a rushing crew that included Bryan Thomas, who went on to be a star in the USFL. Speedy receiver Dwight Collins snagged 30 passes for a spectacular average of 27.6 yards per catch to go with Willie Collier, who caught a team-high 37 passes. As good as the skill positions were, the offensive line is among the best to have played at the college level. It included Emil Boures, who spent four years with the Steelers; Rob Fada, a three-year NFL veteran; Grimm; May; and Jimbo Covert, a member of the famed 1984 Bears who was elected to the College Football Hall of Fame. Even more impressive than the seven players elected to the Pro Football or College Hall of Fames was the fact that of the ten players who have had their numbers retired by Pitt, four of them—Marino, Covert, May and Green—are part of this team.

Ranked third at the start of the season, the Panthers turned the ball over sixteen times in unimpressive wins against Boston College and Kansas before easy wins versus Temple and Maryland. They had dropped a spot to fourth in the polls when they traveled to Tallahassee to face the upstart eleventh-

ranked Florida State Seminoles. The Panthers were favorites and took the lead early with a 39-yard pass from Marino to Collins. It was at that point that they turned the ball over seven times and lost, 36–22, despite outgaining the Seminoles 386–280. They thought their national championship hopes were over.

Angered by the unexpected loss, the Panthers went on to rout the rest of their opponents except seventh-ranked Penn State, whom they beat, 14–9. Pitt accepted a bid to face eighteenth-ranked South Carolina and its Heisman Trophy winner George Rogers in the Gator Bowl. They needed a few teams to lose to have a chance at the official championship. After Pitt soundly beat the Gamecocks, 37–9, number-one Georgia defeated Notre Dame, which left Pitt second in the polls.

While the voters denied Pitt's claim for a championship, almost all of the computer selectors felt the Panthers were the best. If this had been in the BCS era, Pitt would have played Georgia for the title and would have been favored in the game. As it was, the Panthers had to settle for being champions of the computer polls. Despite the fact they had no trophy to raise, they are on the short list of teams that can claim to be the best in school history. If not for an error-filled evening in Tallahassee, there probably would have been no doubt.

14: THE 1974 PITTSBURGH STEELERS

Super Bowl IX Champions
Record: 10-3-1

They say the first is the most memorable. When it comes to a franchise that had been a laughingstock for the better part of its history to this point, this is especially true. For the Pittsburgh Steelers, 1974 is that first occurrence. To say it was a foregone conclusion that they would win the championship is foolhardy. Many obstacles had to be overcome to reach such lofty heights. In the end, the "Steel Curtain" defense became impenetrable as the season went on, leading them to this unexpected moment.

In 1974, the NFL was having its first labor stoppage, but luckily for the Steelers, rookies were not required to be on the picket line. The team had a draft for the ages. In the first five rounds, it selected four players—Lynn Swann, Jack Lambert, John Stallworth and Mike Webster—who would

Statue of beloved Pittsburgh Steelers founder and owner Art Rooney stands outside of Heinz Field. *Author's collection.*

find themselves elected to the hall of fame. No other draft in the history of the National Football League has ever come close to producing such a harvest. All four would have an opportunity to impress Steeler coaches before the veterans crossed the line, as would a quarterback by the name of Joe Gilliam.

An eleventh-round pick out of Tennessee State in 1972, "Jefferson Street" Joe, as he was called, crossed the line early to try to get an edge over starter Terry Bradshaw and his backup, Terry Hanratty. Gilliam's strong arm gave coach Chuck Noll the possibility of a wide-open passing attack to go along with his successful ball-control offense. After the other two quarterbacks crossed the line, Bradshaw was hurt late in preseason, making Noll's choice of a starting QB easier for the season opener against the Baltimore Colts at home.

Until this contest, no African American had ever been named a starting quarterback for a season opener in NFL history. The first one would put on a memorable show. After a Roy Gerela first-quarter field goal, Gilliam launched a perfect 54-yard bomb to Swann early in the second and threw

for 289 yards with two touchdowns in the 30–0 win. The next week, he improved, completing 31 of 50 attempts for 348 yards and a touchdown. Unfortunately, the Denver offense matched Pittsburgh point-for-point, scoring late in a 35–35 tie. It was the apex of Gilliam's career. He was inept in a 17–0 shutout loss against Oakland and was not much better the next week despite the fact they beat the Oilers. He threw for 202 years and two interceptions. Even though Pittsburgh kept winning, standing 4-1-1 after a 20–16 win against the Browns (Gilliam was 5 for 18 for 78 yards), Noll decided to end the Gilliam era and inserted Bradshaw as the starter in a week-seven matchup against Atlanta. Pittsburgh won, but it was on the legs of third-year star Franco Harris, who ran for 141 yards, rather than on Bradshaw's arm.

They shut out the Eagles the next week to stretch their winning streak to five before losing to Cincinnati, 17–10. Noll opted to hand the starting reins over to Hanratty against the Browns. Again, despite a victory, the play at quarterback was less than stellar, with the Notre Dame alum going a poor 2 for 15. A win against the Saints was followed with a 13–10 loss in the rematch with Houston. At 8-3-1, Pittsburgh's best player on defense, "Mean" Joe Greene, was frustrated with the team's effort and stormed out of the locker room, intending to quit.

Greene explained his actions. "I wanted us to be further along than I thought we were. At some point in time over that season, I became very frustrated, really right at the end of the season, after that Houston game."[32] Receivers coach Lionel Taylor calmed him down, and the team won its last two games, beating New England, 21–17, and finishing the year with a dominant 27–3 win over the Bengals to end the season 10-3-1. Running back Rocky Bleier remembered: "Joe obviously thought the New England game was what turned it, because that was the game after he got talked into coming back. He felt it started to finally click for us when we won that game, and then beat Cincinnati at home (27–3) the next week."[33]

If Greene questioned his team's ability, his questions were answered quickly as the team entered the postseason. They began the playoffs hosting Buffalo at home, and two things emerged that carried them through the playoffs: a stifling defense and an effective ground game, with Bradshaw making plays when he had to. Their balanced attack in the 32–14 win over the Bills saw them throw for 203 yards and rush for 235 while holding the great O.J. Simpson to 49 yards on 15 carries. Their reward was a trip to Oakland for the AFC championship and a chance at redemption after a 33–14 loss in the 1973 playoffs and the shutout loss earlier in the season.

The first African American quarterback to begin the season as a starter in the NFL was the Steelers' Joe Gilliam in 1974. *Tennessee State University Athletics.*

In the close game, the Raiders were leading, 10–3, after three quarters. The fourth quarter would exorcise the demons of forty-one frustrating years. Holding Oakland to 29 yards rushing, Pittsburgh outscored the Raiders, 21–3, in the final quarter to win its first conference title and a first trip to the NFL championship. Facing the Minnesota Vikings, Pittsburgh led, 2–0, at the half in Super Bowl IX before opening it up a bit in the second half. Harris, the game's MVP, rambled for a Super Bowl record 158 yards, and the defense was at its best, allowing only 17 yards on the ground. Minnesota's only score came off a blocked punt in a 16–6 victory. It was the beginning of a dynasty and a chance for the team to finally hand its beloved owner, Art Rooney, the thing he had wanted for so long: an NFL championship trophy.

13: THE 1971 PITTSBURGH PIRATES

World Series Champions
Record: 97-65

As the saying goes, "Things get better with age." Perhaps it's a saying more suited for wine than baseball players, but in 1971, as the baseball world

marveled at the excellence of thirty-seven-year-old Roberto Clemente in the World Series, it was a saying that was most appropriate.

For fans of the Pirates, they had seen this act for fifteen seasons. One of the greatest defensive right fielders in the history of the game, Clemente had been a model of consistency since his breakout season in 1960, capturing ten gold gloves (going into 1971), four batting titles and the 1966 Most Valuable Player award. While he should have been revered for most of his career, in an era when both his Latin heritage and his skin color caused racist attitudes, he unfortunately was not appreciated. Sports reporters quoted him phonetically in a mocking manner while some teammates disrespected him and thought him to be a hypochondriac because he wouldn't play at times when suffering from various maladies that plagued him throughout his career. It was only when the Pirates front office started signing more African Americans and players of Latin descent that the right fielder went from an outcast to a beloved team leader.

After a ten-year hiatus from the postseason, Clemente led the Pirates to the National League Championship Series in 1970 after winning its first Eastern Division crown. They were swept by the Reds, but it proved to be a stepping-stone. The 1971 Bucs were a diverse group, uncommon for the time in sports, but the Pirates jelled perfectly. Danny Murtaugh, the manager of this crew, handled them deftly as he had throughout his career, including in 1960, when he helped them to their memorable World Series title.

Pittsburgh started out with a less-than-stellar 11-10 record before winning eight of nine games. They played well but were unable to ascend to the top of the Eastern Division standings until a 3–1 victory over the Cardinals on June 10 put them in first, a spot they retained for the rest of the season.

Holding an eleven-game lead by July 24, the Bucs began to struggle, going 6-16 as their insurmountable lead dwindled to 3½ games. The Pirates eventually rebounded and, by August 31, were 81-56, although their lead was only 4½ games. The next day became perhaps not only the most memorable of the season but also one of the greatest in their history. It was a Wednesday evening, September 1, a day when an important racial barrier was broken.

The Philadelphia Phillies were visiting Three Rivers Stadium. When Murtaugh filled out his lineup card, it contained, for the first time in Major League Baseball history, nine players of color. Rennie Stennett, Gene Clines, Roberto Clemente, Willie Stargell, Manny Sanguillen, Dave Cash, Al Oliver, Jackie Hernandez and Dock Ellis took the field, and unlike when Jackie Robinson broke his barrier in 1947, nobody seemed

The most celebrated athlete in Pittsburgh history, Roberto Clemente led the Bucs to the world championship in 1971 before dying tragically a year later. *Pittsburgh Pirates.*

to notice. Murtaugh most likely didn't notice himself that he was creating history. The next day, it was tough to find a mention of the historic event. Murtaugh claimed: "When it comes to making out the lineup, I'm color blind and my athletes know it. They don't know it because I told them, but they know it because they are familiar with the way I operate."[34] Pittsburgh came back to defeat the Phillies, 10–7, in front of 11,278 fans, few if any understanding what they were witness to.

It was the beginning of a great final month in which the Bucs restored their comfortable lead, winning the East by seven games over St. Louis. They would face the San Francisco Giants in the NLCS, doing so with one of the most potent lineups in baseball. Sanguillen hit .319, while first baseman Bob Robertson smacked 26 home runs. One of the great young hitters in the game, Al Oliver, drove in 64 runs with a .282 average. Dave Cash and Rennie Stennett split time at second base, hitting .289 and .353, respectively. As good as they all were, the two most potent bats belonged to Clemente and slugger Willie Stargell. Clemente knocked in 86 runs with a .341 average,

Perhaps the greatest slugger in team history, Willie Stargell hit a Pirates' record 475 home runs. *Pittsburgh Pirates.*

and Stargell led the league in homers (48) and had a team-high 125 RBIs. It was their leadership off the field that was most appreciated by the club. Oliver explained, "Robby [Clemente] led by example. On and off the field, he exemplified how a player should be and carry himself. He hustled on the field and was a great example for the young players we had on that team.

Will [Stargell] was more hands-on than Roberto, they had a different way. Stargell was more of a leader off the field. If we had a losing streak, he knew when and how to have a team party. He was a socialite, and that helped our team to stay together, including our wives and children."[35]

They won the NLCS in four games after losing the first contest. The highlights were a three-home-run performance by Robertson in game two and a three-run homer by Oliver in the final game that brought the Bucs back from a 5–2 deficit in a 9–5 victory. The win sent them to their first Fall Classic since 1960 to face the heavily favored defending world champions, the Baltimore Orioles. Despite dropping the first two games in Baltimore, the Pirates fought their way back, sweeping the next three contests that included a come-from-behind 4–3 win in game four (the first night game in World Series history) and a two-hit shutout in game five by Nellie Briles. Pittsburgh lost the sixth contest in ten innings, but with Steve Blass on the mound in game seven, Pittsburgh came through with a hard-fought 2–1 win, capturing the championship. Blass took time during the game to appreciate his surroundings. "I took a moment in the bottom of the seventh after I warmed up and before the first pitch. I took the baseball and went to the back of the mound to take in the whole scene. You don't know if you'll ever get back again, and I wanted to soak in the mental image, then we went back to work."[36] It was an image that could be savored by all, including the thirty-seven-year-old right fielder whose World Series MVP performance took the Pirates to heights they hadn't seen in eleven years.

12: THE 1937 UNIVERSITY OF PITTSBURGH PANTHERS

NCAA Football National Champions
Record: 9-0-1

By the end of the 1937 campaign, the University of Pittsburgh had achieved more than any other team the school had ever produced, especially in the fourteen-year career of their iconic coach, Jock Sutherland. They finished the season undefeated, a scoreless tie against Fordham the only blemish on their otherwise perfect record. While four other Sutherland teams were recognized as national champions, they were all done retroactively. In 1937, the Panthers were hailed as the best in the nation by the most prestigious selector of all, the Associated Press. It was a young team that most experts

thought would continue to win more titles. Unfortunately, there were underlying factors at play, namely a team that was still frustrated at the lack of stipends they felt they deserved in the 1937 Rose Bowl and an administration that seemed embarrassed at criticism being lobbied by other institutions—that they were unethical in providing excessive funds for their football team. What should have been the greatest moment in Pitt history was shrouded in controversy and would prove to be the end for both Sutherland's tenure at the school and the dynasty he created.

To say this was an immensely talented team would be an understatement. Pitt had four players who achieved first-team All-American status in Marshall Goldberg, Tony Matisi, Frank Souchak and Bill Daddio. Goldberg was third in the Heisman Trophy balloting, and Sutherland had at his disposal what is considered the greatest backfield in school history if not in the sport itself. Goldberg, Dick Cassiano, Curly Stebbins and John Chickerneo would eventually form a crew that in 1938 was aptly named the "Dream Backfield." But in 1937, the first three formed a deep backfield along with Frank Patrick, John Urban and Bill Stapulis. Goldberg led the high-powered attack called the "Sutherland Scythe," which was Sutherland's version of the double-wing. The All-American had a team-high 701 yards rushing with a 6.1 yards per carry average. Cassiano, a sophomore playing his first varsity campaign, may have been even better, rambling for 620 yards with a team-high 9.0 average.

The Panthers ripped through their first three opponents without allowing a score, including a 6–0 victory over crosstown rival Duquesne, gaining revenge for the defeat in 1936 that cost Pitt an undefeated season. Game four was to be at the Polo Grounds in New York, where Sutherland's boys faced the Fordham Rams, who finished the season third in the Associated Press poll. It had been a very strange series, as not a point was scored in the previous two seasons. In this one, it seemed like that streak was about to break late in the second quarter when Goldberg sprinted around the left end to give Pitt a 6–0 advantage. Unfortunately, it was brought back after a holding call against the Panthers, negating what would be the last scoring opportunity of the day in a game that once again ended 0–0.

After the historic scoreless affair, Pitt did not lose the rest of the way, despite playing one of the most difficult schedules in the country. They recorded their fifth consecutive shutout over the sixteenth-ranked Wisconsin Badgers, 21–0, and then got by Carnegie Tech, 25–14. Three of their last four opponents finished the season ranked in the final AP poll. Notre Dame

Two of the greatest figures in Pitt football history: Jock Sutherland (*left*) speaks with
Marshall Goldberg (*right*) in the locker room. *University of Pittsburgh Athletics.*

(9) temporarily ended the series against Pitt, feeling that the Panthers were
semiprofessionals with what the school was giving its players in stipends. Pitt
got the last laugh this day with a 21–6 win. They then beat Nebraska (11),
13–7, before a 28–7 drubbing over unranked Penn State and a 10–0 shutout
against Duke (20) to finish their undefeated campaign.

It was a tremendous season that saw Pitt ranked thirteenth in the nation
in points per game (20.3) and tenth defensively, allowing 3.4 points against.
All the experts hailed the Panthers as the national champions. With the
accolades, a bowl bid was expected, and three were received: the Rose,
Cotton and Sugar Bowls. It was thought that Pitt once again would travel
to Pasadena to play in the Rose Bowl. It was at that point that the dynasty
began to crumble. The players voted to not accept the bid. They were
upset that athletic director Jimmy Hagan did not include Sutherland in the
vote and disapproved of the way they were treated by the university the
year before. In the bowl game, the Washington players reportedly received
$100 each for expenses. As far as Pitt, Goldberg stated: "We got nothing,
except a sweater and a pair of pants. When we showed up for a reception

with them, imagine how we felt. Jock sold some bonds he had and the other coaches threw some money into a pool. They gave us each $2, all they had. Then the bowl people took us out to the Santa Anita race track for an outing, big deal."[37]

As far as the administration was concerned, Chancellor John Bowman was frustrated at the accusations being made at the school pertaining to the players being semiprofessionals. Notre Dame and the Big Ten schools were threatening to end their relationship with the university, so the chancellor, along with Hagan, was intent on cutting subsidies and forcing the players to work. Sutherland would accept the new philosophy if they would drop to a non-major status, claiming they couldn't compete under those terms as a major program. Bowman and Hagan disagreed. After an 8-2 season in 1938, Sutherland was gone, as were the championship days for the program. It was the season that was supposed to be a celebration of the glory of Pitt football. Instead, it was a sad ending to what had been a tremendous run.

11: The 1990–91 Pittsburgh Penguins

Stanley Cup Champions
Record: 41-33-6

For Pittsburgh Penguin fans who had suffered with the team in the years since its inception in 1967, the moment was unimaginable. Bankruptcy cases, fear of franchise moves, painful defeats, last-place finishes—this is what Pen fans endured almost yearly. Hoisting Lord Stanley's cup—that's what they did in New York, Edmonton and Montreal, not in Pittsburgh. They hoped things would change when the team drafted Mario Lemieux, but in the first six seasons he played, they made the postseason only once, blowing a three-games-to-two lead against the hated Flyers. It seemed hopeless going into the 1990–91 campaign, but something was different. There was a trio in the front office that had an incredible résumé. Craig Patrick was the general manager, the man who had been an assistant coach on the famed 1980 USA gold-medal hockey team. Scotty Bowman, who had captured five Stanley Cups as coach of the Montreal Canadiens, was the director of player personnel. Finally, there was a new coach, a man with an optimism that was so infectious it would permeate the desolation

that was Penguins hockey. His name was "Badger" Bob Johnson. These three men would have an effect that changed the outlook for this franchise, getting the solid core of good young players to understand that there was a possibility for championships. In the next nine months, they would transform the Pittsburgh Penguins to winners and give the long-suffering fans a reason to believe. Within nine months, the empty ceiling of the Civic Arena would be barren no more.

After a disappointing 32-40-8 season in 1989–90, one in which Lemieux missed the end of the season with a herniated disc in his back, the team would find that missing the playoffs turned out to be a blessing. Because of it, they were high enough in the draft to select a young future star by the name of Jaromir Jagr. He helped turn their fortunes around over the next decade. Even with a new future superstar on the roster, things still looked grim for Pittsburgh as Lemieux's back didn't heal in the offseason, requiring surgery and forcing him to miss the first fifty games of the new campaign. It was also another blessing in disguise, as the young club learned how to play and even succeed without their legend, which made them stronger when he returned.

After a slow 12-16-3 start, the team began to jell and, at the fifty-game mark, stood at a surprising 26-21-3. Lemieux returned on January 26 in a 6–5 win over the Quebec Nordiques and looked incredible, adding three assists in the victory. When the future hall of famer returned, he found that the team had developed some stars to go with him. A twenty-two-year-old right-winger by the name of Mark Recchi would score 40 goals with a team-high 113 points, and center John Cullen also came to the forefront, chipping in 31 goals and 94 points. Jagr played like a veteran, while left-winger Kevin Stevens contributed 40 goals. Fellow future hall of famer Paul Coffey was having a typical Coffey season, adding 93 points.

Despite all the firepower, the Penguins stumbled with a 4-9-1 streak that saw them drop to 32-30-4. Patrick needed to make some moves to get the club back on track. To get talent, you need to part with talent. Cullen and rising defensive star Zarley Zalapski were gone; in came the makings of a Stanley Cup winner. Veterans Ron Francis, Ulf Samuelsson and Grant Jennings came to Pittsburgh. Patrick also got future hall-of-fame defenseman Larry Murphy from Minnesota. It was now time for Penguin fans to start imagining the possibilities.

The team ended the season on a 9-3-2 run that saw them battle back to capture the first division title in franchise history after a 7–4 win over the Red Wings—banner number one was soon to be hung. Still, they struggled in the first round of the playoffs and found themselves down three games to

two to the Devils as they traveled to New Jersey for game six. Goaltender Frank Pietrangelo, who was subbing for an injured Tom Barrasso, made the save of a lifetime off the Devils' Peter Stasny to secure a 4–3 victory. They went on to win game seven, advancing to the division finals against Washington, where they won four straight after a game-one loss to advance to their first conference finals since the 1969–70 campaign.

They dropped the first two contests in the Boston Garden before showing Pens fans that things were now different. The Penguins swept the final four games, the last after a spectacular third-period goal by Recchi that led them to a 5–3 win, sending the Civic Arena fans into hysteria. The Wales Conference championship was now theirs—banner number two was a reality.

Winger Joe Mullen gave up a chance to play on the 1980 Olympic team to pursue a professional career. *Boston College Athletics.*

Pittsburgh entered its first Stanley Cup finals against the Minnesota North Stars, who had been twelve games under .500 in the regular season before catching fire in the playoffs. The North Stars continued their inspired play in the first three games, winning two and seizing home-ice advantage. Some of the Minnesota players and media members were discussing how they would be going to the White House after they won and planning the parade. It seemed just enough to wake up the Pens. After exciting 5–3 and 6–4 victories, the stars seemed to align in game six at the Met Center in Minnesota. The Pens scored early and often, allowing fans to fully cherish the moment they were about to experience as the game came to an end with a dominant 8–0 victory.

Banner three was now a certainty as the players paraded around the ice with the famous trophy. The moment was almost surreal; one that no one could have imagined nine months earlier finally was a reality. While the Pens' fortunes have permanently changed, with five cups in the last twenty-five years, that first moment will always be the one most in the minds of Steel City hockey fans.

Pittsburgh fans were excited when the Pirates hosted the 1909 World Series at Forbes Field. Spectators climb a pole to see the action. *Library of Congress, Prints and Photographs Division, LC-USZ62-103768.*

5

THE LEGENDARY ONES

THE TOP 10 TEAMS

10: The 2008 Pittsburgh Steelers

Super Bowl XLIII Champions
Record: 12-4-0

When the Pittsburgh Steelers won their first Super Bowl in 1974, it was appropriate that the first points a Steeler team scored in an NFL championship tilt was by the defense. Dwight White tackled Vikings quarterback Fran Tarkenton in the end zone for a 2–0 first-half lead. The defense was the rock that the first Steeler dynasty was built upon. In the championship era that has stretched from Bill Cowher to Mike Tomlin, the defense continues to lead the way. When Pittsburgh won its record sixth Super Bowl in 2008, it was led by a defense that would have made the original Steel Curtain proud. Names like Aaron Smith, Brett Keisel, Casey Hampton, James Farrior, Ryan Clark, Deshea Townsend, LaMarr Woodley, Larry Foote, Ike Taylor and Bryant McFadden made this defense good. Linebacker James Harrison, safety extraordinaire Troy Polamalu and legendary defensive coordinator Dick LeBeau took it to the next level as one of the greatest outfits ever to wear a Steeler uniform.

They led the circuit in both yards allowed and points allowed, a rare feat they share with such legends of the gridiron as the 1985 Bears and the 1976 Steelers. It was pivotal for the success of the team, as quarterback

Ben Roethlisberger was dealing with a questionable offensive line and a rushing attack that was without its star, Willie Parker, who missed five contests after injuring his knee against the Cleveland Browns in week two.

The Steelers had built their offense around Roethlisberger, their first-round pick in the 2004 draft, and many questioned the strategy of surrounding him with a less-than-stellar cast of offensive linemen. In the salary-cap era, some units must suffer in order for the team to sign and keep intact its perceived strength. In Pittsburgh's case, the offensive line seemed to be the unit at risk in order to keep their potent defense in place.

Marvel Smith and Kendal Simmons were effective offensive linemen, but both ended their seasons early with back surgery and a torn Achilles tendon, respectively. Their replacements, Max Starks and Darnell Stapleton, were not at their level. Tackle Willie Colon and guard Chris Kemoeatu, who replaced the departed Alan Faneca, were solid if unspectacular. In a franchise that has had the likes of Ray Mansfield, Mike Webster, Dermontti Dawson and Maurkice Pouncey at center, Justin Hartwig started for this crew; needless to say, he wasn't as memorable as the other four.

With an impressive defense and a questionable offense, Pittsburgh set out to take on one of the toughest schedules in league history. In fact, at the time, of all the Super Bowl champions, the 2008 Steelers played the second-most difficult schedule, taking on opponents who had a total .520 winning percentage, including six clubs that made the postseason. Only the 1979 Steelers played a tougher schedule.

Losing once, to Philadelphia, in its first five games, Pittsburgh lost two of the next three contests, both at Heinz Field, and stood at 6-3 heading into a very difficult stretch that included the Chargers, Patriots, Titans and Cowboys, as well as their division foes in Baltimore and Cincinnati. Only the season finale versus the Browns was considered an easy outing. They began with a strange affair, against San Diego, falling behind, 7–0, on a LaDainian Tomlinson run midway in the first quarter. Despite dominating the contest statistically, it took a Jeff Reed 32-yard field goal with 11 seconds left for the Steelers to secure an 11–10 victory. They then proceeded to roll over the Bengals and a Tom Brady–less New England club before facing the Cowboys on a cold December day in Pittsburgh. Down 13–3 midway through the fourth quarter, the Steelers scored the game's final 17 points, including two touchdowns in the final 2:04 of the game, to win, 20–13. A win over the Ravens on a controversial Santonio Holmes touchdown pass with 43 seconds left secured the AFC North crown. Pittsburgh put the finishing touches on a 12-4 campaign

Right: Receiver Santonio Holmes became a Steelers legend by making an acrobatic catch for the winning TD in Super Bowl XLIII. *Author's collection.*

Below: Waving to the crowd in the parade after winning Super Bowl XLIII is safety Troy Polamalu, who revolutionized the position in his twelve-year career. *Author's collection.*

with a 31–0 rout of Cleveland in the final game of the season, but their championship hopes were put on hold as Roethlisberger lay on the ground motionless after a hit and was carted off on a stretcher with a concussion. Luckily, the Steeler quarterback had great recuperative powers and was ready to play when San Diego came to town once again in the first round of the postseason.

Up only 14–10 at the half, Pittsburgh dominated the second half as Parker ran for 146 yards in a 35–24 win, setting up an AFC championship matchup with their bitter division rivals from Baltimore. The Steeler defense was dominant, but the offense was unable to capitalize. When Willis McGahee scored with 9:29 left, Pittsburgh was holding on to a precarious 16–14 lead. After turning the ball back over to Baltimore with 6:50 left, the game was now in the defense's hands; thankfully, the Steelers had a great one. After moving from their 12 to the 34, Joe Flacco threw a pass toward Derrick Mason that was picked off by Polamalu. In one of the greatest plays in franchise history, Polamalu zigzagged through the Ravens offense and scored the clinching touchdown in a 23–14 win.

Now all that stood between the Steelers and a sixth Super Bowl crown was the underdog Arizona Cardinals. After Harrison's remarkable 100-yard interception return as Arizona was going in for the go-ahead score at the half, the Steelers were on top, 17–7. Going into the final quarter, a Reed field goal gave Pittsburgh a 20–7 lead that did not last. Two Larry Fitzgerald touchdowns, the second a spectacular 64-yard one, coupled with a safety on Hartwig's holding penalty in the end zone, and the Cardinals were ahead, 23–20, with 2:37 left. It was now time for Holmes to become a Steel City hero. The receiver caught three passes for 67 yards, all in clutch situations, as Pittsburgh found itself at the 6-yard line with time running out. After missing Holmes on the first play in the end zone, Roethlisberger found him on the second in what was arguably the greatest catch in league history and a 27–23 lead the Steelers would not relinquish. In the end, it was their unbeatable defense that got them to this point, but it was their much-maligned offense that secured a championship.

9: THE 2016–17 PITTSBURGH PENGUINS

Stanley Cup Champions
Record: 50-21-11

In days gone by, winning back-to-back championships was a challenging feat, for sure, reserved only for the game's greats. In the salary-cap era, it's damn near impossible. That's why no one in the National Hockey League had done it since the Red Wings in 1997–98, and no one since the salary cap was implemented in 2005. Capturing the 2015–16 Stanley Cup championship was challenging for the Penguins, but they developed an attitude that helped them win no matter the obstacles. With everything the 2016–17 version of the Pens faced, the trials and tribulations of the previous season paled in comparison.

It was not only the unbelievable amount of injuries to their key players but also a goalie controversy that wouldn't go away. Apparently, the controversy was only among the fans and media, not the team itself. Coach Mike Sullivan was direct from the beginning that Matt Murray was his man, the goalie who led them in the playoffs the year before. But that didn't stop the fans and media from insisting Marc-André Fleury be in goal. Sullivan proved to be correct, as Murray was spectacular with a 2.41 goal against average and a .923 save percentage. With that, there were many rumors until the trade deadline that Fleury was gone. Almost every day, the press had a story speculating that this game or that would be the legendary goalie's last game, but general manager Jim Rutherford insisted that the team was lucky to have two great goalies and that the team would need each if they were to win the cup again. He surprisingly kept them both. He was prophetic in his thought process, as the club needed Fleury to survive the first two rounds of the playoffs.

Along with the goalies, injuries played a huge part during the season and postseason with other players. Sidney Crosby started the year on the bench, suffering yet another concussion that kept him out for the first six games. When he came back, he did so with a vengeance, leading the league with 44 goals. The injury list was extensive and included many of the club's better players. Evgeni Malkin missed 20 games; Conor Sheary, 21; Bryan Rust, 31; Patric Hornqvist, 12; Trevor Daley, 26; and Olli Maata, 27. Most important, the team's top defenseman, Kris Letang, was lost for the season, missing 41 games with a herniated disc in his neck that required surgery.

No matter what happened, this team developed a next-man-up mentality. Young players like Jake Guentzel, Scott Wilson, Chad Ruhwedel and Carter

Rowney stepped in and helped keep the Pens winning despite the setbacks. Even with all the injuries, they won fifty games with an NHL second-best 111 points. But the team was going into the playoffs without Letang. And with the way the league strangely set up its postseason seedings, they had to face the Columbus Blue Jackets, who had the fourth-best point total in the NHL, and then take on the top-seeded Washington Capitals in the second round.

To make matters worse, Murray injured himself in the warmups before the first game against the Blue Jackets. This is where Rutherford's wisdom in keeping both goalies paid off. Fleury helped steal the first two games when the team was not playing its best, allowing only two goals. Pittsburgh went on to easily defeat the Jackets in five. Next up was the Capitals, who were thought by most experts to have enough talent to finally win their first cup. The problem for Washington was not whether or not their players were more talented than the Penguins; it was the issues they experienced against the Pens in the past, losing eight of the nine playoff series the teams had played against each other, some in horrifying fashion.

It looked as if this would be more of the same, as the Capitals fell behind three games to one. But when defenseman Matt Niskanen cross-checked Crosby in the head, causing yet another concussion during game three, many wondered if it was the play the Caps needed to put them over the top. Despite the fact the Capitals lost game four without Crosby going up against them, they outscored the Penguins, 9–4, in the next two contests, tying the series and forcing a game seven in their own building with all the momentum. The character of Pittsburgh was apparent in this deciding contest, with Fleury stopping twenty-nine shots, some in spectacular fashion. The next-man-up mentality was at its best in a 2–0 victory.

Against a very physical Ottawa Senators team in the Eastern Conference finals, Pittsburgh dropped two of the first three games, including a decisive 5–1 game-three defeat that saw Sullivan reinsert a now-healthy Murray. Murray was every bit as good as Fleury had been, with the Pens winning three of the next four games, including a compelling game seven when Chris Kunitz scored in the second extra period for a dramatic 3–2 win.

The improbable run continued in the team's sixth Stanley Cup final, against the last seed in the west, the Nashville Predators. Pittsburgh was facing not only the Predators on the ice but also seemingly the entire country music community, along with a boisterous fan base intent on tossing one catfish after another onto the ice. While they may have had the sixteenth-best record going into the postseason, by this point, the Predators were

arguably the best team in the league and showed it in game one, holding the Penguins shotless for thirty-seven minutes after Pittsburgh had built a 3–0 lead. Nashville fought back to tie the game at three. Just when everyone was about to concede the first game to the Predators, rookie Jake Guentzel, who posted the second most goals by a rookie in NHL playoff history with 13, scored late in the game. Pittsburgh tacked on an empty-net goal in a 5–3 victory it had no business winning. The Penguins played better in the second contest, winning 4–1 before losing both games in Nashville in front of the rowdy Predator crowd. Looking like Pittsburgh's run was about to come to an end, the greatest player in the world, Sidney Crosby, decided to take matters into his own hands. He played arguably the greatest playoff game in his illustrious career, inspiring his teammates as they finally dominated Nashville in a 7–0 win. If they were to try and avoid a third consecutive seventh game, they would have to do so in a place where they had played so horribly for game six: the Bridgestone Arena in the heart of Nashville.

It was a game that was dominated by the two spectacular goalies, Murray and the Predators' Pekka Rinne. Nashville thought it went ahead in the second period, but an inadvertent whistle when the referee lost sight of the puck negated the Predator goal. For almost three complete periods, the teams battled to a scoreless tie. Just when it looked like it was going to overtime, Hornqvist, a former Predator, beat his old teammates by sneaking one past Rinne with 1:35 left to give Pittsburgh the only goal it needed. Hagelin, who often was the best player on the ice that evening, added an empty net goal in the exciting 2–0 win that gave Pittsburgh its fifth Stanley Cup title and second consecutive cup, something no other salary-cap-era team had ever done. It was a victory for the ages.

8: THE 1925 PITTSBURGH PIRATES

World Series Champions
Record: 95-58

For the Pittsburgh Steelers, it took twenty-six years before they won a fifth title that was hoped would come much earlier. As for the Pirates, who won four National League pennants in the first decade of the twentieth century, including their first World Series championship in 1909, it was hoped the franchise would continue to succeed into the 1910s.

Kiki Cuyler had one of the greatest hits in Pirates history, doubling in the winning runs in game seven of the 1925 World Series. *Pittsburgh Pirates*.

Like the Steelers, the Bucs got old quickly, and the championships soon turned into second-division finishes. The low point came in 1917 under Nixey Callahan, when the team fell to 51-103. Ironically, the franchise began to rebuild under a manager who was more renowned as a college football coach, Hugo Bezdek.

Bezdek, the only man to manage a Major League Baseball team and coach in the NFL, was unexpectedly hired by Barney Dreyfuss and finished 65-60 in the war-shortened year of 1918. After two seasons, former Pirates catcher George Gibson took over before giving way to future hall-of-fame skipper Bill McKechnie in the middle of the 1922 campaign. It was McKechnie who took the young team that Dreyfuss was putting together and began to mold a championship squad. Finishing third in 1923 and 1924—only three games out of first in a tight 1924 pennant race—the young Bucs took that final step a year later.

It was a dangerous lineup that had only one regular player hit under .300, second baseman Eddie Moore. They led the circuit with a .307 average while their star-studded lineup, which included three future hall of famers, plated 912 runs, 84 more than St. Louis and 136 more than the league average.

The team was led by Hazen "Kiki" Cuyler, who was in the midst of an incredible three-year run with the Pirates. Elected by the veterans' committee to the Baseball Hall of Fame in 1968, Cuyler hit a team-high .357 while leading the circuit in runs with 144 and triples with 26 and garnering 220 hits. As incredible as he was in the regular season, it would be a double in the driving rain at Forbes Field in game seven of the Fall Classic that elevated Cuyler to franchise legend.

In center field was Max Carey, thirty-five, who, despite being in the latter half of his magnificent career, was having a phenomenal campaign with a .343 average. The hall-of-fame center fielder was an outstanding defensive player but also an innovative base stealer. He had special pants made by his mother that had pads sewn in to reduce the wear and tear on his legs, which he later patented. He also learned how to read pitchers, a strategy not many base stealers used at the time. This helped him amass what today is still the ninth-best figure of all-time, 738 steals, including a record ten stolen-base crowns.

The third hall of famer was probably the best of the group, third baseman Pie Traynor, who was considered by many experts at the time as the best ever to play the position. The great Branch Rickey once said of Traynor that "he was a mechanically perfect third baseman, a man of intellectual worth on the field of play."[38] A .320 lifetime hitter who also hit his career average in 1925 along with 106 RBIs, Traynor led an effective infield that included first baseman George Grantham (.326), Moore and Glenn Wright at short (.308). Rounding out the impressive lineup were Earl Smith behind the plate (.313) and Clyde Barnhart (.325) in left.

While not as impressive on the mound, the Pirates still had a formidable rotation, led by nineteen-game winner Lee Meadows; three seventeen-game winners in Ray Kremer, Johnny Morrison and Emil Yde; and Vic Aldridge, who was brought over from the Cubs in the off-season with Grantham in what was a controversial trade at the time, with the Bucs sending the franchise's all-time wins leader, Wilbur Cooper, to Chicago.

The season did not begin well. On May 23, the Pirates found themselves 14-16, nine games behind the New York Giants. After losing to the Giants that day, they went on a seven-game winning streak that cut the deficit in half. The Bucs continued to win and were in a brutal back-and-forth battle with New York until sweeping Philadelphia in an August 3 doubleheader that made a half-game deficit at the beginning of the day a one-and-a-half-game lead by the end. It was a lead they would not relinquish. As the season went on, they kept increasing their advantage, which eventually ballooned to ten games following a 2–1 victory over the Phillies on September 23. As the campaign ended, the Pirates captured that long-awaited fifth National League crown and would play the defending champion Washington Senators in the World Series.

Led by Walter Johnson and Goose Goslin, the world champions took a

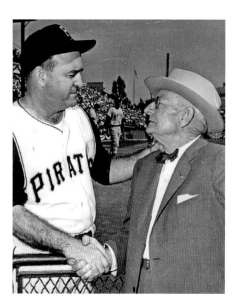

three-games-to-one lead against the Pirates in the series. Since no team at that point had ever come back from such a deficit, it appeared to be all but over for Pittsburgh. This was a tough Pirates team, however, and they would continue to battle back, winning games five and six, 6–3 and 3–2, coming back from down 2–0 in the latter contest. It set up a seventh and final game in the driving rain at Forbes Field that the powers that be in baseball were determined to finish despite the less-than-stellar conditions. In what would be the greatest game in team history next to game seven of the 1960 series, the Senators were up, 6–3, in the bottom of the fifth with Johnson on the mound. While

Shaking hands before the 1960 World Series are manager Danny Murtaugh and the manager of the 1925 team, Bill McKechnie. *Pittsburgh Pirates.*

they battled back, the Pirates' hopes were fading as the game entered the bottom of the eighth with the Bucs down, 7–6. Cuyler came up with the bases loaded and two out. On a two-two count, the future hall of famer ripped a ball down the right-field line that was a ground-rule double, plating three runs and giving Pittsburgh a 9–7 lead, which they held on to for the thrilling victory. It may have been sixteen years between titles, but with the way they battled back to win this series, it was a wait that was well worth it.

7: THE 1976 UNIVERSITY OF PITTSBURGH PANTHERS

NCAA Football National Champions
Record: 12-0-0

Since its last national championship in 1937, it seemed like every time the University of Pittsburgh football team was about to turn the corner and return to the days of Jock Sutherland, the administration would decide to toughen academic standards and the program inevitably tumbled. Following a 9-1 mark in 1963, when they finished fourth in the nation, the team stumbled, going 1-9 for three consecutive seasons between 1966 and 1968. Following a 1-10 mark in 1972, the school, wishing to be embarrassed no more, hired Iowa State head coach Johnny Majors to lead them out of the doldrums. He had an incredible recruiting class his first season that included a speedy running back from Hopewell High School by the name of Tony Dorsett. He would lead the team to one of the most incredible turnarounds in college football history. The 1975 season ended with a 33–19 win over Kansas in the Sun Bowl that was a prelude to a 1976 campaign that proved to be the year the Panthers finally matched the 1937 team, winning the school's first national championship in thirty-nine years.

It all ended well, but after the humiliation of the 1972 campaign, it was rumored that the hiring of Johnny Majors would be the university's last effort at major college football; if it didn't work, the program faced de-emphasis. As the *Sporting News* stated in its book *College Football's 25 Greatest Teams*, "Compounding matters there had been whispers that if newly appointed coach Johnny Majors didn't produce a winner, Pitt might deemphasize football and replace the Notre Dame's on its schedule with the Carnegie-Mellon's."[39] Luckily, Majors was able to secure Dorsett from the likes of Notre Dame and Alabama, as the running back wanted to be closer to home.

Tony Dorsett was the catalyst for Pitt's run to the national championship in 1976 and became the school's lone Heisman Trophy winner. *University of Pittsburgh Athletics.*

It was a combination that had immediate impact, as the team finished over .500 in 1973 for the first time in ten years at 6-4-1, securing their first bowl bid since 1956. Improving to 7-4 a year later, Pitt matched that mark in 1975 and then played Kansas in the Sun Bowl, where their veer offense was on display. Quarterback Robert Haygood, as well as Dorsett and running back Elliott Walker, eclipsed 100 yards in the team's first bowl victory since the Rose Bowl of 1937. Securing a number fifteen ranking in the final Associated Press poll, the team seemed poised for greater things in 1976.

The veer offense is an option offense usually run out of the "I" formation, in which the quarterback makes a defensive read before deciding who gets the ball. It's meant to be a great equalizer when a team has smaller offensive linemen and it makes matchups defensively more difficult; it also makes offenses more prone to fumbles. Luckily for the 1976 Panther offense, it was run to perfection, finishing seventh in the nation in rushing and sixth in scoring. They put their dangerous offense on display in the opener as they visited the Notre Dame Fighting Irish. Notre Dame got off to a quick lead, but any hopes of dashing the Panthers' national championship aspirations ended quickly when Dorsett broke away for a 61-yard romp on the first offensive play, leading Pitt to a dominant 31–10 win.

The next week, they defeated Georgia Tech, 42–14, in a game in which Haygood hurt his knee and was out for the season. Instead of the Pitt coaches worrying, Matt Cavanaugh entered the picture; what he gave them was a vast improvement to the veer, one with a legitimate passing option. Against Duke the following Saturday, he put that on display, completing fourteen passes for 339 yards as Pitt beat the Blue Devils, 44–31.

Pitt moved to 5-0 after a 27–6 win over Louisville, but their season was in jeopardy when Cavanaugh suffered a fractured ankle. The third-string quarterback was walk-on Tom Yewcic, who was an effective quarterback but not on the same talent level with Haygood and Cavanaugh. Luckily for Johnny Majors, he had the best running back in the nation. Dorsett rambled for 227, 180, 241 and 199 yards over the next four weeks to push the Panther record to 9-0. Against Navy in week seven, he became the all-time leading rusher in NCAA history as a 32-yard touchdown romp gave him 5,206 yards, vaulting him ahead of the former leader, Archie Griffin.

As the Panthers were beating Army in week nine, number one Michigan lost to Purdue, pushing Pitt into the spot no one would have imagined four years earlier: the top team in the nation. They held on to the top ranking with a 24–16 win over West Virginia, putting them one step away from an undefeated season. That step was a difficult one: Penn State at Three Rivers Stadium. Things looked tough as Dorsett was controlled by the Nittany Lion defense in the first half with the score tied, 7–7. At that point, Majors outfoxed Joe Paterno and put his All-American at fullback for the first time in his career. The results were spectacular, with Dorsett rambling for 224 yards as Pitt won easily, 24–7.

The awards started coming. Dorsett, who ran for a record 1,948 yards while becoming the only runner in college football history to eclipse 6,000 yards in a career, became the first Panther Heisman Trophy winner, while noseguard Al Romano joined him as a consensus All-American. To complete the final step, the award the team wanted the most, the national championship, they had to defeat Georgia in the Sugar Bowl. They would not let this opportunity slip through their hands, as Cavanaugh won the game's MVP award, passing for 192 yards and running for another score while Dorsett ran for a Sugar Bowl–record 202 yards in a 27–3 win.

The season was over. Pitt completed the magnificent turnaround with a unanimous national title. While others don't give the 1976 club their just due in rating the greatest teams in school history, mainly due to a subpar schedule in which their opponents had a .478 winning percentage, the bottom line is that Pitt won all of its games and captured the unanimous national crown, something no team since the Pop Warner days has done.

6: THE 1931 HOMESTEAD GRAYS

Negro Eastern Independent Team Champions
Record: 22-13-1

Statistics in the Negro leagues can be inconsistent and incomplete, making it difficult to tell at times just how successful a team was, especially those playing as independents. The 1931 Homestead Grays is a prime example. On the website Seamheads.com, the team is credited with a good but not great 22-13-1 record, while Negro League historian John Holway in his book *The Complete Book of Baseball's Negro Leagues* has them with a much more impressive 46-19 mark. In independent play, there were no structured league schedules, and the teams considered the best weren't always the ones with the best records. In 1931, despite the disparity of records, most experts who study the league consider the Grays the best eastern independent team and the Kansas City Monarchs the best in the west. Kansas City challenged Homestead to a world Negro league championship series to determine the best that season.

Manager and owner Cumberland "Cum" Posey had incredible talent at his disposal. The potent Homestead lineup led all eastern independent teams in every category offensively except walk percentage, finishing second. The lineup included nineteen-year-old prodigy Josh Gibson. It was his second year in the league after hitting .417 in sixteen games for the Grays in 1930. According to the stats in Holway's book, the future hall of famer finished behind John Beckwith in home runs with 14 (equal to 35 in a full major-league season of 550 at bats). Gibson ended up hitting .308.

Besides Gibson, the Grays had five other players who now call Cooperstown home. First baseman Oscar Charleston had a fine season with a .341 average. Third baseman Jud Wilson led the team in hitting at .352 (.422, according to Seamheads.com). Wilson, who was elected to the hall of fame in 2006, was an incredible hitter whom Posey felt was the most dangerous and consistent offensive force in the game. The great Satchel Paige dubbed him one of the top two hitters ever in Negro league baseball.[40] On the mound, Willie Foster, the half brother of Rube Foster, confused hitters by throwing pitches at several angles and speeds. He finished the year 12-2 while fellow hall of famer Smokey Joe Williams, a control pitcher with an incredible fastball, was 10-6. Paige was the sixth member at Cooperstown to play for the Grays, although he started only one game, allowing 1 earned run and 11 hits in nine innings.

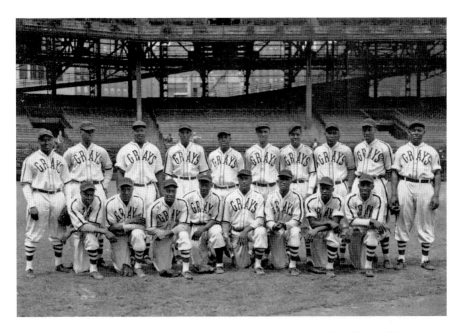

The Homestead Grays were among the most celebrated teams in Negro league history, winning nine league championships. *Pittsburgh Pirates.*

After a successful season, the Grays took on the Kansas City Monarchs in what was billed as the championship series of Negro league baseball. The nine-game series, detailed in Holway's book, began with Homestead blowing an early 4–1 advantage and losing the contest, 6–5. Angry at the defeat, the Grays came back to thoroughly dominate the Monarchs the next three contests, winning 9–3, 8–1 and 9–1, respectively, before Kansas City cut the advantage to three games to two, led by Newt Allen's four hits in a one-sided 8–1 victory.

Following so many routs, the two teams settled down to a pitchers' duel in game six at Canton, Ohio. With the game tied at one in the bottom of the sixth, Monarch pitcher Chet Brewer struck out Gibson but was then ejected from the game for cutting the ball. With a man on third and reliever Charles Beverly in the game, Vic Harris was at bat and lifted a fly ball deep enough to score the run that won the game. The contest was called an inning later with umpires feeling it was too dark to continue.

The final three games would be played in Kansas City, with the Grays needing to win one game for the title. With the Monarchs in front, 8–2, Homestead made it close with five runs in the top of the eighth but scored no more. Kansas City cut the lead to one game with an 8–7 win. Unfortunately

for the Monarchs, in game eight, their defense let them down, misplaying several balls. Homestead held on for the series-clinching 7–5 win. With the series already won, the two teams played a ninth game as the Grays put an exclamation point on their championship, scoring six runs in the top of the sixth inning to turn a 4–2 deficit into an 8–4 victory. It was a great victory that saw Charleston amass 22 hits with a .511 average in the series; Wilson and George Scales contributed 11 hits apiece.

An exciting team with so much talent, the debate went on whether or not the 1931 Homestead Grays were in fact the greatest Negro league squad of all time. Many Negro league historians believe that their inter-city rivals the 1935 Pittsburgh Crawfords were the superior team, but on MLB. com, Justice B. Hill disagrees. He cites the fact that so many hall of famers dotted the Grays roster to go along with such standouts as Harris, Scales and Double Duty Radcliffe. Double Duty remembered that "on the Grays, it didn't matter if we got behind by four or five runs because Josh would hit in 12 runs all by himself. Josh was some kind of hitter."[41]

Rob Ruck, Negro league historian who is a lecturer at the University of Pittsburgh, agrees that this team had the credentials to be the best of all time. "You have to (consider them) because of their roster. I mean, my goodness—Josh Gibson, Vic Harris, Double Duty Radcliff, Smokey Joe Williams, and Oscar Charleston—that's quite a team. So, surely, they were awesome."[42] It certainly gives credence to the claim, but even though it isn't a definitive statement, it does make it clear that between the Grays and Crawfords, the best Negro league baseball was played in the Steel City.

5: The 1909 Pittsburgh Pirates

World Series Champions
Record: 110-42

In the first decade of the twenty-first century, the worst baseball team in the Majors was the Pittsburgh Pirates. They finished the decade with a 681-936 record for a .421 winning percentage. Go back one hundred years, and the Pirates were the polar opposite. A model franchise that won four National League crowns, Pittsburgh led the Majors with a .636 winning percentage, fashioning a 938-538 record and capturing the franchise's first World Series title in the memorable campaign of 1909.

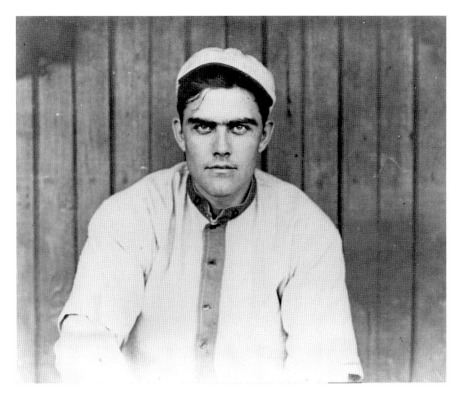

At the beginning of the 1909 World Series, no one would have guessed that Babe Adams would finish it with a record three wins. *Pittsburgh Pirates.*

As the decade was coming to an end, the core of the Pirates was aging. After losing a close pennant race in 1908 in which they finished a game behind the Cubs, the team had to wonder if they could continue the championship era a year longer. Six players were now over thirty, including two of the team's all-time greatest hurlers in Sam Leever and Deacon Phillippe, both of whom were thirty-seven years old, to go along with Fred Clarke (thirty-six), Honus Wagner (thirty-five), Vic Willis (thirty-three) and Tommy Leach (thirty-one). Despite being past their peak, for the most part these aging stars combined perfectly with the team's younger players to formulate one of the greatest seasons in team history—one last day in the sun, if you will. The championship days ended with the decade, but did so with a world title.

While winning a World Series automatically makes a season one for the ages, it was another event that put the franchise in the forefront of baseball history this year: the opening of Forbes Field. Exposition Park had served the Pirates well over the years. Unfortunately, it was built right next to the

river, approximately between where PNC Park and Heinz Field currently sit. Floods had become commonplace in the outfield, so much so that ground rules had to be established at times to deal with the water that stood there. Owner Barney Dreyfuss had enough of the situation and, in addition, wanted to build a much larger facility to handle the bigger crowds for his championship team. Wood stadiums were popular at that time, but such facilities were prone to catch fire and be damaged or destroyed. Forbes Field and Shibe Park in Philadelphia, the latter of which also opened earlier the same year, were built out of concrete and steel, the first baseball facilities so constructed. They were monuments to the game itself, magnificent structures. But before they entered their new stadium at the end of June, the Pirates had to play most of the first half of the campaign at flood-infested Exposition.

The Pirates started the season an unspectacular 5-6 before going on a seven-game winning streak. They spent the next month in a tight battle with the defending world champion Chicago Cubs before a doubleheader sweep on May 30 vaulted them into first, a spot they wouldn't relinquish for the rest of the year. The two victories would be the first of fourteen consecutive that stretched their advantage to five by June 15. Two weeks later, the lead stretched to seven and a half games as the Bucs said goodbye to Exposition with an 8–1 win against Chicago. The next day, June 30, with a fanfare reserved for royalty, 30,388 fans traveled to the Oakland section of the city to celebrate the opening of this great stadium. It was the largest crowd to see a baseball game at that time. Pittsburgh lost to Chicago, 3–2, but it would be just a temporary downtrend. The Pirates continued their excellent play, and after a 12–7 win at Forbes against Brooklyn, they stood ten games up with a 103-36 mark.

It was apparent at that time that the pennant was a sure thing. Eventually, Pittsburgh captured its fourth National League crown and first since 1903, when the Pirates unfortunately ended the season losing to the American League champion Boston Americans in the first World Series. It was an upset loss that the team and its star, Honus Wagner, never got over. The Carnegie native hit only .222 in the series and was branded as yellow by the media for playing cowardly on the national stage. It was a stigma that followed him, even though he won seven batting titles, the latest in 1909 with a .339 average.

If the Pirates hoped to finally get over the criticism, they would have to defeat the three-time defending American League champion Detroit Tigers. The Tigers were a great team led by their superstar, Ty Cobb. Detroit had

lost the previous two Fall Classics to the Cubs. The 1909 series would be theater—good versus bad. The good being Wagner, the consummate sportsman, against the bad in Cobb, who seemed constantly at odds with the law, opponents and teammates. The series lived up to the hype.

While the two superstars were the focal point, it was a quizzical move by Clarke that was the difference in the Fall Classic. He started little-used rookie Babe Adams in the opening game. Adams had a fine season at 12-3, mostly out of the bullpen, and was chosen instead of Willis and Howie Camnitz, who won 22 and 25 games, respectively. The move turned out to be genius, as Adams won not only that contest, 4–1, but also game five, 8–4, to give the Bucs a three-games-to-two lead as the series shifted back to Detroit. The Tigers won the sixth contest, creating the first seventh and deciding game in the short history of the iconic event. Appropriately, Adams took the mound and won a one-sided contest, 8–0, for his third victory of the Fall Classic, giving Pittsburgh the championship. The team would relieve itself of the bad experience of 1903, and Wagner would be called yellow no more as he outhit Cobb .333 to .231. It was the last championship the team would win until 1925, but if the era had to end, there was no better way to finish it than by winning the World Series.

4: THE 1935 PITTSBURGH CRAWFORDS

Negro League World Series Champions
Record: 48-21-3

The debate as to the greatest Negro league team seems to be between the 1931 Homestead Grays and the 1935 Pittsburgh Crawfords, the team that signed most of the best players away from its inter-city rivals. MLB.com made its case for the Grays, citing their hall-of-fame talent. But it seems like the consensus, including such experts as James A. Riley and Merl Kleinknecht, as well as Rob Neyer and Eddie Epstien (who named the 1934–36 teams as the greatest Negro league dynasty in their book *Baseball Dynasties*), may actually come on the side of the Crawfords, who fashioned a memorable championship campaign with their own array of talent that has been enshrined in Cooperstown. Their 1935 campaign culminated in an exciting come-from-behind victory against the New York Cubans in the league championship series.

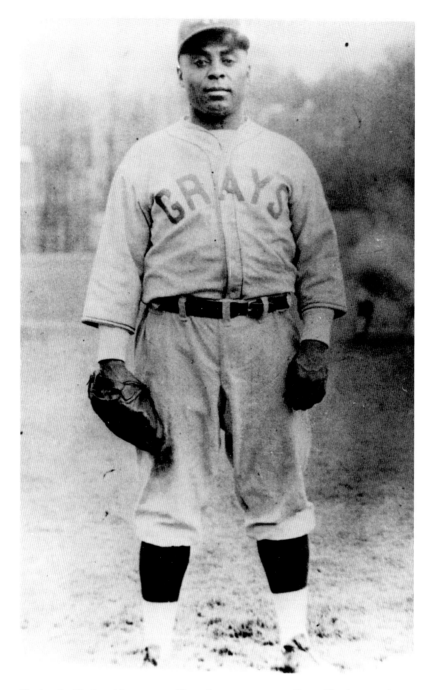

Playing for Pittsburgh's two great Negro league teams was Oscar Charleston, who was on the 1931 Grays and 1935 Crawfords. *Pittsburgh Pirates.*

In the mid-1930s, the Crawfords were the New York Yankees of the era, if you will. Gus Greenlee was a local numbers king and owner of the famed Crawford Grill in the Hill District section of the city. He had a stable of boxers, including the world light-heavyweight champion, John Henry Lewis, and decided to add to his growing sports empire by purchasing a sandlot team, eventually turning it into one of the greatest forces in Negro league history. He spent money like George Steinbrenner, collecting hall-of-fame talent, mostly off the roster of the Grays. He also built the first African American–owned stadium in Negro league history, Greenlee Field. The facility made the players feel like they were major-league quality. According to James "Cool Papa" Bell, "It was beautiful. It had lots of grass and you almost felt like you were playing in a major league park."[43]

Everything was first class for the Crawfords, and the team reciprocated by winning the newly formed Negro National League in a controversial 1933 pennant race, then finishing with the best overall record a year later despite being unable to win either half. Just like the 1931 Homestead Grays, they did so with an incredible array of talented men, some of whom were the same players. Greenlee was able to recruit Oscar Charleston and the great Josh Gibson to play for his team. Charleston was in his late thirties but still effective at first as well as flawlessly handling the managing chores. Gibson, considered by many as the best hitter the Negro leagues ever produced, was a young player entering his prime. The Crawfords' owner also convinced Bell, arguably the fastest player in the history of the game, and third baseman Judy Johnson to join his team. Both players were in their thirties when they signed, but both played well and eventually were given baseball's ultimate honor by being elected to the hall of fame.

Between 1931 and 1934, the Crawfords roster included a fifth future hall of famer, one of the greatest hurlers to ever take the mound: Satchel Paige. But he decided to barnstorm in 1935 and was not available to Pittsburgh. It didn't make a difference, as pitcher Leroy Matlock fashioned one of the greatest seasons in the sport's history.

The team was impressive offensively, with Bell hitting .337 and Gibson .366. Pat Paterson, a fine-fielding second baseman, was a great contact hitter (.385) and aggressive base runner. Sam Bankhead (.353) also surpassed the .300 plateau. As good as their offense was, it was the Crawford pitchers who made this team special.

Paige had been the unabashed leader of the staff but was allowed to barnstorm and play semipro ball in Bismarck, North Dakota, in 1935. Some say his absence was a result of a contract dispute between Greenlee

and Paige. The story was that Greenlee had Paige sign his contract—which did not include a raise—at the hurler's wedding reception while Paige was reportedly inebriated. Whether the story is correct or not, they lost their best pitcher. But it turned out to be an opportunity for Matlock to show how superb he was. A southpaw whose strength was his breaking and off-speed pitches, Matlock was untouchable. Whether you believe historian James A. Riley, who has him at 18-0, John Holway (17-0) or Seamheads. com (10-1), there is no disputing that he was far and away the best pitcher in the circuit. Matlock not only was on a streak that saw him win 21 games in a row according to Holway, but he also led the circuit with a miniscule 1.52 ERA on a club that had a team mark of 3.78, which was the best in the Negro National League. He was joined by a stellar staff that included Bert Hunter, Roosevelt Davis (whom Holway has credited with a 12-4 record) and Sam Streeter.

The Crawfords were ten and a half games ahead of the second-place New York Cubans by season's end and faced the Cubans in the Negro League World Series. Unfortunately, it looked like the magnificent campaign the Crawfords had fashioned would be for naught, as they fell behind New York three games to one in the best-of-seven series, being defeated easily in each of their three losses. With their chance at Negro league immortality now threatened, Pittsburgh put on a comeback for the ages, pulling out victories from what often looked like certain defeat. In game five, with the score tied at two in the bottom of the ninth, Bell scored the winning run on an error as the Cubans were trying to get the lead runner after a bunt by Chester Williams. The sixth game was perhaps the most magnificent. In the last of the ninth, the Cubans had a 6–3 lead and were beginning to count out the winners' share of the series. Future hall of famer Martin Dihigo, who was also manager of the team, surprisingly put himself into the game to finish the Crawfords off. He gave up a three-run homer to Charleston, then allowed a bases-loaded single to Johnson, who had been hitless in his last ten at bats, scoring Patterson with the game-winning run and unexpectedly sending the series to a seventh and deciding game. With the score tied at five in the top of the ninth, Gibson and Charleston, who hit .407 and .370, respectively, in the series, hit back-to-back homers to put Pittsburgh up, 8–5. New York battled back, scoring two in the bottom of the frame, but they could score no more as Davis shut the door, getting Alejandro Oms to ground out and end the game. The Crawfords earned not only the championship but also a place among the elite in Negro league history.

3: The 1975 Pittsburgh Steelers

Super Bowl X Champions
Record: 12-2-0

When a young team surprises the league and wins a world championship, one of two things usually happens: they don't work as hard the following season and the results inevitably don't meet expectations, or they decide to work harder and focus on maximizing their untapped potential. The latter are the teams that often form dynasties and become among the best to ever play the game. In 1975, the Pittsburgh Steelers were coming off a season in which they struggled at times yet began to play their best in the playoffs, winning the Super Bowl when not many expected them to do so. A year later, they were still a young team, but they had the disciplined Chuck Noll coaching them. Lackadaisical practice habits were not an option. The 1975 Steelers became a team that went from wondering if it could defend its title to one that is considered among the best in the history of the league.

The Steelers came into the 1974 campaign with a solid core of talent, but it was their draft, one that is not only the best in NFL history but also arguably the greatest in any sport, that took them from also-rans who never won a league title to a franchise known for one of the celebrated dynasties in sports. Defensive back Jimmy Allen, a fine player in his own right, will always be the answer to a trivia question. He was drafted between four future hall of famers. In five rounds, Pittsburgh took Lynn Swann in the first, Jack Lambert in the second, Allen and John Stallworth in the fourth (there was no third-round pick) and finished with Mike Webster from Wisconsin in the fifth. By the time it was done, the seeds were planted. The Steelers then took advantage of their harvest to present owner Art Rooney his first NFL championship trophy in forty-one years of operation.

A year later, the 1975 draft was the polar opposite, perhaps the worst in the Chuck Noll era. It didn't matter. This team was young and still hungry. The four future hall of famers in the '74 draft were now all a year older. Quarterback Terry Bradshaw, the first overall pick in 1970, had struggled for much of his first five seasons to live up to the potential most had predicted for him. After retaking the starting job from Joe Gilliam in the middle of the '74 campaign, his solid performance in the postseason gave Bradshaw confidence. In 1975, he went from potential first-round bust to first-ballot hall-of-fame selection. In his first five seasons, he threw

There was no tougher linebacker in the history of the Pittsburgh Steelers than hall of famer Jack Lambert. *Kent State Athletics.*

48 touchdowns and 81 interceptions. In 1975, he went in reverse, with 18 touchdown tosses and only 9 pickoffs. His 57.7 completion percentage was a career high, as was his 88.0 quarterback rating. The Louisiana Tech alum was no longer fighting for the starting spot; instead, he was selected to his first Pro Bowl.

The defense was also extremely confident. The group was filled with players now enshrined in the hall of fame and those who have credentials to be considered for it. Joe Greene, Jack Ham, Jack Lambert and Mel Blount have plaques in Canton, while Andy Russell, L.C. Greenwood, Dwight White and Donnie Shell, who was a second-year reserve safety, are in the conversation. The team wanted to make a statement early in the season, and they did so with Bradshaw throwing for 227 yards in a 37–0 demolition of the Chargers in San Diego. The next week, in the home opener, O.J. Simpson stunned the Steel Curtain by running for 227 yards in a 30–21 upset. Gilliam replaced an ineffective Bradshaw and made the game close, as the Bills were ahead at one point, 23–0. While it was disappointing, it seemed to focus this team—they would not lose until the season's final week.

Unlike the year before, when Noll sat the Louisiana native after a poor performance, he stuck with Bradshaw this time. The quarterback was almost perfect the next game, hitting seven of eight passes for 151 yards before a laceration between his thumb and index finger in the second quarter ended his game early. It made no difference, as an angry Steeler squad crushed Cleveland, 42–6. It was the beginning of ten consecutive weeks in which they comfortably beat almost everyone they played, outscoring their opponents 312–122. Pittsburgh traveled to Los Angeles the last week of the season with nothing to play for. Their eleven-game winning streak was ended with a meaningless 10–3 loss. It didn't matter, as they began another streak with a 28–10 win in the first round of the postseason against Baltimore at Three Rivers Stadium.

With the victory, they faced perhaps their biggest rival in the 1970s, Oakland, in the AFC championship. In this game, the Astroturf at Three Rivers was particularly inhospitable. The wind howled, circulating through the stadium, as players and fans alike were chilled in the fifteen-degree weather. The turf had been under a tarp all week, but it still froze, leading to an icy field that prompted thirteen total turnovers in the ugly contest. With a 3–0 lead in the fourth, Franco Harris ran for a 25-yard score and Stallworth caught a 30-yard touchdown pass to give Pittsburgh a 16–7 lead late. George Blanda kicked a 41-yard field goal to cut the score to 16–10 with seventeen seconds left. Then, after the Raiders recovered the onside kick, Kenny Stabler lofted a 37-yard pass to Cliff Branch, who was unable to get out of bounds at the Steeler 15. The game ended, and Pittsburgh was headed to the Super Bowl.

Playing the Dallas Cowboys in Super Bowl X, things looked troubling for the Steelers as they were down 10–7 going into the fourth. A safety on a blocked punt by Reggie Harrison, two Roy Gerela field goals and a 64-yard bomb to Swann put the finishing touches on his amazing MVP day. Swann made four acrobatic catches for 161 yards and led Pittsburgh to a 21–17 victory.

As far as their rank among all-time Steeler teams, most experts seem to go back and forth between the four champions of the 1970s, although ESPN.com's James Walker made a compelling case for this team. Regardless of where they rank in Steeler annals, the team showed that they weren't complacent in 1975. Their second Lombardi Trophy proves that.

2: THE 1902 PITTSBURGH PIRATES

National League Champions
Record: 103-36

In a list such as this, it's unusual for a team that didn't win a championship to be named as the top club in franchise history. It's not the 1902 Pittsburgh Pirates' fault for that, though. The World Series was still a year away from coming into existence. Five Pirates teams have been labeled world champions following victories in the Fall Classic, and this team is not among them. An argument for this team not being rated highly is the fact that the newly formed American League was raiding the National League of many of its

stars, yet Pittsburgh was left relatively untouched by the fledgling circuit. As the defending pennant winners, being left virtually intact was perhaps the main reason they won their second league crown by a record margin. Even with all the factors that led to their domination and the fact that this squad doesn't have a World Series banner, it nonetheless is statistically the best Pirates team to ever take the diamond. Looking at the talent and statistics they produced, the 1902 Pittsburgh Pirates take a back seat to no one.

The Pirates in 1902 was a team with no weakness. Offensively, they led the circuit in batting average (.282), runs (774, 142 more than the next team), hits (1,410), doubles (189), triples (95), slugging (.344) and OPS (.718). The team was second in home runs (18) in an era when there weren't many. On the mound, Pittsburgh was second in ERA (2.30), but that was an anomaly, as they led the circuit in fewest runs allowed (440, 65 less than the second-best rotation). They also gave up the fewest hits (1,142), had the lowest WHIP (1.101) and gave up a league-low four home runs.

With so many impressive team stats, many of the Pirates were included on the list of league leaders. Ginger Beaumont won the batting title with a .357 average, and he led the circuit with 193 hits. A .311 hitter for his twelve-year major-league career, Beaumont had the distinction of using the heaviest bat at the time, weighing fifty-five ounces. A year later, he hit .341 and would

The 1902 Pittsburgh Pirates were the most dominant club in team history, with a 103-36 mark. They won the pennant by twenty-seven and a half games. *Pittsburgh Pirates.*

make major-league history as the first player to bat in a World Series. Honus Wagner finished fourth in the batting race at .330, while manager/left fielder Fred Clarke was sixth at .316.

Over the course of his fabulous career, Wagner would win eight batting titles. This year wasn't one of them, but he had an incredible season nonetheless as the National League leader in slugging, OPS, offensive WAR (wins above replacement) and doubles. Diminutive Tommy Leach was at the top in defensive WAR and tied for the lead in triples.

While they had the best lineup in the league, Pittsburgh could also boast the best starting rotation in the game. Future hall of famer Jack Chesbro set a Pirates record for wins in a season with 28, one that in the subsequent 115 years remains a franchise record. Two years later, after jumping to the New York Highlanders (Yankees) in 1903, Chesbro set a modern major-league record that still stands, winning 41 games. Two other Pirates eclipsed the 20-win plateau. Deacon Phillippe, who in 1903 became a World Series hero with three wins, was 20-9 with a 2.05 ERA. Jesse Tannehill, who deserted the Bucs for the American League a year later with Chesbro, was 20-6 with a team-low 1.95 earned run average. Even though Sam Leever and Ed Doheny did not win 20 games, they did have phenomenal seasons, with 15-7 and 16-4 records, respectively. As impressive as the individual stats were, the season the team had was that much more.

April 25 would be the low point of the season. A second consecutive loss to the Cubs, this one 4–2, dropped Pittsburgh's record to 5-2 as they fell to second place, a game behind Chicago. Luckily, they shut out the Cubs the next two days, 7–0 and 2–0, respectively, one of twenty-two shutouts for the pitching staff on the season, putting them back into first, a position they would not relinquish the rest of the season. It was the beginning of a ten-game winning streak in which they outscored their opponents 74–25, including a one-sided 18–6 victory over St. Louis.

Now at 15-2, things didn't get easier for their opponents. It would be June 3 when the Pirates next lost consecutive games, but despite the losses the team stood at an unbelievable 30-7, six and a half games in front of Chicago. Looking at their run differential on that date, one can see just how dominating they were, outscoring their opponents 226–104. "Cooling off" in June with an 11-6 record, Pittsburgh never let up the rest of the campaign. From July to September, they went 60-23, finishing the season with a record only the 1909 team approached at 103-36.

This was a great season for sure, but was this team a better club than the 1909 Pirates? While the 1902 season was affected by the fact that the

American League took many of the National League stars, looking at the disparity in stats, it's tough to believe that it would have made more than a few games' difference. Despite playing thirteen fewer games than their 1909 counterparts, this squad scored 775 runs to 701 for 1909 and allowed 9 fewer runs. In the book by Rob Neyer and Eddie Epstien, *Baseball Dynasties*, they list the top teams in standard deviations for a particular year, a statistic that takes into account runs scored and runs allowed versus the league norm, and the 1902 club finished tied for the seventh-highest mark in major-league history at 3.63 (the highest being the 1998 New York Yankees at 3.88). To extrapolate that for a 162-game schedule, the 1902 Pirates would have been 120-42. Would this team have won the National League pennant by twenty-seven and a half games if not for the mass exodus, a record that stood for ninety-three years until Cleveland beat Kansas City by thirty and a half in 1995? Probably not, but they most likely would have still won by a very significant amount, because they were a great team, as they were the year before, when they won the pennant. So, what would make them better than the 1909 champions? If you compare the two clubs position by position, you have Clarke and Wagner in their primes and a better pitching staff. The bottom line is that the 1902 team had better players and is the best in Pirates history.

1: THE 1978 PITTSBURGH STEELERS

Super Bowl XIII Champions
Record: 14-2-0

Debating the best team in a dynasty can sometimes be a fruitless venture. Any one of the championship clubs that represented the Steelers franchise in the 1970s has the credentials to be the best. For the Pittsburgh Steelers, it depends on which part of the dynasty suits you: the original two seasons (1974 and 1975) or three years later, when injuries seemed to slow their progress and the team reinvented itself, at least offensively. They went from a physical, ball-control offense that threw only when necessary to a more wide-open one that took advantage of their stable of receivers, led by future hall of famers Lynn Swann and John Stallworth as much as their corps of running backs, including the legendary Franco Harris and Rocky Bleier.

Terry Bradshaw struggled at the start of his career, but by the time it was over, he had won four Super Bowl championships. *Louisiana Tech Athletics.*

In 1978, the transformation came to fruition. Terry Bradshaw went from a potential first-round bust to the MVP. While they scored more offensively a year later, they also gave up more points. The significance of this team was the fact that their staunch defense didn't suffer because of their quick-strike offense, leading the NFL by allowing only 12.2 points per game. In 1989, ESPN aired a series in which a computer simulation was used to determine the greatest team ever to grace the gridiron. After going undefeated in the regular season, the '78 Steelers defeated the 1984 49ers in the semifinals before beating the Dolphins in the championship, 21–20. The cable sports conglomerate seemed to get it right. No conversation as to the best team in NFL history can take place without including the 1978 Steelers.

It wasn't that 1976 and 1977 weren't successful seasons for the franchise. In fact, some experts think the 1976 club was the best of the bunch. Starting 1-4, then losing Terry Bradshaw to injury, prospects were not good for the two-time defending champions. The defense picked up the slack, leading the team to nine wins in a row, allowing only 28 points during the streak. They crushed the Colts in the first round of the playoffs, but Harris and Bleier were injured in the game, and the team fell easily to Oakland in the AFC championship. A year later, they struggled, especially defensively, and had their worst season since 1971, losing to Denver in the first round, 34–21. The team had to change quickly.

The league decided to cut preseason games from six to four while expanding the regular season to the current sixteen games. Some of the staples of the first two championships were traded before the season, as Ernie Holmes, Jim Clack, Jimmy Allen, Glen Edwards and Frank Lewis were all dealt. To rebuild the dynasty, such changes were necessary.

Trying to prove that 1977 was a fluke, the team started the season by traveling to Buffalo. Bradshaw was almost perfect, with a 14-for-19 performance and throwing for 217 yards and two touchdowns as Pittsburgh

broke out to a 21–0 lead en route to a 28–17 victory. It would be the first of seven consecutive wins to start the season, including two against their bitter rivals from Cleveland, the first a classic 15–9 overtime victory in which tight end Bennie Cunningham snagged a 37-yard pass for the win.

After falling at home to another division rival, the Houston Oilers, in week eight, Pittsburgh struggled, with close victories against the Chiefs and Saints before a 10–7 loss to Los Angeles cut their record to 9-2. The 1-10 Bengals outplayed the Steelers but lost, 7–6. Noll had had enough, as had his team. When they came out against the 49ers in week twelve, they were dominant once again, outgaining their opponents in yardage, 380–141, in a 24–7 victory. Pittsburgh went on to win its final three games against Houston, Baltimore and Denver to finish the season with a then team record fourteen wins.

Heading into the postseason, they seemingly had no weakness. They were fifth in the NFL in points scored and eighth in total yards while leading the circuit in fewest points allowed and third in fewest yards permitted. As for Bradshaw, he definitely turned the corner in his career. He threw for a career-high 2,915 yards and a league-high twenty-eight touchdown passes. He led ten Steelers into the Pro Bowl. Bradshaw, Jack Ham, Swann, Webster and Mel Blount were named to the All-Pro team. The NFL MVP took his game to another level in the postseason.

Great teams play their best in the playoffs, and that's what makes this Steelers club the best. Against Denver in the first round, bombs to Stallworth (45 yards) and Swann (38 yards) in the fourth quarter turned a 19–10 game into a 33–10 rout. Bradshaw threw for 272 yards, Harris rambled for 105 and Stallworth caught ten passes for 156 yards in the victory. The win sent the Steelers back to the AFC championship for the fifth time in seven seasons, this time against the runner-up in the central division, the Houston Oilers.

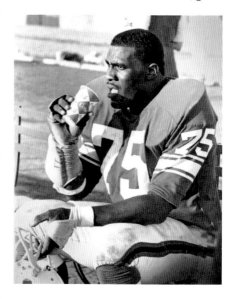

Famous for his Coca-Cola commercial, Steeler great Joe Greene enjoys a soda while playing for North Texas State. *North Texas Athletics.*

In the final years of the 1970s, the Oilers were probably the second-best team in football. Unfortunately, they played in the same division as Pittsburgh. The conference title was to be played at frozen Three Rivers Stadium as the Steel City was being deluged with a major ice storm. The AstroTurf was an icy mess, but it did not slow down the Steeler offense. Up 14–3 with 1:30 left in the first half, Pittsburgh had an incredible offensive burst after some Oiler turnovers. Once again, the wide-receiver duo was on display, as 29- and 17-yard touchdown passes to Swann and Stallworth, respectively, and a 37-yard field goal by Roy Gerela made the score 31–3 going into the half. The 17-point outburst occurred in a span of 90 seconds. There was little scoring in the second half as the Steelers once again went to the Super Bowl with the 34–5 win.

Super Bowl XIII was a rematch of Super Bowl X, as the Steelers once again faced the Dallas Cowboys. While the final score was close, 35–31, the game really wasn't, as Pittsburgh held a 35–17 advantage in the final quarter before two late Dallas touchdowns made it artificially close. Matching his season MVP season, Bradshaw captured the Super Bowl MVP award, throwing for four touchdowns and 318 yards. His receivers were spectacular, with Stallworth catching three passes for 115 yards and Swann adding seven catches for 124.

Pittsburgh was dominant in the playoffs, outscoring its opponents 102–46, the kind of postseason that the great teams have. Few if any teams in NFL history were better than this one, and none in the history of sports in western Pennsylvania.

In 1999, the University of Pittsburgh at Johnstown wrestling team won its second national championship in three seasons. *University of Pittsburgh at Johnstown Athletics.*

NEXT UP

THE TEN TEAMS THAT CAME CLOSE

1. THE 1910 UNIVERSITY OF PITTSBURGH PANTHERS
NCAA football champions. While the university doesn't recognize this season as a national championship campaign, it really should. A record of 9-0 while outscoring their opponents by a 282–0 margin makes one wonder why it doesn't.

2. THE 1999 UNIVERSITY OF PITTSBURGH AT JOHNSTOWN MOUNTAIN CATS
NCAA Division II men's wrestling champions. Led by phenomenal wrestlers such as Jody Strittmater, the University of Pittsburgh at Johnstown had a 23-2 dual meet record as it captured its second national championship in four seasons.

3. THE 1920 LOENDI BLACK FIVES
Black Five World Basketball champions. Capturing the African American world championship with the Monticello Athletic Association in 1912, Cum Posey formed the Loendi Big Five and won four consecutive championships between 1920 and 1923.

4. THE 1939–40 DUQUESNE UNIVERSITY DUKES
NCAA Final Four and NIT finalist. At 20-3, they became the first college team, along with Colorado, to be invited to both the NCAA and NIT tournaments in the same season. With the only Final Four appearance in school history and a spot in the NIT finals, this team was legendary.

5. THE 1941 DUQUESNE DUKES

NCAA football champions. While their claim to a national championship is sketchy at best, winning the Massey computer ratings retroactively, it was nonetheless a solid team, going 8-0 while allowing only 21 points in the process.

6. THE 2004 CALIFORNIA (PENNSYLVANIA) VULCANS

NCAA Division II women's basketball champions. Beating Drury in an exciting 75–72 game, the Cal women won the first basketball title in a tourney for a western Pennsylvania school since the 1955 Duquesne Dukes.

7. THE 1955 HEIDELBERG SOCCER CLUB

U.S. Amateur Cup champions. In the last U.S. Amateur Cup championship, a western Pennsylvania soccer club won. The Heidelberg Soccer Club defeated the AAC Eagles for the title.

8. THE 1902 PITTSBURGH STARS

National Football League champions. It was the first National Football League, in 1902: a three-team circuit that featured baseball hall of famers Christy Mathewson and Rube Waddell and two Philadelphia teams, along with the Stars, competing for the initial NFL championship. Pittsburgh went 9-2-1 and was named the titlist after beating the Philadelphia Athletics, 11–0.

9. THE 1990 ALLEGHENY COLLEGE GATORS

NCAA Division III football champions. The last western Pennsylvania team to win an official NCAA national football championship was the 1990 Allegheny College Gators, who defeated Lycoming, 21–14, in overtime to win the title.

10. THE 2007 PITTSBURGH PASSION

NWFA national champions. The Passion have become one of the best women's professional football teams in the country, capturing three national championships in their short history. In 2007, they won their first, going undefeated before beating Columbus, 32–0, for the title.

APPENDIX II

THE LIST

WESTERN PENNSYLVANIA CHAMPIONS

This list includes western Pennsylvania champions from the college level and above, including professional teams in both minor and major leagues that have represented this area. Included are some Pirates, Crawfords and Grays teams that won league championships instead of World Series. In those seasons, there was no World Series. There are also the 1910, 1980 and 1981 Pitt Panther football teams. Those seasons aren't recognized by the university but are included in the NCAA record manual, so they are included here. This list is a twenty-five-year labor of research love and is probably not 100 percent complete at this point, but it is one in which we can properly honor the great men and women who have made this area proud over the years.

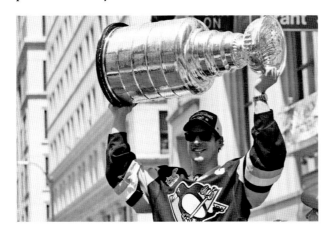

Sidney Crosby, lifting the Stanley Cup, matched Mario Lemieux by captaining two Stanley Cup championships. *Author's collection.*

APPENDIX II

YEAR	TEAM	CHAMPIONSHIP
1890	Allegheny Athletic Association	Western Pennsylvania Independent Football Champions
1891	Pittsburgh Athletic Club	Western Pennsylvania Independent Football Champions
1892	Allegheny Athletic Club	Western Pennsylvania Independent Football Champions
1894	Allegheny Athletic Club	Western Pennsylvania Independent Football Champions
1895	Duquesne Country and Athletic Club	Western Pennsylvania Independent Football Champions
1896	Allegheny Athletic Association	Western Pennsylvania Independent Football Champions
1897	Greensburg Athletic Association	Western Pennsylvania Independent Football Champions
1898	Duquesne Country and Athletic Club	Western Pennsylvania Independent Football Champions
1899	Duquesne Country and Athletic Club	Western Pennsylvania Independent Football Champions
1899	Pittsburgh Athletic Club	Western Pennsylvania Hockey League
1900	Homestead Library and Athletic Club	Western Pennsylvania Independent Football Champions
1900	Pittsburgh Athletic Club	Western Pennsylvania Hockey League
1901	Homestead Library and Athletic Club	Western Pennsylvania Independent Football Champions
1901	Pittsburgh Athletic Club	Western Pennsylvania Hockey League
1901	Pittsburgh Pirates	National League Champions
1902	Pittsburgh Pirates	National League Champions
1902	Pittsburgh Stars	National Football League Champions

YEAR	TEAM	CHAMPIONSHIP
1902	Pittsburgh Keystones	Western Pennsylvania Hockey League
1903	Pittsburgh Bankers	Western Pennsylvania Hockey League
1903	Latrobe Athletic Association	Western Pennsylvania Independent Football Champions
1903	Franklin Athletic Club	World Series of Football Champions
1904	Latrobe Athletic Association	Western Pennsylvania Independent Football Champions
1904	Pittsburgh South Side	Western Pennsylvania Basketball League
1904	Pittsburgh Victorias	Western Pennsylvania Hockey League
1905	Latrobe Athletic Association	Western Pennsylvania Independent Football Champions
1907	Pittsburgh Bankers	Western Pennsylvania Hockey League
1907	Pittsburgh South Side	Central Basketball League Champions
1908	Duquesne Athletic Club	Western Pennsylvania Hockey League
1908	Uniontown Coal Barons	Pennsylvania–West Virginia League Champions (Minor League Baseball)
1909	Pittsburgh Pirates	World Series Champions
1909	Uniontown Coal Barons	Pennsylvania–West Virginia League Champions (Minor League Baseball)
1910	University of Pittsburgh	NCAA Football Champions
1910	Altoona Rams	Tri-state League Champions (Minor League Baseball)
1912	Pittsburgh Filipinos	United States Baseball League

YEAR	TEAM	CHAMPIONSHIP
1912	Monticello Athletic Association	Black Fives World Basketball Champions
1913	Pittsburgh South Side	Western Pennsylvania Basketball League
1915	University of Pittsburgh	NCAA Football Champions
1916	University of Pittsburgh	NCAA Football Champions
1918	University of Pittsburgh	NCAA Football Champions
1920	Loendi Big Five	Black Fives World Basketball Champions
1921	Washington & Jefferson College	NCAA Football Champions
1921	Loendi Big Five	Black Fives World Basketball Champions
1922	Loendi Big Five	Black Fives World Basketball Champions
1923	Loendi Big Five	Black Fives World Basketball Champions
1924	Pittsburgh Yellow Jackets	U.S. Amateur Hockey Association Champions
1924	University of Pittsburgh	Intercollegiate Association of Amateur Athletes of America Cross Country Champions
1924	Brownsville Independents	Independent Football Champions of Western Pennsylvania
1925	Pittsburgh Yellow Jackets	U.S. Amateur Hockey Association Champions
1925	Pittsburgh Pirates	World Series Champions
1925	Johnstown Johnnies	Middle Atlantic League Champions (Minor League Baseball)
1926	Johnstown Johnnies	Middle Atlantic League Champions (Minor League Baseball)

YEAR	TEAM	CHAMPIONSHIP
1927	Heidelberg Soccer Club	U.S. Amateur Cup Champions
1928	University of Pittsburgh	NCAA Basketball Champions
1929	University of Pittsburgh	NCAA Football Champions
1929	Charleroi Governors	Middle Atlantic League Champions (Minor League Baseball)
1929	Heidelberg Soccer Club	U.S. Amateur Cup Champions
1930	University of Pittsburgh	NCAA Basketball Champions
1930	Homestead Grays	Eastern Independent Champions
1930	Johnstown Johnnies	Middle Atlantic League Champions (Minor League Baseball)
1930	James F. Rooney Football Team	Senior Conference Independent Football Champions
1931	Homestead Grays	Eastern Independent Champions
1931	James F. Rooney Football Team	Senior Conference Independent Football Champions
1931	University of Pittsburgh	NCAA Football Champions
1933	Pittsburgh Crawfords	Negro National League Champions
1934	University of Pittsburgh	NCAA Football Champions
1934	Greensburg Trojans	Pennsylvania State Association Champions (Minor League Baseball)
1935	Pittsburgh Crawfords	Negro National League Champions
1935	Monessen Reds	Pennsylvania State Association Champions (Minor League Baseball)
1935	W.W. Riehl Soccer Club	U.S. Amateur Cup Champions
1935	Carnegie Tech	NRA Collegiate Rifle Champions
1936	Carnegie Tech	NRA Collegiate Rifle Champions

YEAR	TEAM	CHAMPIONSHIP
1936	Jeannette Little Pirates	Pennsylvania State Association Champions (Minor League Baseball)
1936	Pittsburgh Crawfords	Negro National League Champions
1936	University of Pittsburgh	NCAA Football Champions
1937	Carnegie Tech	NRA Collegiate Rifle Champions
1937	Butler Yankees	Pennsylvania State Association Champions (Minor League Baseball)
1937	University of Pittsburgh	NCAA Football Champions
1937	Homestead Grays	Negro National League Champions
1938	Homestead Grays	Negro National League Champions
1938	Butler Yankees	Pennsylvania State Association Champions (Minor League Baseball)
1939	Washington (PA) Red Birds	Pennsylvania State Association Champions (Minor League Baseball)
1940	Homestead Grays	Negro National League Champions
1940	Butler Yankees	Pennsylvania State Association Champions (Minor League Baseball)
1940	Morgan Strasser Soccer Club	U.S. Amateur Cup Champions
1941	Homestead Grays	Negro National League Champions
1941	Butler Yankees	Pennsylvania State Association Champions (Minor League Baseball)

APPENDIX II

YEAR	TEAM	CHAMPIONSHIP
1941	Erie Sailors	Middle Atlantic League Champions (Minor League Baseball)
1942	Erie Sailors	Middle Atlantic League Champions (Minor League Baseball)
1942	Butler Yankees	Pennsylvania State Association Champions (Minor League Baseball)
1942	Gallatin Soccer Club	U.S. Open Cup Champions
1943	Homestead Grays	Negro League World Series Champions
1944	Homestead Grays	Negro League World Series Champions
1946	Erie Sailors	Middle Atlantic League Champions (Minor League Baseball)
1946	Bloomfield Rams	Universal Football League Champions
1947	Pittsburgh Indians	North American Professional Soccer League Champions
1947	Vandergrift Pioneers	Middle Atlantic League Champions (Minor League Baseball
1948	Erie Sailors	Middle Atlantic League Champions (Minor League Baseball)
1948	Homestead Grays	Negro League World Series Champions
1949	Morgan Soccer Club	U.S. Open Cup Champions
1949	Erie Sailors	Middle Atlantic League Champions (Minor League Baseball)

APPENDIX II

YEAR	TEAM	CHAMPIONSHIP
1950	Butler Tigers	Middle Atlantic League Champions (Minor League Baseball)
1952	Pittsburgh Hornets	American Hockey League Champions
1952	Harmarville Hurricanes Soccer Club	U.S. Open Cup Champions
1954	Beadling Soccer Club	U.S. Amateur Cup Champions
1955	Pittsburgh Hornets	American Hockey League Champions
1955	Duquesne University	NIT Basketball Champions
1955	Heidelberg Soccer Club	U.S. Amateur Cup Champions
1955	Bloomfield Rams	Steel Bowl Conference Champions
1956	Harmarville Hurricanes Soccer Club	U.S. Open Cup Champions
1957	Erie Sailors	New York–Pennsylvania League Champions (Minor League Baseball)
1960	Pittsburgh Pirates	World Series Champions
1966	Waynesburg College	NAIA Football Champions
1967	Pittsburgh Hornets	American Hockey League Champions
1968	Pittsburgh Pipers	American Basketball Association Champions
1968	Indiana University of Pennsylvania	NAIA Men's Golf Champions
1970	Westminster College	NAIA Division II Football Champions
1971	Pittsburgh Pirates	World Series Champions
1971	Slippery Rock University	NCAA Men's Division II Outdoor Track and Field Champions

YEAR	TEAM	CHAMPIONSHIP
1973	Duquesne University	National Club Football Association Champions
1973	Community College of Allegheny College– Allegheny Campus	NJCAA Men's Cross Country Champions
1974	Pittsburgh Steelers	Super Bowl IX Champions
1975	Pittsburgh Steelers	Super Bowl X Champions
1975	Pittsburgh Triangles	World Team Tennis Champions
1975	Johnstown Jets	North American Hockey League Champions
1975	Edinboro University	NAIA Men's Cross Country Champions
1975	Pittsburgh Ironmen	Mid-Atlantic Semipro Football League Champions
1976	Community College of Allegheny College– Allegheny Campus	NJCAA Men's Cross Country Champions
1976	University of Pittsburgh	NCAA Football Champions
1976	Mercyhurst University	NAIA Men's Tennis Champions
1976	Pittsburgh Ironmen	Mid-Atlantic Semipro Football League Champions
1976	Clarion University	AIAW Gymnastics Champions
1976	Westminster College	NAIA Division II Football Champions
1976	Community College of Allegheny College– Allegheny Campus	NJCAA Women's Cross Country Champions
1976	Community College of Allegheny College– Allegheny Campus	NJCAA Men's Marathon Champions
1976	Edinboro University	NAIA Men's Cross Country Champions
1977	Clarion University	AIAW Gymnastics Champions

YEAR	TEAM	CHAMPIONSHIP
1977	Clarion University	AIAW Division II Swimming and Diving Champions
1977	Westminster College	NAIA Division II Football Champions
1977	Community College of Allegheny College–Allegheny Campus	NJCAA Men's Cross Country Champions
1977	Community College of Allegheny College–Allegheny Campus	NJCAA Men's Marathon Champions
1978	Community College of Allegheny College–Allegheny Campus	NJCAA Men's Indoor Track and Field Champions
1978	Community College of Allegheny College–Allegheny Campus	NJCAA Men's Marathon Champions
1978	Clarion University	AIAW Division II Swimming and Diving Champions
1978	Pittsburgh Steelers	Super Bowl XIII Champions
1979	Pittsburgh Steelers	Super Bowl XIV Champions
1979	Pittsburgh Pirates	World Series Champions
1980	Clarion University	AIAW Division II Swimming and Diving Champions
1980	University of Pittsburgh	NCAA Football Champions
1981	University of Pittsburgh	NCAA Football Champions
1981	Clarion University	AIAW Division II Swimming and Diving Champions
1982	Clarion University	AIAW Division II Swimming and Diving Champions
1983	Allegheny College	NCAA Men's Division III Golf Champions
1983	Clarion University	NCAA Division II Swimming and Diving Champions

YEAR	TEAM	CHAMPIONSHIP
1984	Clarion University	NCAA Division II Swimming and Diving Champions
1986	Edinboro University	NCAA Men's Division II Cross Country Champions
1986	Clarion University	NCAA Division II Swimming and Diving Champions
1987	Edinboro University	NCAA Men's Division II Cross Country Champions
1988	Westminster College	NAIA Division II Football Champions
1988	Edinboro University	NCAA Men's Division II Cross Country Champions
1989	Westminster College	NAIA Division II Football Champions
1990	Edinboro University	NCAA Men's Division II Cross Country Champions
1990	Allegheny College	NCAA Division III Football Champions
1990	Community College of Allegheny College– Allegheny Campus	NJCAA Men's Division II Basketball Champions
1991	Pittsburgh Penguins	Stanley Cup Champions
1992	Pittsburgh Penguins	Stanley Cup Champions
1994	Westminster College	NAIA Division II Football Champions
1994	Erie Sailors	Frontier League Champions (Minor League Baseball)
1995	Johnstown Johnnies	Frontier League Champions (Minor League Baseball)
1995	Slippery Rock University	USA Water Polo Collegiate Champions
1996	University of Pittsburgh– Johnstown	NCAA Men's Division II Wrestling Champions

YEAR	TEAM	CHAMPIONSHIP
1997	California University of Pennsylvania	NCAA Women's Division II Softball Champions
1997	Community College of Beaver County	NJCAA Men's Division II Basketball Champions
1998	California University of Pennsylvania	NCAA Women's Division II Softball Champions
1999	Robert Morris University	NCAA Division I-AA Mid Major Football Champions
1999	University of Pittsburgh–Johnstown	NCAA Men's Division II Wrestling Champions
2000	Robert Morris University	NCAA Division I-AA Mid Major Football Champions
2000	Johnstown Johnnies	Frontier League Champions (Minor League Baseball)
2000	Pittsburgh Colts	National Minor Pro Football League Champions (Minor League Football)
2002	Robert Morris University	American Collegiate Hockey Association Division III Champions
2002	Erie Otters	Ontario Hockey League (Junior Hockey)
2003	Pittsburgh Forge	North American Hockey League Champions
2003	Duquesne University	NCAA Division I-AA Mid Major Football Champions
2004	Mercyhurst College	NCAA Women's Division II Rowing Champions
2004	California University of Pennsylvania	NCAA Women's Division II Basketball Champions
2005	Pittsburgh Steelers	Super Bowl XL Champions
2006	Beaver County Vipers	United States Football Alliance Champions

YEAR	TEAM	CHAMPIONSHIP
2007	Pittsburgh Passion	National Women's Football Association Champions
2008	Pittsburgh Steelers	Super Bowl XLIII Champions
2008	Indiana Ice Miners	Mid-Atlantic Hockey League Champions
2008	California University of Pennsylvania	American Collegiate Hockey Association Division III Champions
2009	Pittsburgh Penguins	Stanley Cup Champions
2009	Pittsburgh Colts	Grassroots Football League Champions (Minor League Football)
2010	Altoona Curve	Eastern League Champions (Minor League Baseball)
2011	Erie Outlaws	National League of Semipro Football Champions (Minor League Football)
2014	University of Pittsburgh–Greensburg	College Ice Hockey Association Champions
2014	Pittsburgh Passion	Independent Women's Football League Champions
2015	Pittsburgh Passion	Independent Women's Football League Champions
2015	California University of Pennsylvania	NCAA Women's Division II Basketball Champions
2015	Indiana Tomahawks	West Penn Sports League Champions (Minor League Football)
2015	Mon Valley Mayhem	Showdown Football League Champions (Minor League Football)
2016	Pittsburgh Penguins	Stanley Cup Champions
2016	WPA Wildcatz	National Champions (Minor League Football)

YEAR	TEAM	CHAMPIONSHIP
2017	Erie Otters	Ontario Hockey League (Junior Hockey)
2017	Pittsburgh Penguins	Stanley Cup Champions

James Harrison (16), a reserve with the Steelers in 2005, showed his potential with a dramatic interception return against San Diego. *Kent State Athletics.*

NOTES

Chapter 1

1. Jacqueline Cantor, "California University of Pennsylvania Women's Basketball Reaches Division II National Championhip," Pennlive.com, March 25, 2015. http://www.pennlive.com/sports/index.ssf/2015/03/california_university_of_penns_1.html.
2. Rick Shrum, "Love Triangles; Pittsburgh Adored Its World Team Tennis Franchise," *Pittsburgh Post-Gazette*, September 10, 2000. http://old.post-gazette.com/sports/other/20000910triangles5.asp.
3. Fred Landucci, "Hornets Sweep Hockey Laurels," *Pittsburgh Press*, April 11, 1955, 20.
4. Henry Peter Gribbin, "1938: Year of the Carnegie Tech Tartans," July 28, 2016. http://pittsburghseniornews.com/2016/07/28/1938-year-carnegie-tech-tartans.
5. Ray Fittipaldo, "Work Ethic Made Harmarville Toast of U.S. Soccer in the 1950s," *Pittsburgh Post-Gazette*, July 13, 2003. http://old.post-gazette.com/sports/other/20030713opencup0713p4.asp.
6. Ibid.
7. PittsburghHockey.net, "1915–1925 Pittsburgh Yellow Jackets." http://pittsburghhockey.net/other-teams/yellow-jackets.
8. John McMahon, "Hornets Again National Hockey Champs," *Pittsburgh Press*, April 12, 1925.
9. Finoli, *When Pitt Ruled the Gridiron*, 149.
10. Ibid.

11. Corey Masisak, "Part 1: Lemeiux's Cancer Comeback Great Sports Story," March 2, 2013. https://www.nhl.com/news/part-1-lemieuxs-cancer-comeback-great-sports-story/c-658116.

12. Ibid.

Chapter 2

13. Carroll and Braunwart, *Pro Football*, 129.

14. Fred Landucci, "Hornets Win First Cup in History," *Pittsburgh Press*, April 21, 1952, 18.

15. Finoli, *When Pitt Ruled the Gridiron*, 25.

16. Black Five Foundation, "Monticello Athletic Association." http://www.blackfives.org/teams/monticello-athletic-association.

17. Ibid.

18. Pro Football Hall of Fame, "Greasy Neale." http://www.profootballhof.com/players/earle-greasy-neale.

19. Deborah Duncan, "W&J Honors Early Black Football Star," *Pittsburgh Post-Gazette*, September 8, 2011. http://www.post-gazette.com/neighborhoods-south/2011/09/08/W-J-honors-early-black-football-star/stories/201109080225.

Chapter 3

20. *Seattle Post-Intelligencer*, "Vince Cazzetta Dead at 79: Kept Seattle U on the Basketball Map," May 5, 2005. http://www.seattlepi.com/sports/article/Vince-Cazzetta-dead-at-79-Kept-Seattle-U-on-1172695.php.

21. Baseball-Reference.com Bullpen, "Honus Wagner." http://www.baseball-reference.com/bullpen/Honus_Wagner.

22. Ibid.

23. Ron Cook, "Jerome Bettis' Teammates Make Good on Their Super Bowl Vow," *Pittsburgh Post-Gazette*, August 6, 2005. http://www.post-gazette.com/sports/ron-cook/2015/08/06/Ron-Cook-Jerome-Bettis-teammates-make-good-on-their-Super-Bowl-vow/stories/201508060040.

24. Ibid.

25. Mike Lucas, "Penguin Coach Is Dead at 60: Hockey: Bob Johnson Is Remembered Fondly, Especially for His Days at Wisconsin," *Los Angeles*

Times, November 27, 1991. http://articles.latimes.com/1991-11-27/sports/sp-163_1_bob-johnson.

26. Bleacher Report, "Wooooo, It's a Great Day for Hockey: Remembering 'Badger' Bob Johnson," July 22, 2008. http://bleacherreport.com/articles/40084-its-a-great-day-for-hockey-remembering-badger-bob-johnson.

Chapter 4

27. Keith Pearson, "Bill Belichick Reminisces about Chuck Noll, Battles with Steelers," *Boston Herald*, October 16, 2016. http://www.bostonherald.com/sports/patriots/the_blitz/2016/10/bill_belichick_reminisces_about_chuck_noll_battles_with_steelers.

28. Fayette County Sports Hall of Fame, "1900–1949 Charley Hyatt (2010)." http://www.fayettecountysportshalloffame.com/2010/hyatt.html.

29. Baseball Hall of Fame, "Josh Gibson." http://baseballhall.org/hof/gibson-josh.

30. Ibid., "Ray Brown." http://baseballhall.org/hof/brown-ray.

31. Ibid.

32. Don Banks, "An Oral History of the 1974 Steelers, a Team That Launched a Dynasty," December 18, 2014. http://www.si.com/nfl/2014/12/18/pittsburgh-steelers-1974-oral-history.

33. Ibid.

34. Charlie Vascellaro, "Bucs Broke Ground with First All Minority Lineup," September 1, 2011. http://m.mlb.com/news/article/24052540.

35. Ibid.

36. Bob Huarte, "Steve Blass." http://sabr.org/bioproj/person/27a6a54d.

37. William Wallace, "College Football: This Pitt Backfield Is Still a Dream," *New York Times*, October 15, 1994. http://www.nytimes.com/1994/10/15/sports/college-football-this-pitt-backfield-is-still-a-dream.html.

Chapter 5

38. Baseball Hall of Fame, "Pie Traynor." http://baseballhall.org/hof/traynor-pie.

39. Scott Pitoniak, in Hoppel, Nahrstedt and Zesch, eds., *The Sporting News: College Football's 25 Greatest Teams*, 170.

40. Riley, *Biographical Encyclopedia of the Negro Baseball Leagues*, 869.

41. Justice B. Hill, "1931 Homestead Best Team Ever," February 26, 2007. ttp://m.mlb.com/news/article/1816465.

42. Ibid.

43. Kevin Kirland, "Greenlee Field Site Earns Place in History," *Pittsburgh Post-Gazette*, July 17, 2009. http://www.post-gazette.com/sports/pirates/2009/07/17/Greenlee-Field-site-earns-place-in-history/stories/200907170124.

BIBLIOGRAPHY

Books

Bankes, James. *The Pittsburgh Crawfords: The Lives and Times of Black Baseball's Most Exciting Team.* Dubuque, IA: W.C. Brown, 1991.

Carroll, Bob, and Bob Braunwart. *Pro Football: From AAA to '03: The Origin and Development of Professional Football in Western Pennsylvania, 1890–1903.* North Huntingdon, PA: PFRA, 1991.

Clark, Dick, and Larry Lester, eds. *The Negro Leagues Book.* Cleveland, OH: SABR, 1994.

Epstein, Eddie. *Baseball Dynasties: The Seasons of Pro Football's Greatest Teams.* New York: W.W. Norton, 2000.

Epstein, Eddie, and Rob Neyer. *Baseball Dynasties: The Greatest Teams of All Time.* Washington, D.C.: Brassey's, 2002.

Finoli, David. *Classic Bucs: The 50 Greatest Games in Pittsburgh Pirates History.* Kent, OH: Kent State Press, 2013.

———. *Classic Pens: The 50 Greatest Games in Pittsburgh Penguins History.* Kent, OH: Kent State Press, 2015.

———. *Classic Steelers: The 50 Greatest Games in Pittsburgh Steelers History.* Kent, OH: Kent State Press, 2014.

———. *Kings on the Bluff: The 1955 N.I.T. Champion Duquesne Dukes.* North Charleston, SC: Createspace, 2016.

———. *When Pitt Ruled the Gridiron: Football at the University of Pittsburgh, 1924–1938.* Jefferson, NC: McFarland, 2011.

Finoli, David, and Bill Ranier. *The Pittsburgh Pirates Encyclopedia*. 2nd ed. New York: Sports Publishing Inc., 2015.

———. *When Cobb Met Wagner: The Seven Games of the 1909 World Series*. Jefferson, NC: McFarland, 2015.

———. *When the Bucs Won It All: The 1979 World Champion Pittsburgh Pirates*. Jefferson, NC: McFarland, 2003.

Finoli, David, and Chris Fletcher. *Steel City Gridirons*. Pittsburgh, PA: Maguire Towers, 2005.

Finoli, David, and Tom Aikens. *The Birthplace of Professional Football: Southwestern Pennsylvania*. Charleston, SC: Arcadia Publishing, 2004.

Hogan, Lawrence D. *Shades of Glory: The Negro Leagues and the Story of African American Baseball*. Washington, D.C.: National Geographic Society, 2006.

Holway, John. *The Complete Book of Baseball's Negro Leagues: The Other Half of Baseball History*. Fern Park, FL: Hastings House, 2001.

Hoppel, Joe, Mike Nahrstedt and Steve Zesch, eds. *The Sporting News College Football's 25 Greatest Teams*. St. Louis, MO: The Sporting News, 1988.

James, Bill. *The New Bill James Historical Baseball Abstract*. New York: Free Press, 2001.

Riley, James A. *The Biographical Encyclopedia of the Negro Baseball Leagues*. New York: Carroll and Graf, 1994.

Waldo, Ronald T. *The 1902 Pittsburgh Pirates: Treachery and Triumph*. Jefferson, NC: McFarland, 2015.

Media Guides

California University of Pennsylvania Women's Basketball Record Book. 2017.

Duquesne University Basketball Media Guide. 2017.

Duquesne University Football Media Guide. 2015.

National Hockey League Official Guide and Record Book. 2017.

NIT Finals Program. 1955.

Pittsburgh Penguins Media Guides. 1992, 1993, 2010, 2017.

Pittsburgh Pirates Media Guide. 2016.

Pittsburgh Steelers Media Guides. 1975, 1976, 1979, 1980, 2006, 2009, 2016.

Spalding Football Guide. 1936.

University of Pittsburgh Basketball Media Guide. 2017.

University of Pittsburgh Football Media Guides. 1977, 1981, 2015.

BIBLIOGRAPHY

Newspapers

New York Daily News
New York Times
Pittsburgh Post-Gazette
Pittsburgh Press
Tribune Review

Magazines

Sporting News
Sport Magazine
Sports Illustrated

Web Sites

Aboutsports.com.
Allegehenygators.com. The official athletic website of Allegheny College.
Baseballhall.org. The official Baseball Hall of Fame website.
Baseball-reference.com.
Basketball-reference.com.
Bigbluehistory.net. Kentucky basketball.
Blackfives.com.
Bleacherreport.com. The website of the Bleacher Report.
Britannica.com. The online Encyclopedia Britannica.
Cfbdatawarehouse.com. College football data warehouse.
coe.k-state.edu/annex/nlbemuseum. The Negro League Museum Emuseum resource for teachers.
Explorepahistory.com.
Fayettecountysportshalloffame.com. The official website of the Fayette County Sports Hall of Fame.
Footballoutsiders.com.
Goduquesne.com. The Duquesne University official website.
Googlenews.com.
History.com.
Hockeydb.com. Hockey database.
Hockey-reference.com.

Jewsinsports.org.

LATimes.com. The website of the *Los Angeles Times.*

Library.la84.org. The website of the 1984 Los Angeles Olympics Organization.

Mapleleaflegends.blogspot.com.

Masslive.com. Massachusetts news website.

Maxwellfootballclub.org. The official website of the Maxwell Football Club.

MLB.com. The official website of Major League Baseball.

Negroleaguebaseball.com.

NHL.com. The official website of the National Hockey League.

Observer-reporter.com. The website of the *Washington Observer-Reporter.*

Pennlive.com.

PFRA.org. The official website of the Pro Football Research Association.

Pittjohnstownathletics.com. The official website of UPJ athletics.

Pittpanthers.com. The University of Pittsburgh official website.

Pittsburghhockey.net.

Pittsburghpenguins.com. The Pittsburgh Penguins official website.

Pittsburghpirates.com. The Pittsburgh Pirates official website.

Pittsburghseniornews.com.

Profootballhof.org. The official website of the Pro Football Hall of Fame.

Profootball-reference.com.

Quod.lib.umich.edu. The University of Michigan Center for History of Medicine website.

Remembertheaba.com.

SABR.org. The official website of the Society of American Baseball Research.

Seamheads.com. Negro League Database.

Seattlepi.com. The official website of the *Seattle Post-Intelligencer.*

Sportsreference.com.

Steelers.com. The Pittsburgh Steelers official website.

Thisgreatgame.com.

TipTop25.com.

225.pitt.edu. The University of Pittsburgh's 225th anniversary website.

www.donnan.com/Murphy.htm. The Incredible Bob Murphy, by E. Lee North.

ABOUT THE AUTHOR

David Finoli is an author and sports historian who has written numerous titles on the history of sports in western Pennsylvania. He has written five other titles for Arcadia Publishing, including *Forbes Field* and *The Pittsburgh Pirates* for the Images of America and Images of Baseball series. He also is a contributor to various books, magazines and sports websites. He lives in Monroeville with his family.

Author David Finoli poses with the Prince of Wales Trophy, which the Penguins captured in 2016 for winning the Eastern Conference. *Author's collection.*